Loan Oei and Cecile De Kegel

the elements of design

rediscovering colours, textures, forms and shapes

with 177 colour illustrations

Thames & Hudson

First published in the United Kingdom in 2002 by Thames & Hudson
Ltd, 181A High Holborn, London WC1V 7QX

British Library Cataloguing-in-Publication Data
A catalogue record for this book is available from the British Library

ISBN 0-500-28339-7

Printed and bound in Singapore

contents

Acknowledgments and credits

Special thanks to Itie van Hout (Tropenmuseum, Amsterdam)
and Liban Pollet (Gallery Daroun, Antwerp) for enabling
us to photograph items from their collections.
Gert Staal for his assessment of the concept.
Geert Bosschaert, Hilde Van kerckhoven
and Anneke de Bruin for their critical comments.
Joan Gannij for fine-tuning the English.
Francis, Wanda and Iwan Strauven for their valuable input.
All of those who have helped us realize this project.

Concept and layout Loan Oei and Cecile De Kegel
Text Loan Oei
Photography Cecile De Kegel (143 photographs)

Completed with photographs from Iene Ambar: p. 23
Anna Beeke: p. 91
Loan Oei: pp. 18, 20, 45 left and right, 48 right,
66, 69, 74, 75 left, 95, 104-5, 107, 110-11, 115, 116, 133,
146, 149, 151, 157, 166, 172 left, 189 top, 191, 197
Hiroyuki Shindo: p. 145
Francis Strauven: p. 171
Wanda Strauven: pp. 40, 127
Yap Hong Seng: pp. 90, 181 left
Takahiro Yonekawa: pp. 194-5

Introduction

'The true mystery of the world is the visible, not the invisible.'
Oscar Wilde

For a considerable time we have nurtured a common interest in the obvious but generally unnoticed qualities of things. Attracted by the hidden beauty in our natural and manmade environment, we became fascinated by textures, patterns and colours. Recording the ever-recurring visual patterns of nature and of diverse artefacts, we noticed striking similarities between them and wondered if these were the result of a principle of order, active in both man and nature. When we juxtaposed the results of our observations - ranging from scenic views of landscapes and cities to close-ups of objects from fine art, crafts and daily life - they proved to display a number of constants, such as dots, lines and elementary figures. These elements, irrespective of their origin, appeared to us to be the basic ingredients of a universal language of pattern.

Various arrangements of dots; lines that are straight, curving, bending or crossing; geometrical figures, such as rectangles, squares, lozenges, triangles and circles - all are found in a wide range of materials and techniques throughout the world. They are common among people from all cultures and in all ages. They prove to be timeless and universal constants that appear in different forms, depending on the maker's identity, his or her physical conditions and the cultural context. These universal elements are rediscovered and reshaped time and again in new patterns, so that creation is in fact primarily recreation, whether by inspiration or imitation, as representation or interpretation. Nevertheless, the perpetual recourse to the same constants need not be a hindrance to creativity or originality. As the Dutch architect Aldo van Eyck said: 'to discover anew implies discovering something new'. Originality means going back to origins.

The concept of the book is based on a slide show created on behalf of the experimental project *Junichi Arai and Nuno no Kodo*, launched in 1997 in the Netherlands Textile Museum, Tilburg and supported by the Netherlands Design Institute, Amsterdam. The design brief given to us by Junichi Arai was to make pattern designs inspired by ethnic textiles and by nature for fabrics to be woven in Japan. The slide show was meant to reveal our sources of inspiration. From the countless images stored over the years in our memory, many were spontaneously captured in pictures. Thus we have drawn from our vast reservoir of self-made photographs, shot on our travels over a period of decades, as well as from our own textile and ethnographic collections. Where appropriate, they were completed with photographs and objects from collections of third parties. This book comprises a selection of our findings, and can as such be used as a design sourcebook.

Loan Oei and Cecile De Kegel

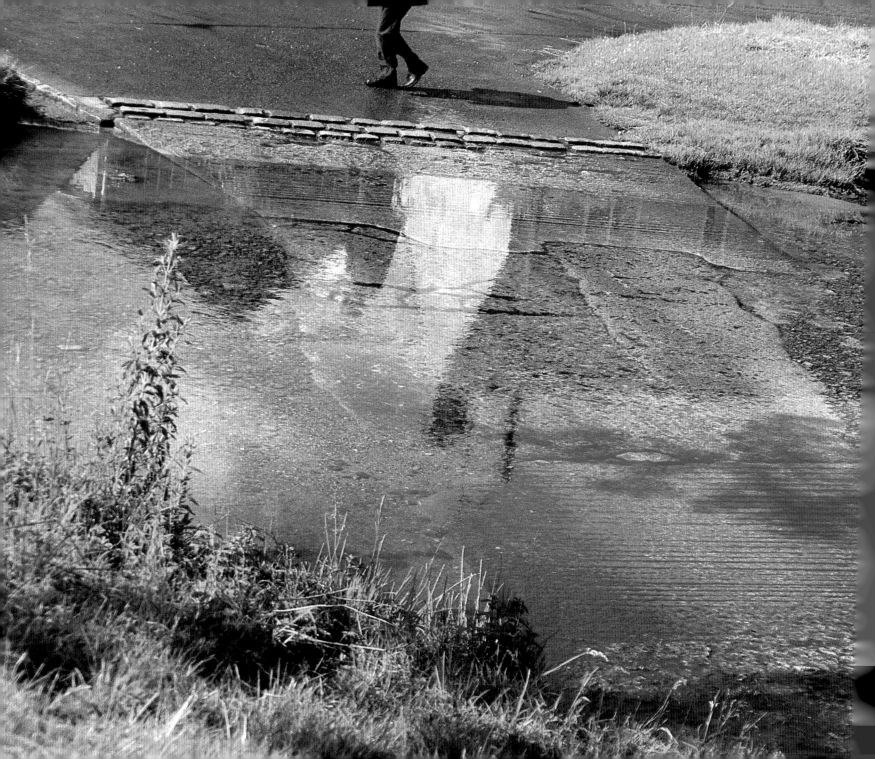

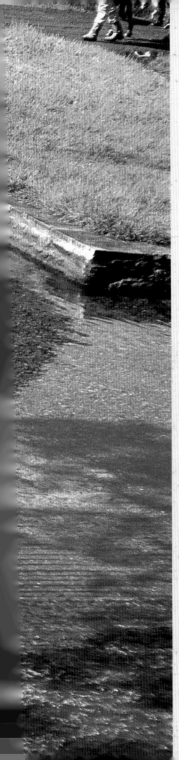

Colours

The most striking feature of any structure or pattern is its colour. The same structure or pattern in another colour scheme looks quite different. Colour variations are conceivable *ad infinitum*. When a colour image is reproduced, the variations can also occur unintentionally.

For someone seeking a colour scheme, nature is an inexhaustible source of inspiration. Flora and fauna provide ready-made design models in terms of colour and pattern. Sky, earth and water offer changing palettes in a continuous day-and-night performance by the sun and the moon.

Theoretically every conceivable colour tone can be realized in a designed object, but in practice this is not always possible and usually it is very hard to achieve the desired shade in the desired material. Too many factors are involved when deliberately setting out to produce a colour scheme, making it the more fascinating to discover a coincidental correspondence between natural phenomena and manmade creations.

9

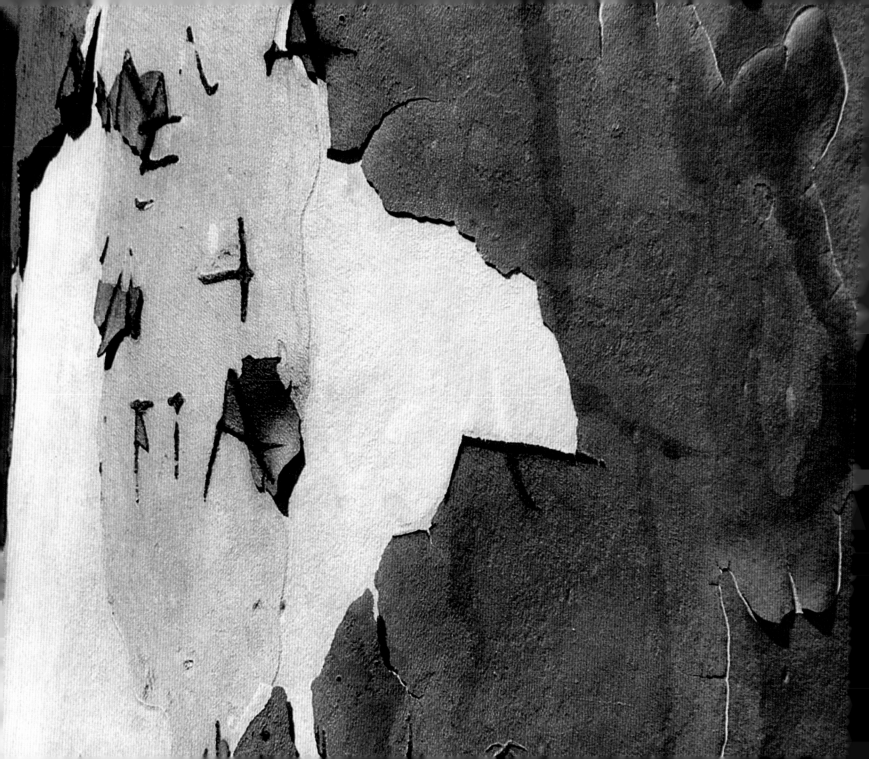

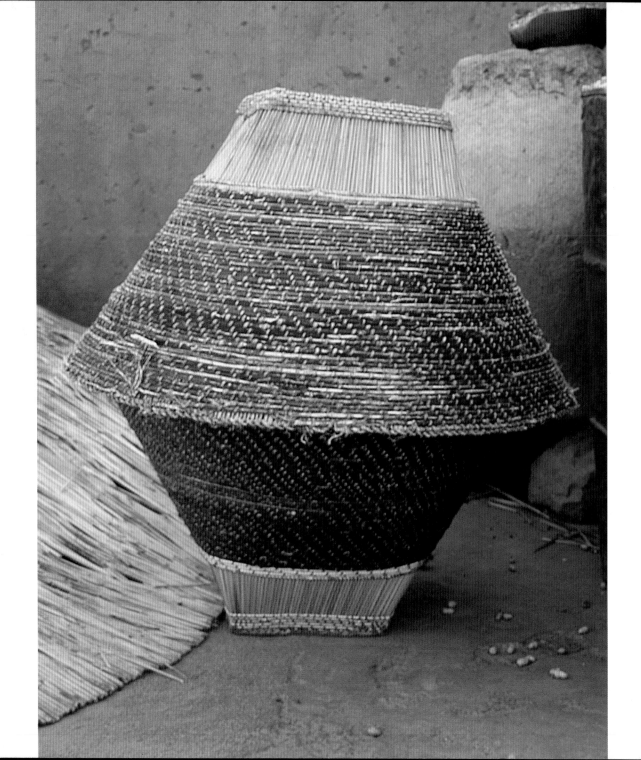

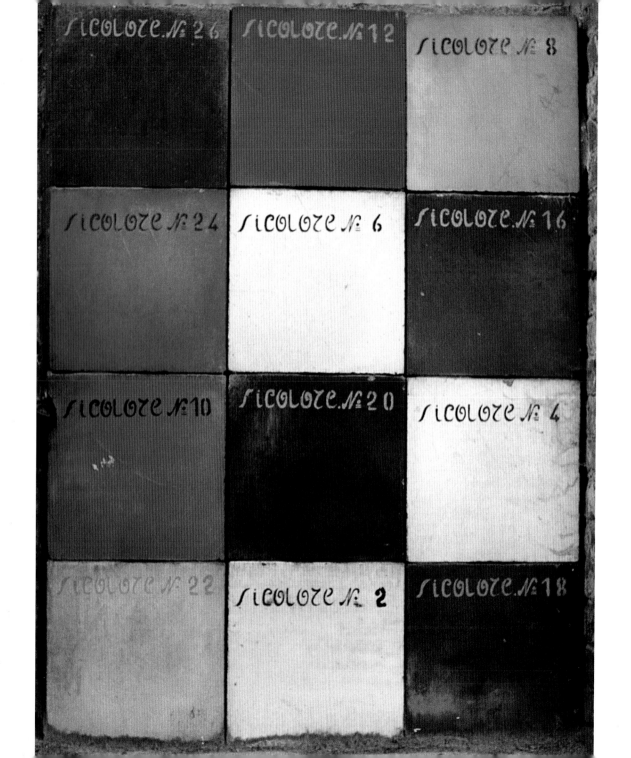

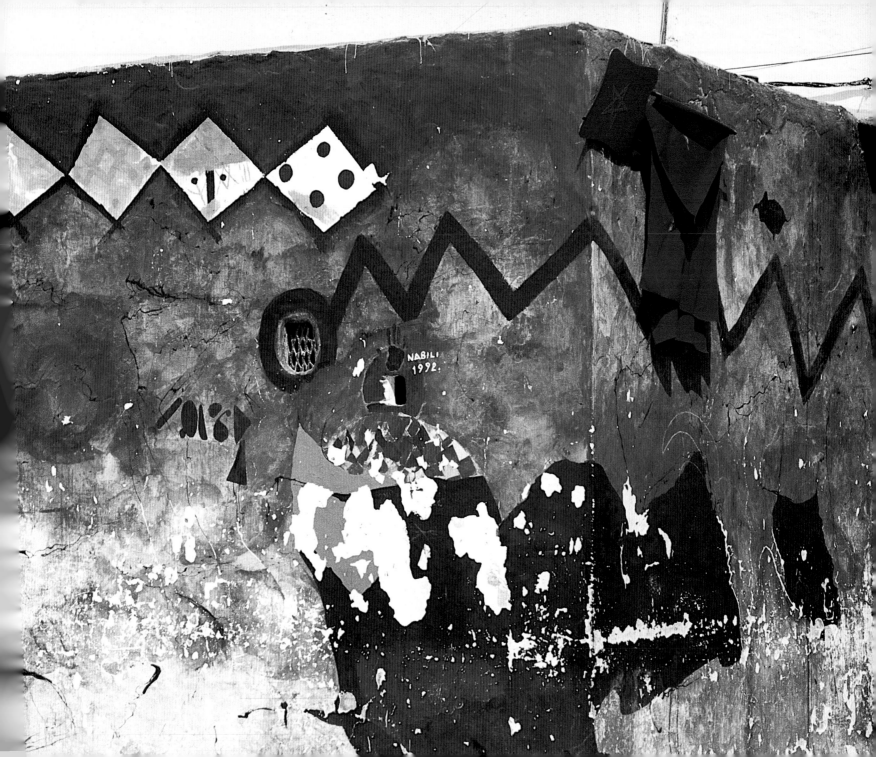

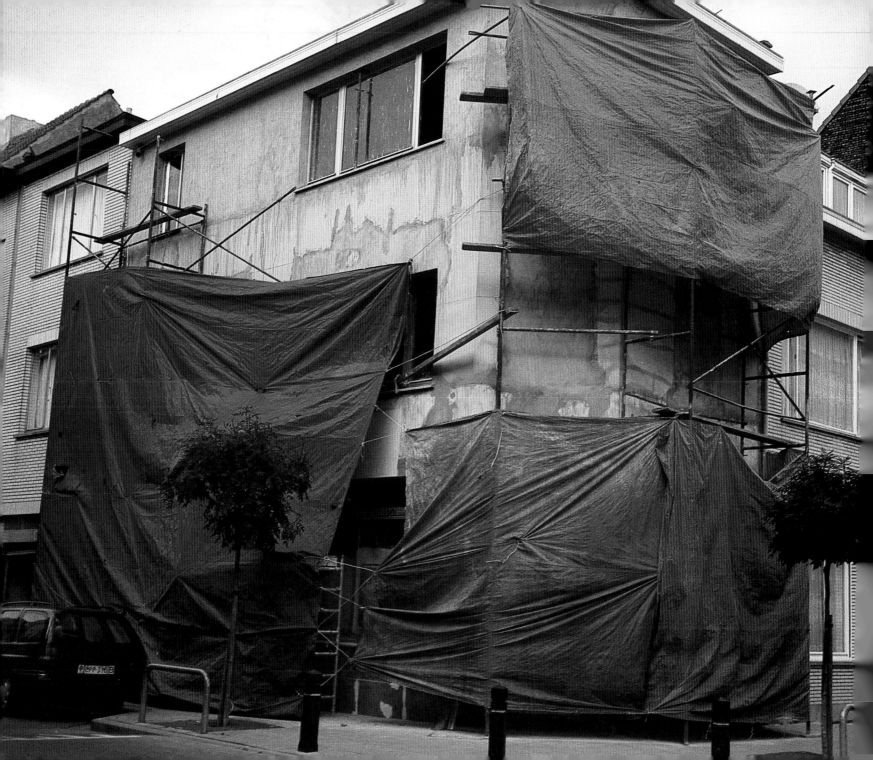

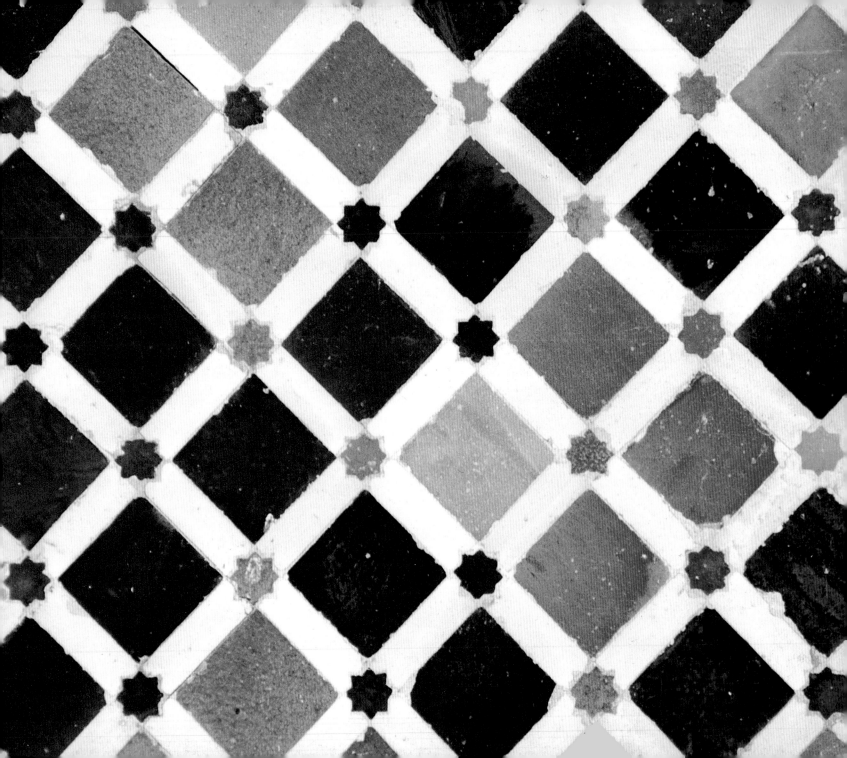

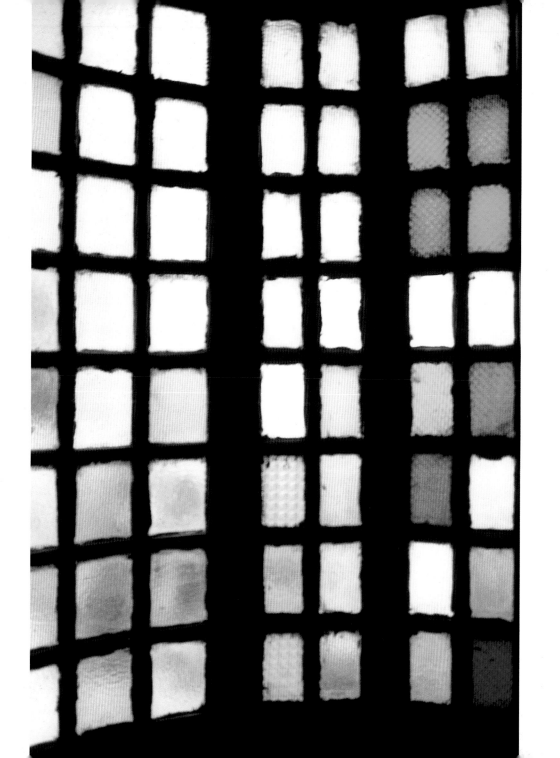

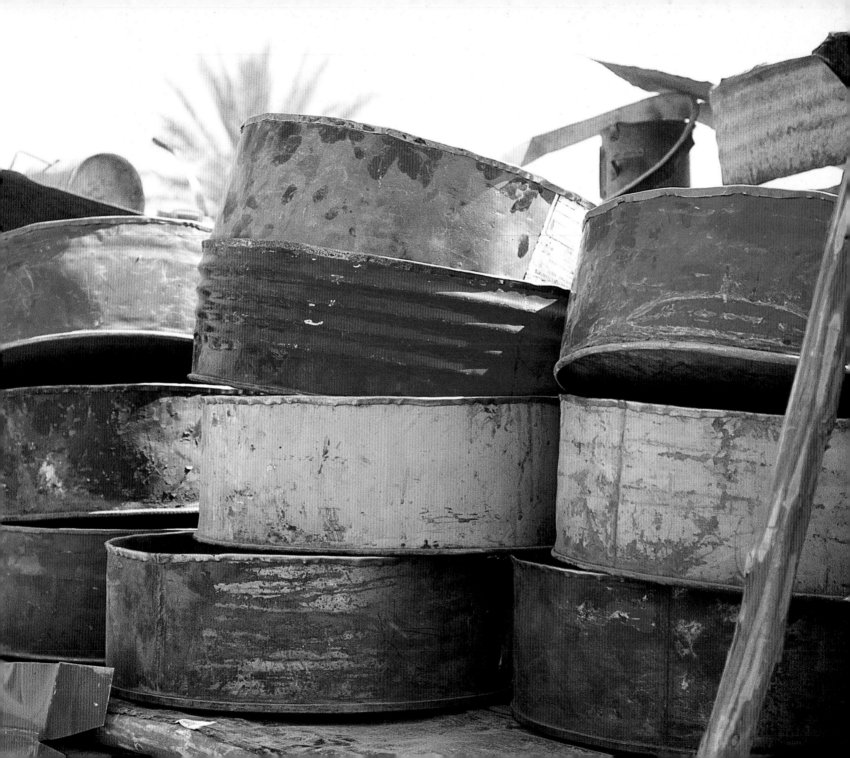

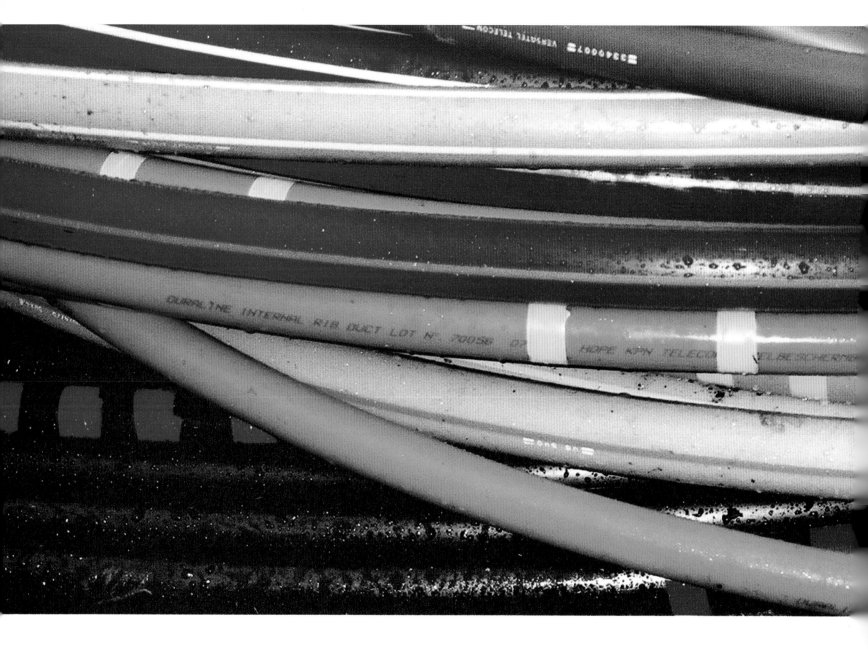

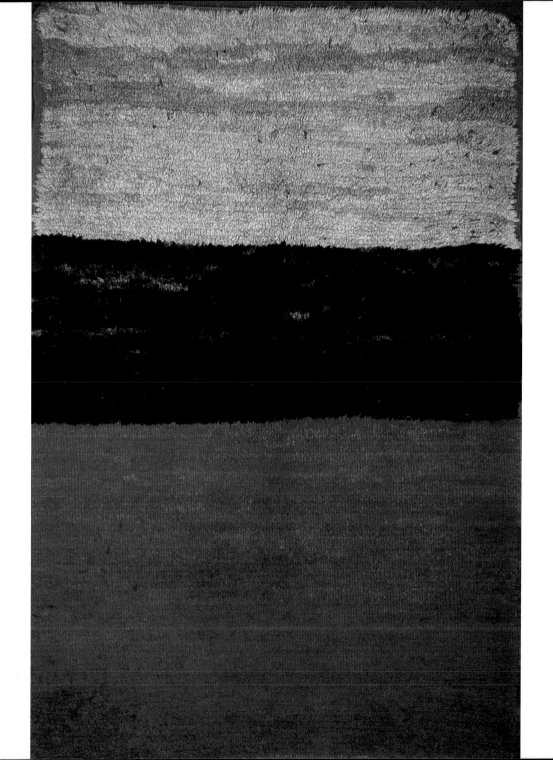

22

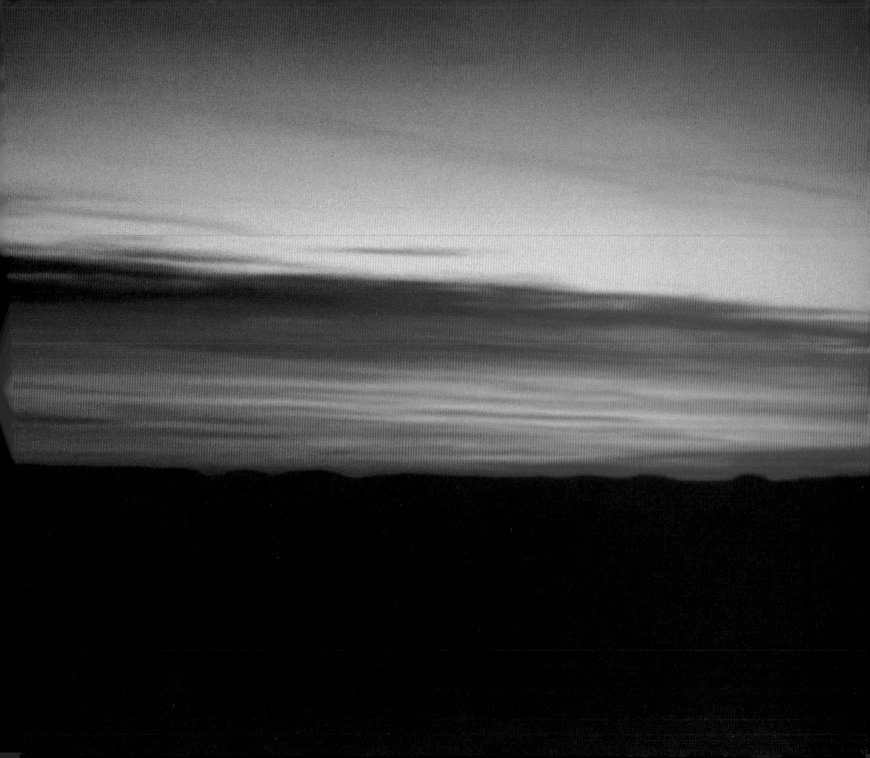

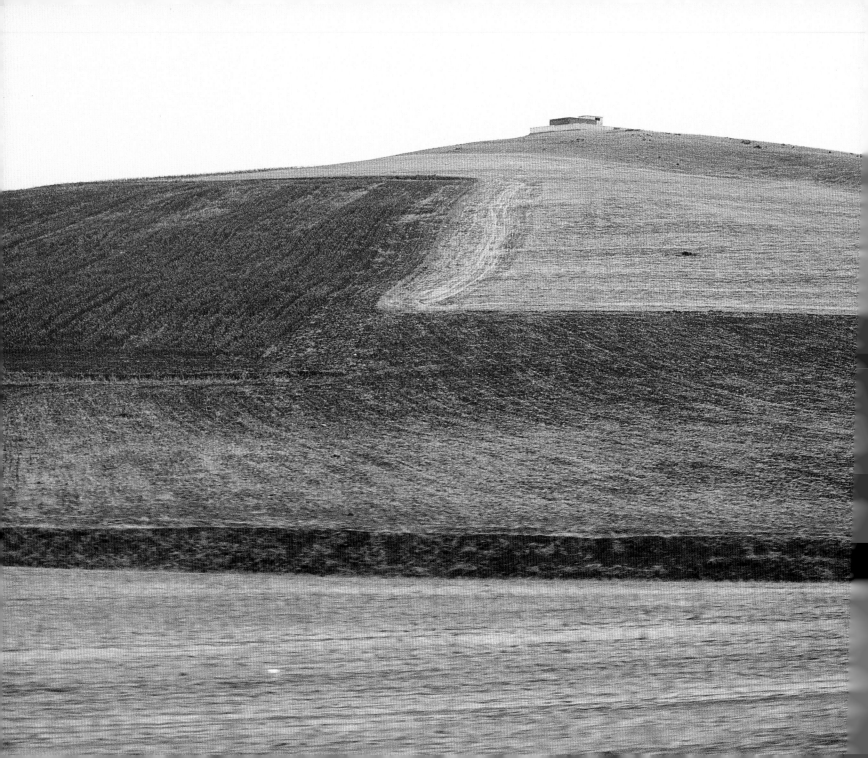

Textures

All matter has a texture of its own, whether soft or solid, smooth
or coarse, loose or dense, light or heavy. Texture is an intrinsic
property of each and every thing. It is the result of the interplay
of raw materials and workmanship, composition or construction
and external forces or finishing. Apart from tactility, texture
lends a decorative effect – and sometimes an overall pattern –
to an object.

Textures appearing in our natural environment have for a long time
been imitated in industrial products. To achieve the same textural look,
different components may be used, both natural and synthetic.
Popular examples of look-alike materials are imitation leather
and fur, as well as plastics capable of mimicking practically any
other substance. Through advanced technology, textures with the
same look but a different touch are seen ever more frequently.

Stylists and manufacturers provide their products with a particular
texture. The resulting tactile quality is not only relevant for aesthetic
and decorative purposes, but may also be practical and functional.

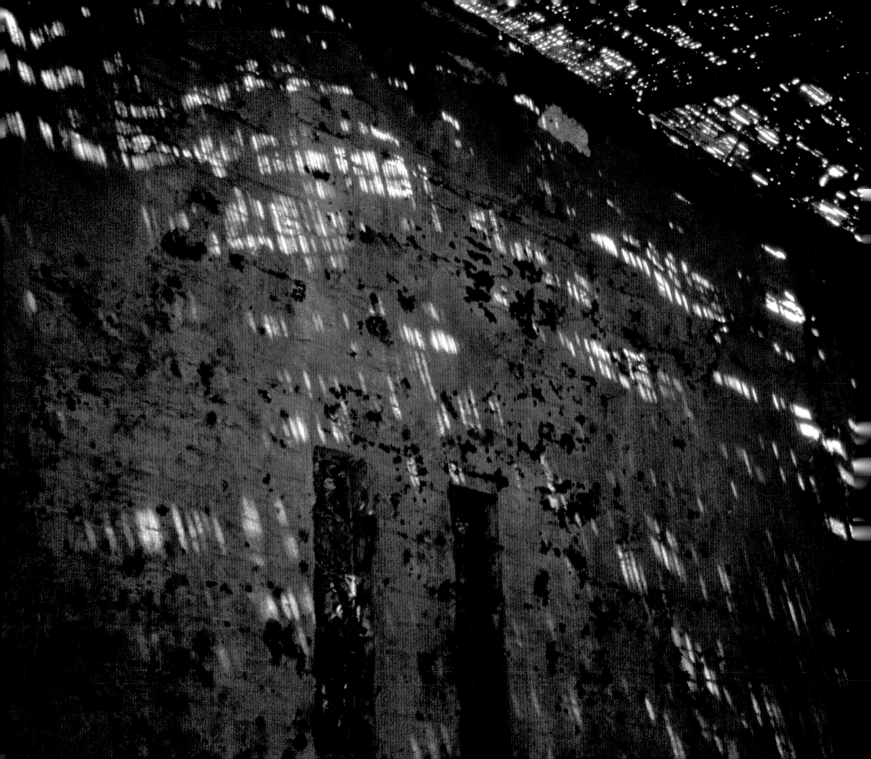

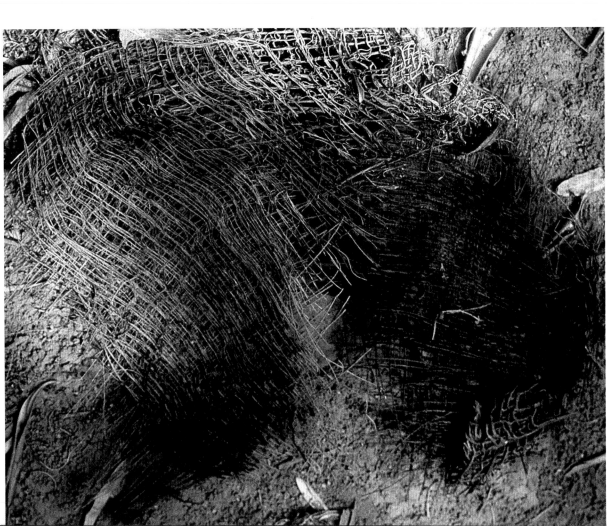

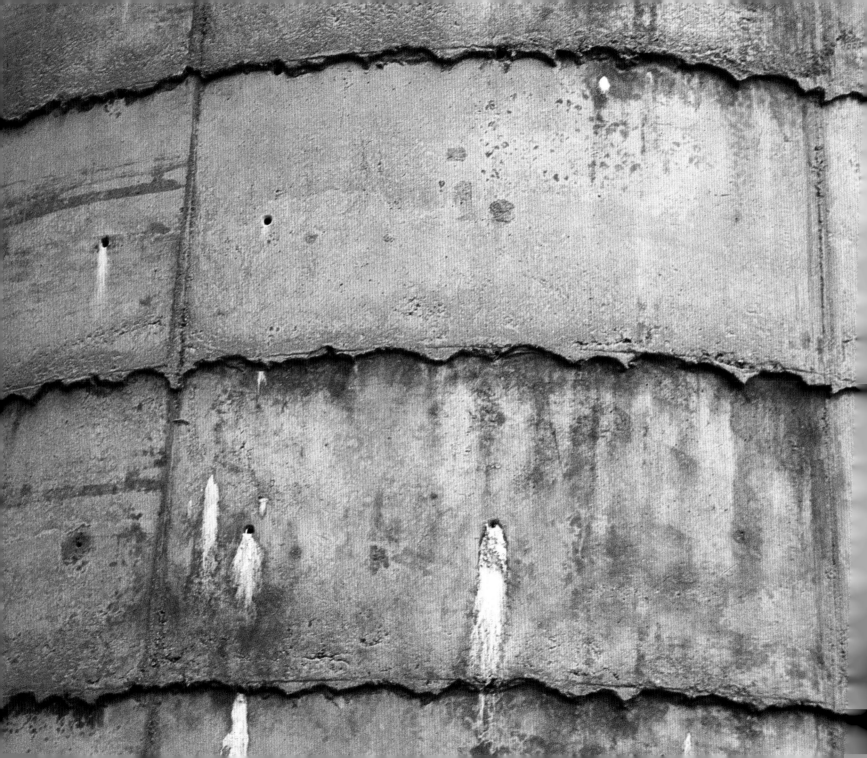

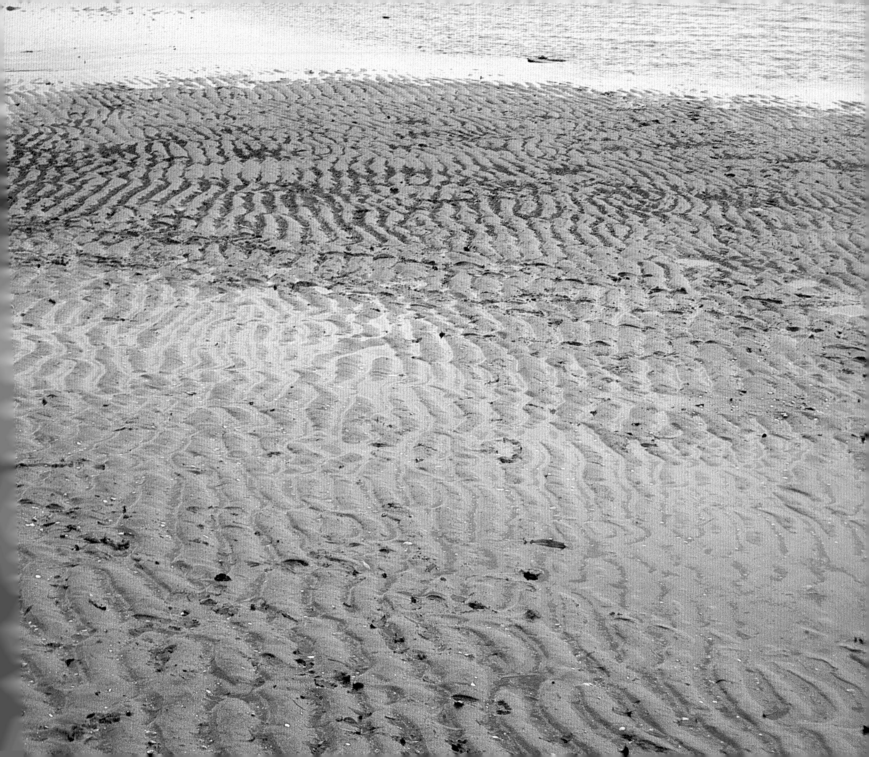

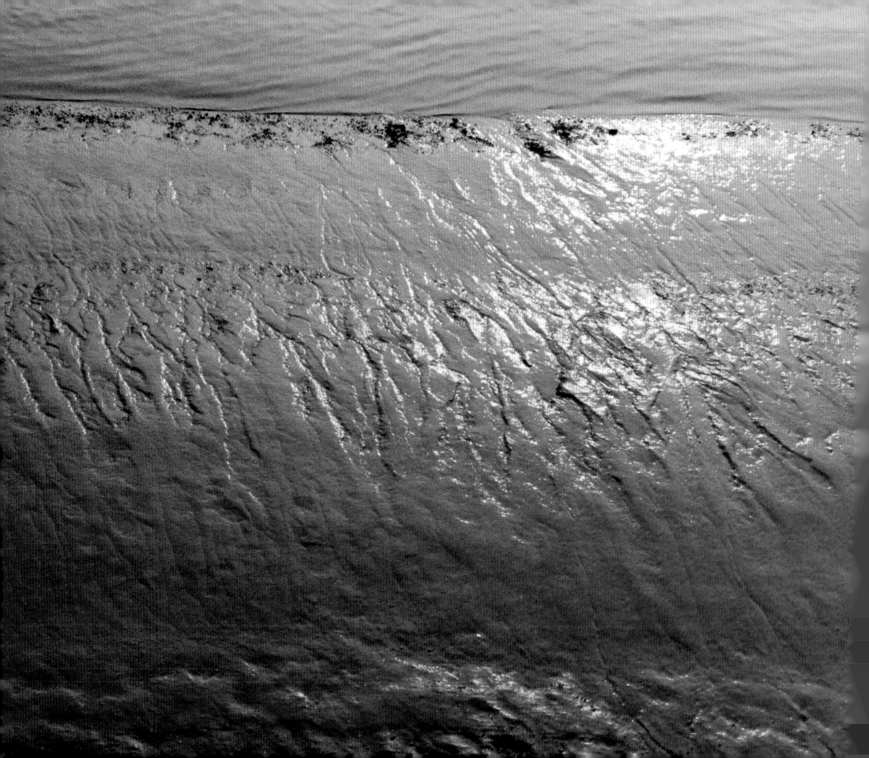

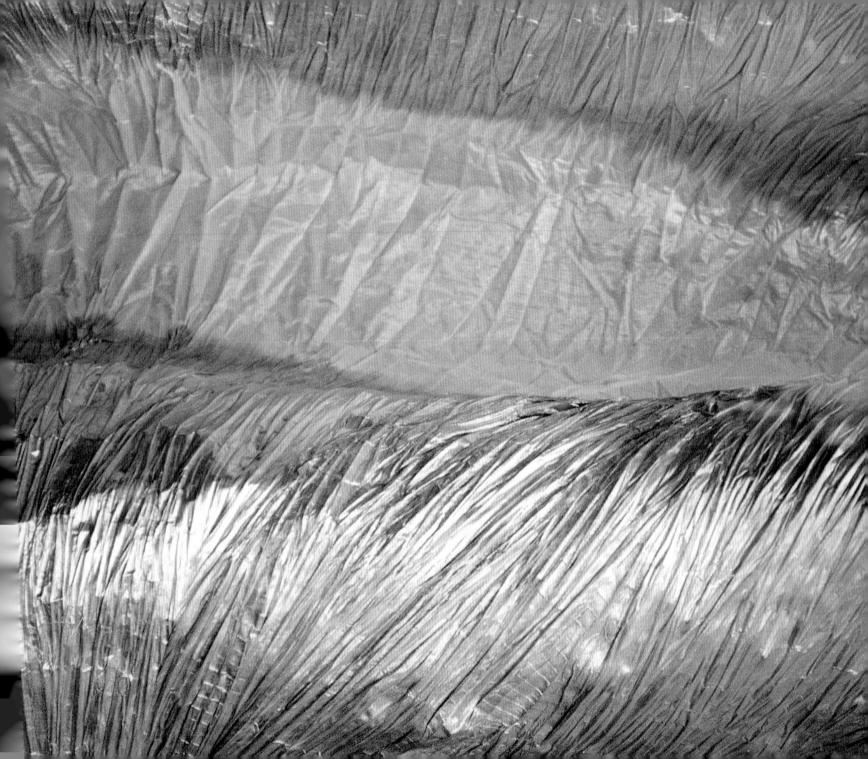

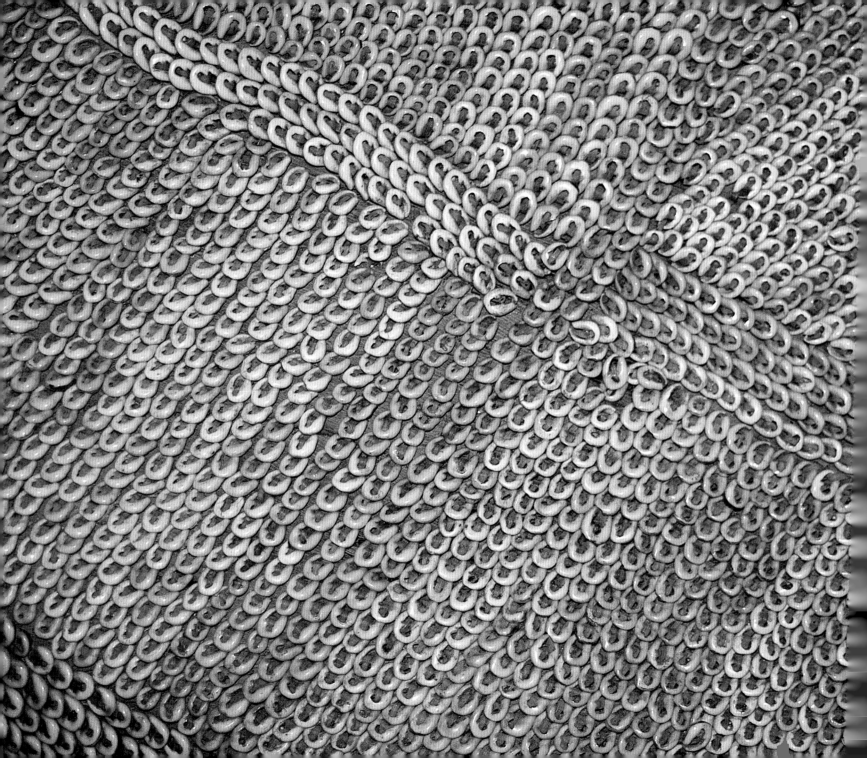

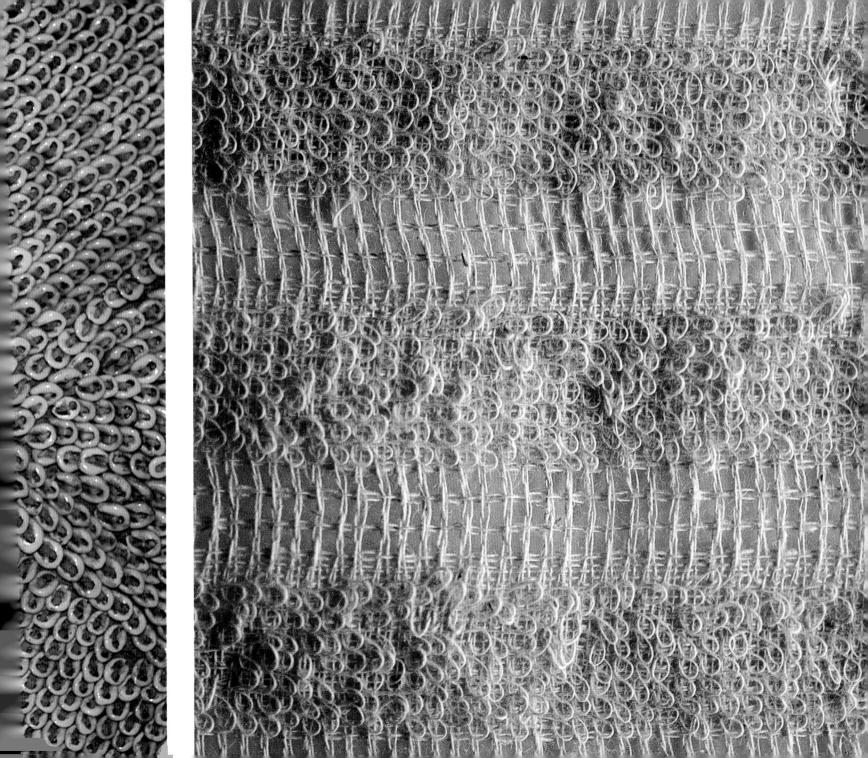

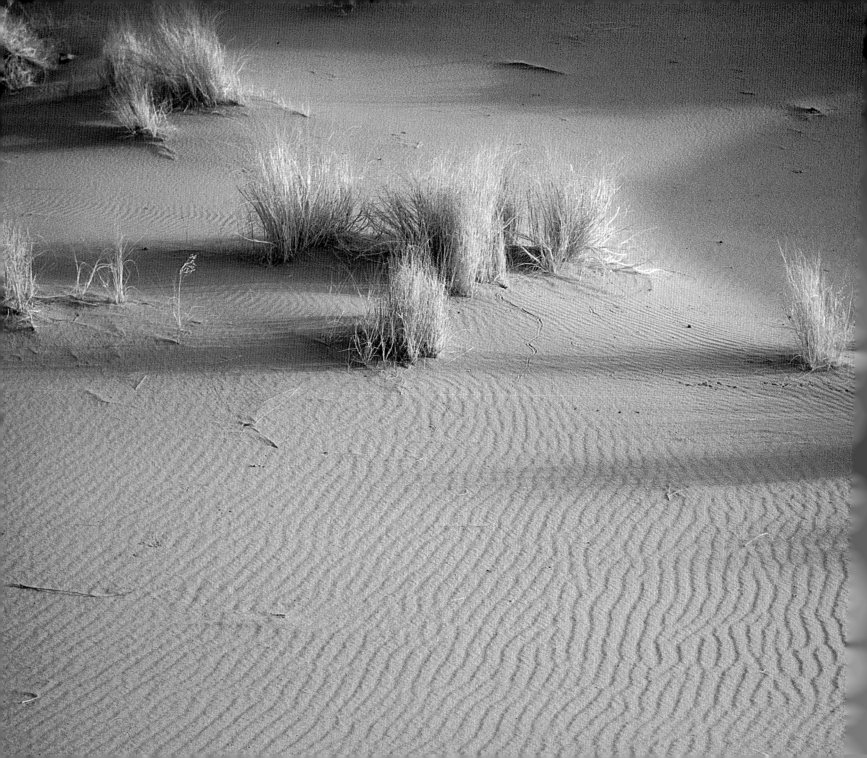

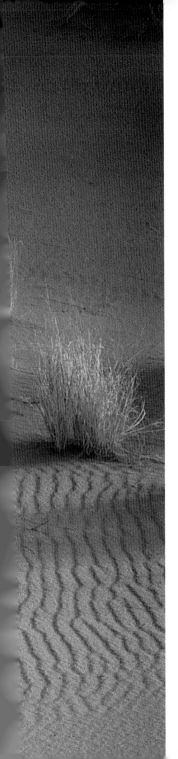

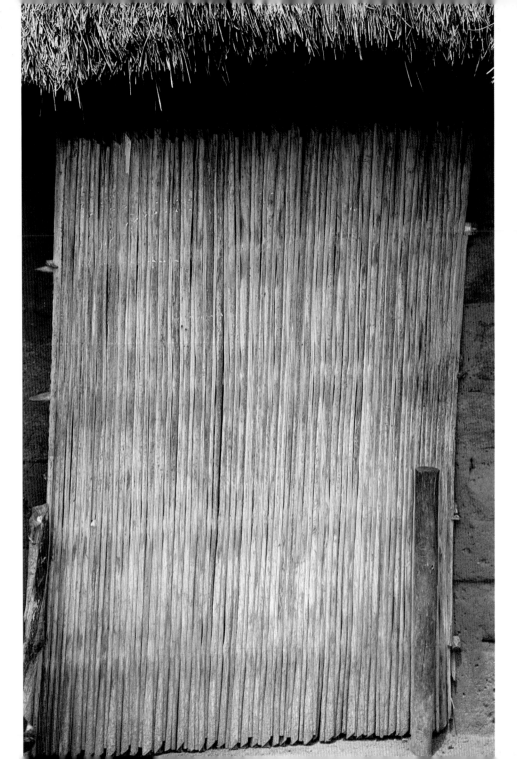

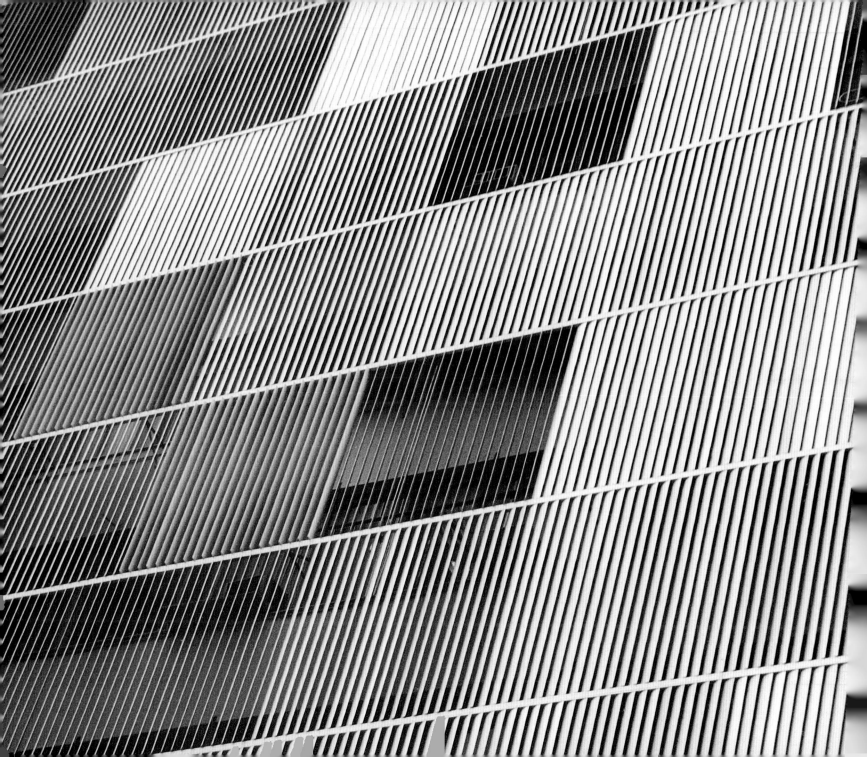

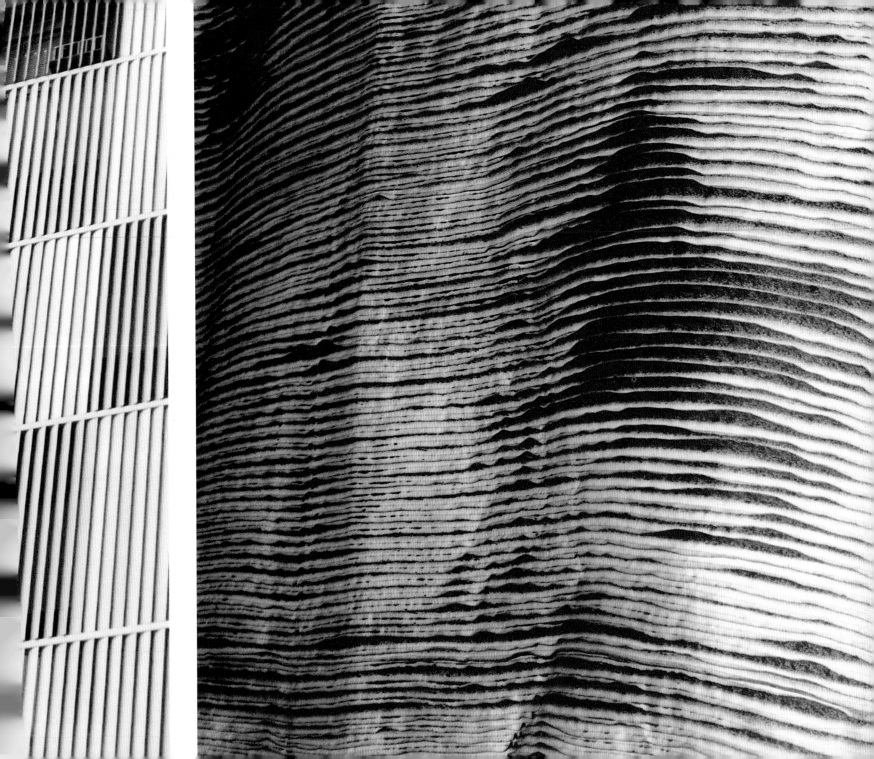

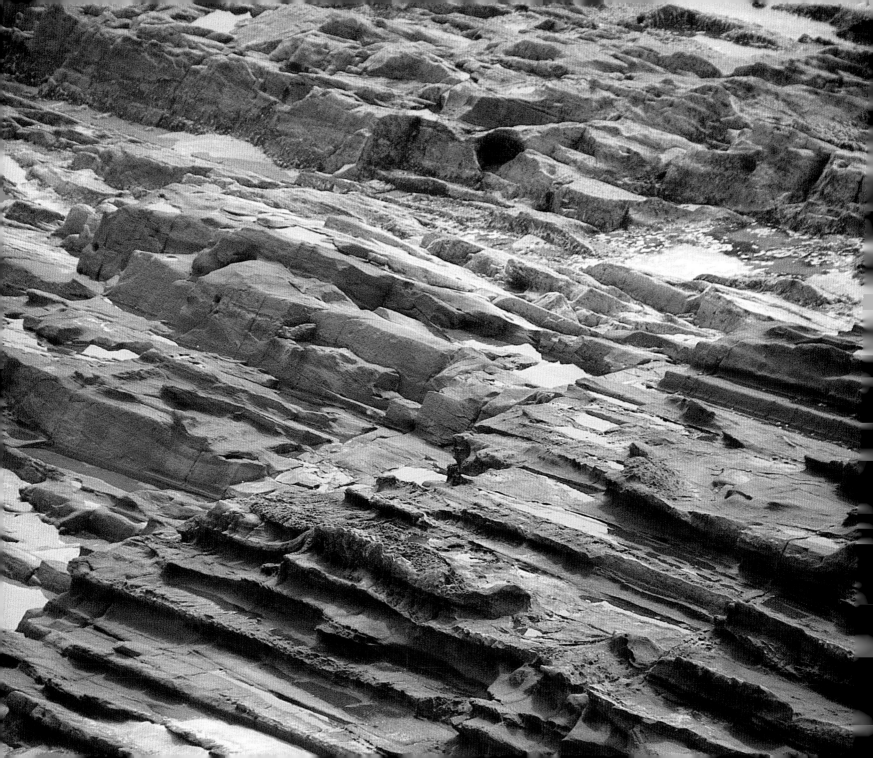

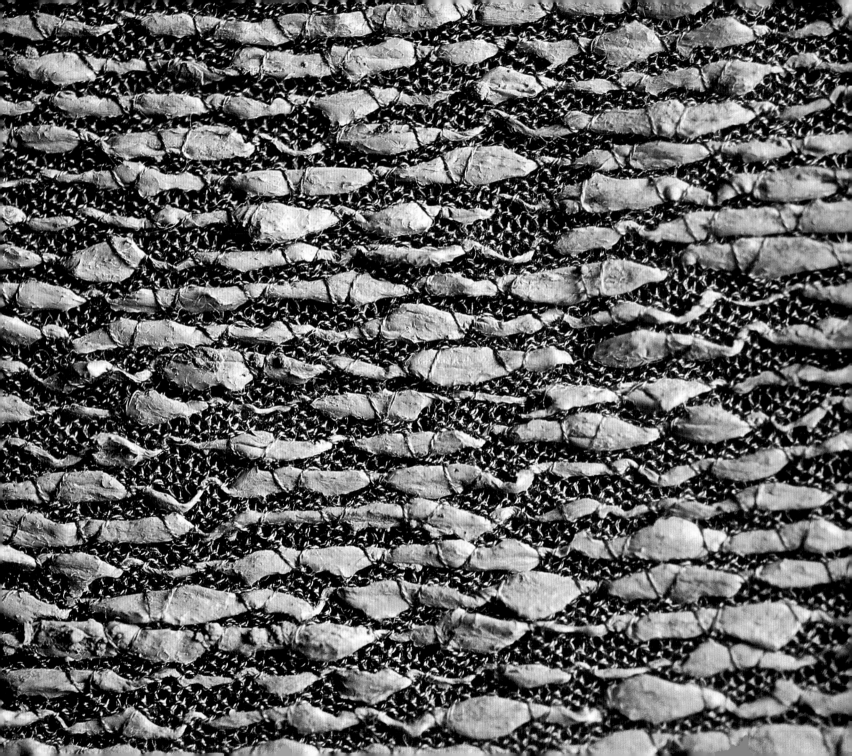

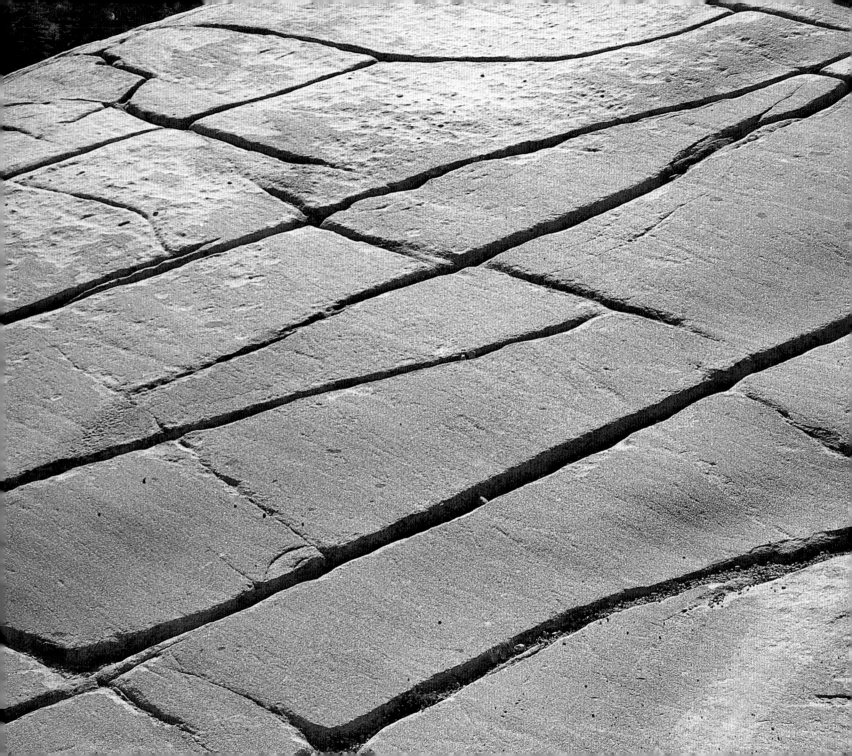

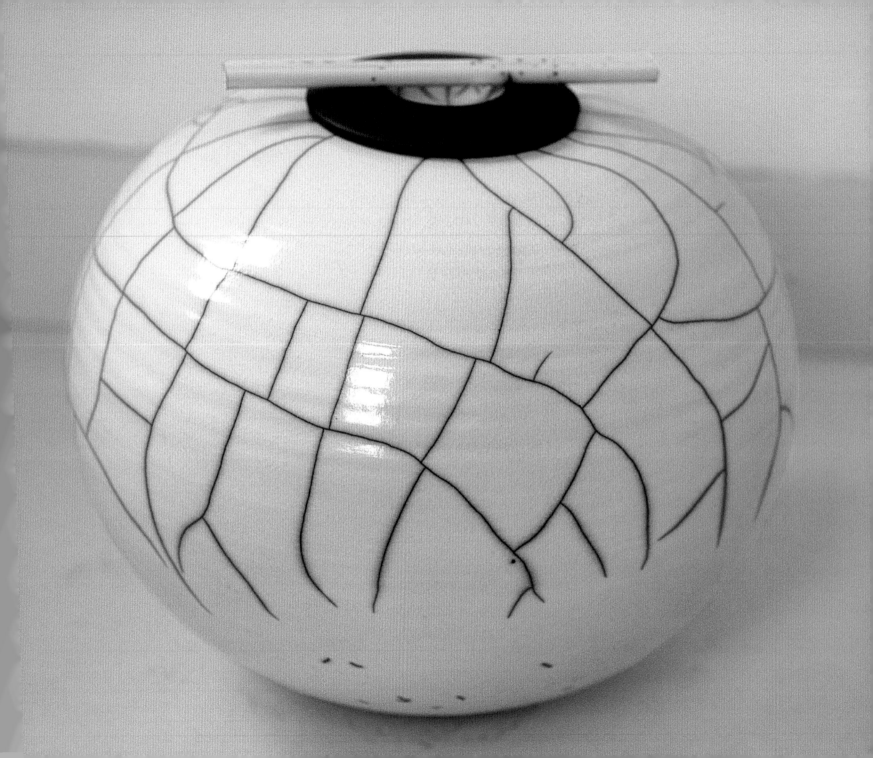

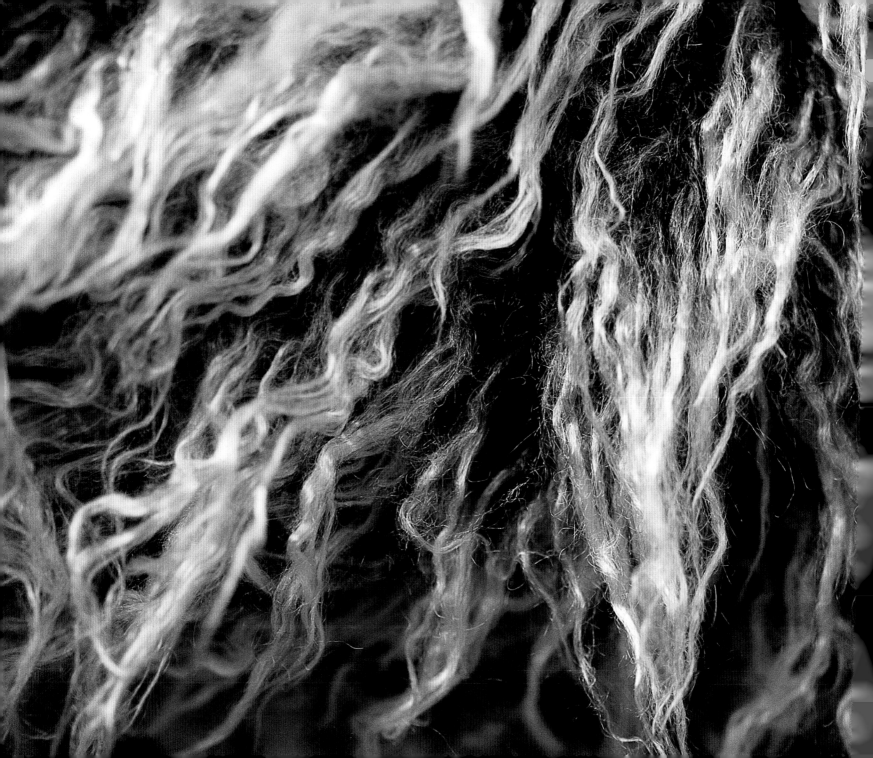

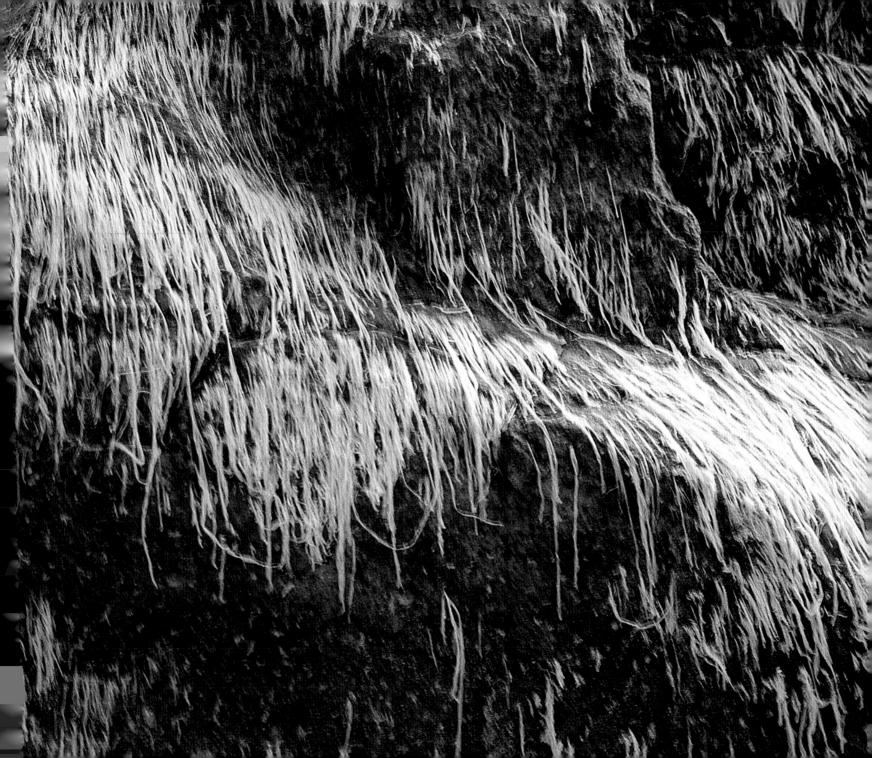

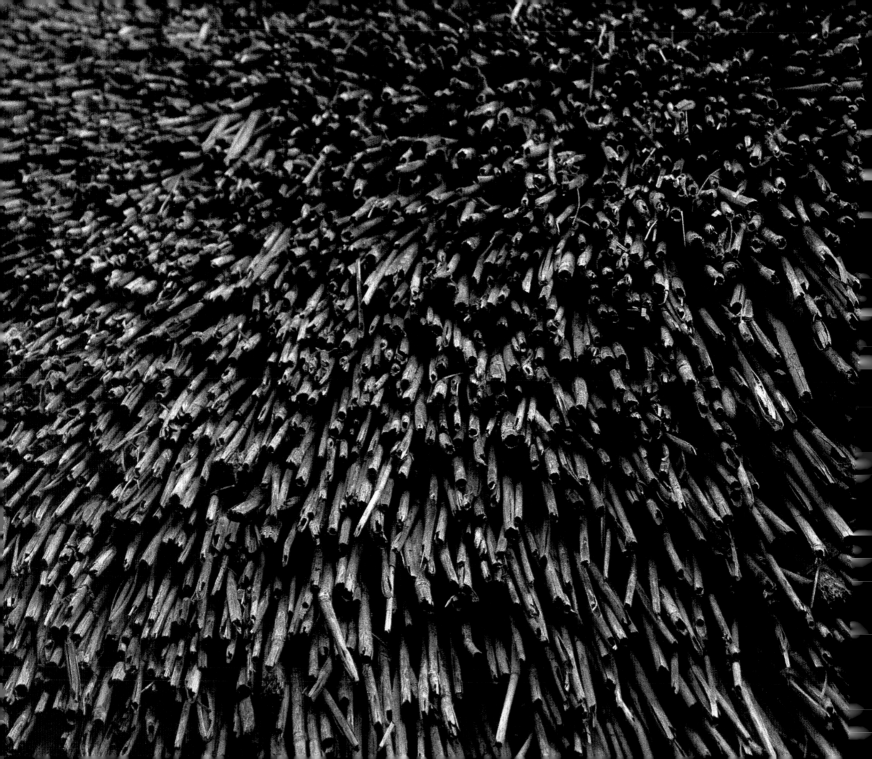

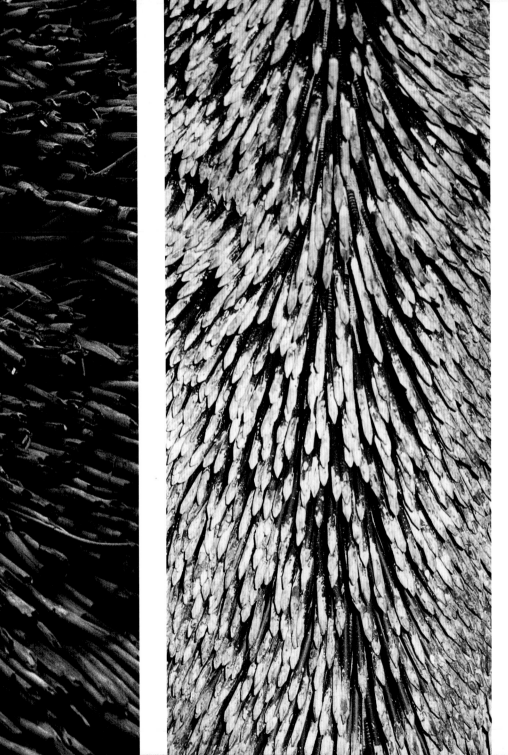
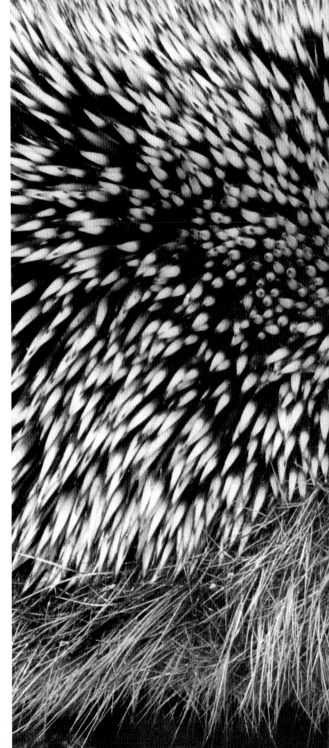

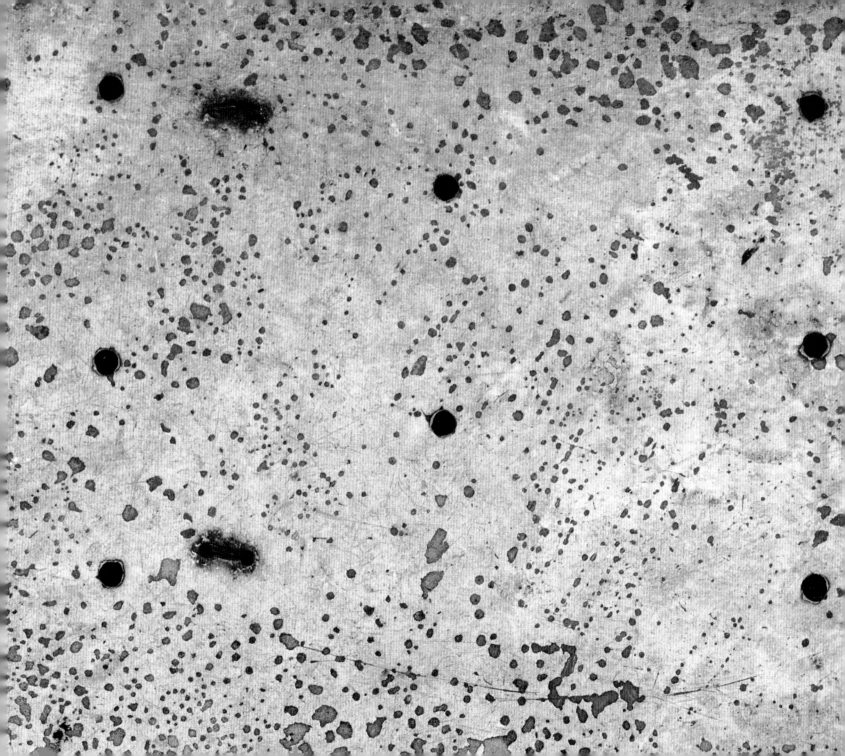

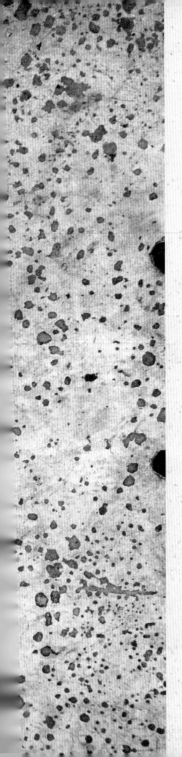

Dots

Any graphic pattern may be traced back to its smallest element, its starting point and often its finishing touch: the dot. The dot is the beginning of graphic creation, the first contact of the illustrator's pencil with the paper, the painter's brush with the canvas, the designer's cursor on the computer screen, the carver's chisel or awl with the stone or the wood. Dots may be recognized in random spots of rust, ink or paint, in bubbles and pierced holes, in other words in anything minute with a round shape. A single dot on the human skin may be regarded as a charming *tache de beauté* or as an evil wart.

As a primordial element the dot holds great potential for the development of form. An infinite number of forms, with infinite variation, may evolve from the tiny little dot. It may grow into a spot or a polka dot; and it may be multiplied into a scattered motif. It may also grow into a stroke and be elongated into a line. Dots may be arranged into dotted lines, dotted geometric figures or free forms. A dot feels as if it may become the most imaginative design ever seen.

The analysis of the dot as a graphic entity holds only for surface design. In two-dimensional design, such as weaving, creating a dot is a matter of calculation.

47

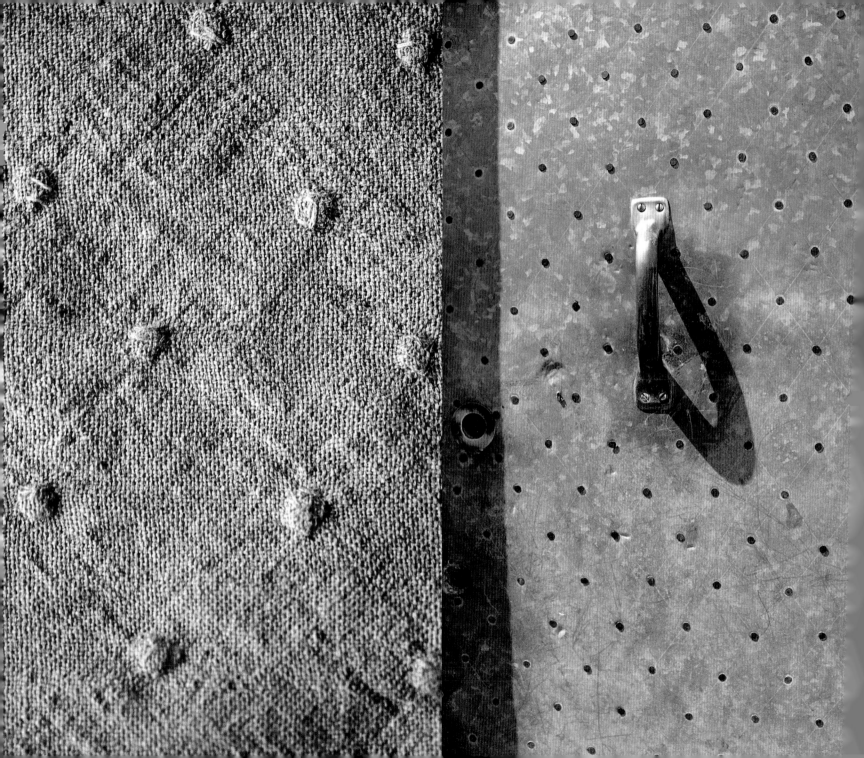

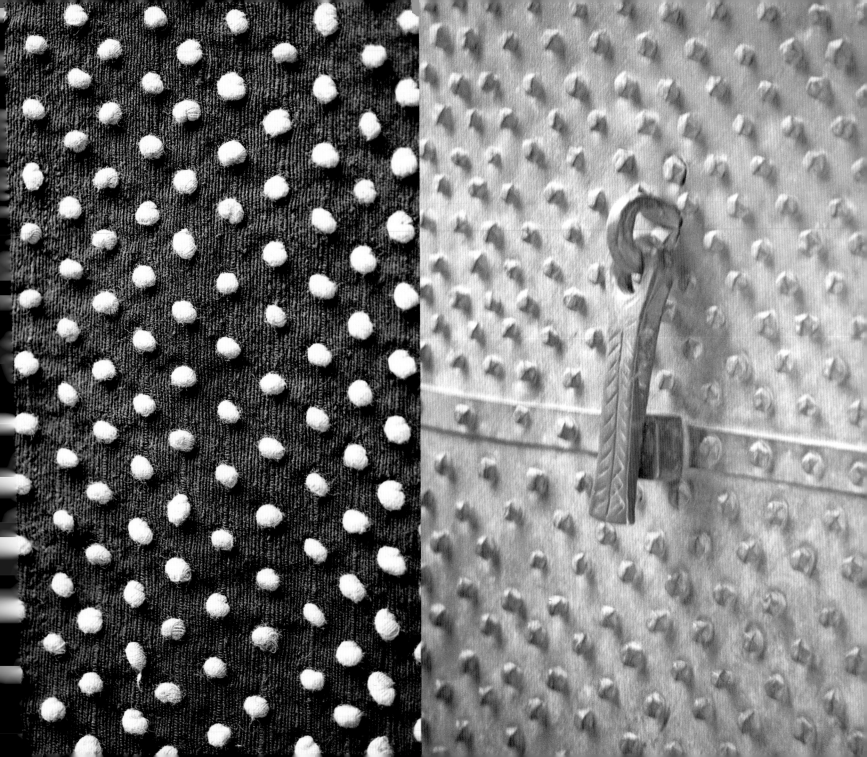

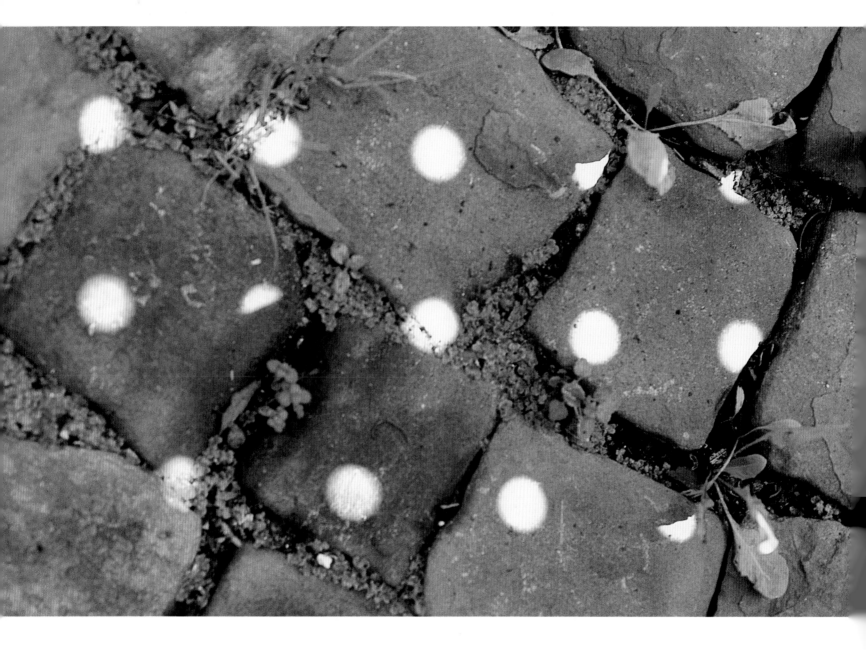

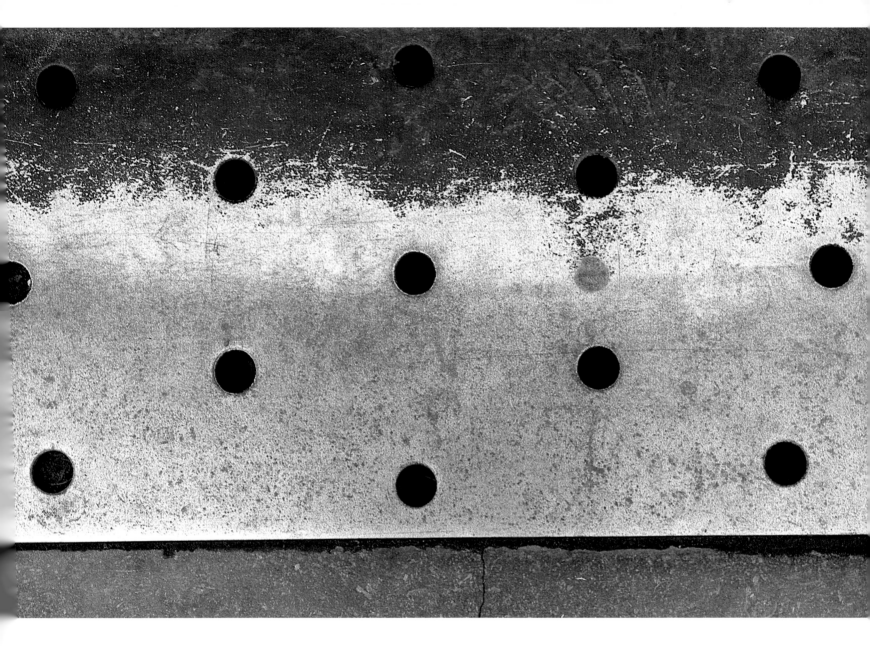

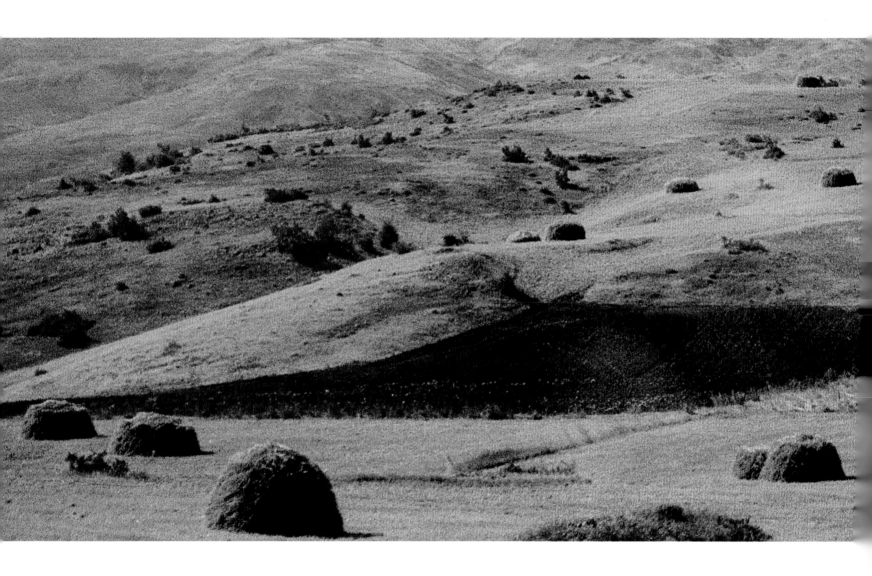

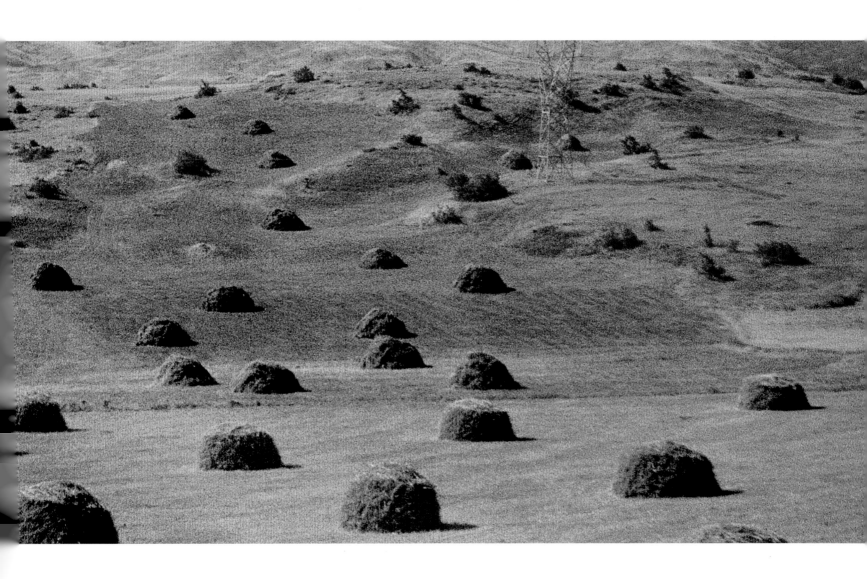

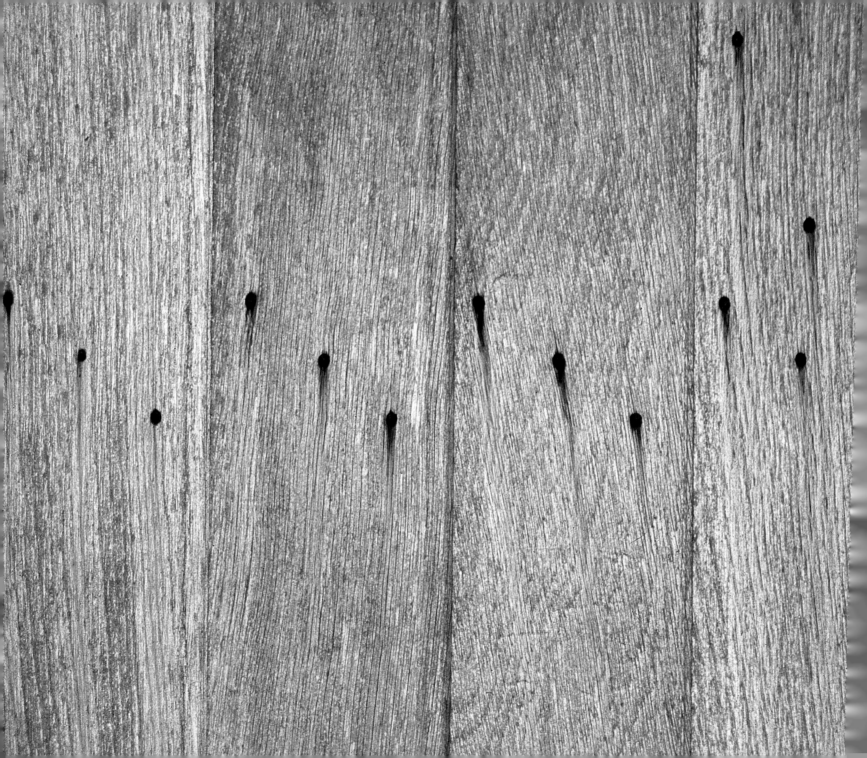

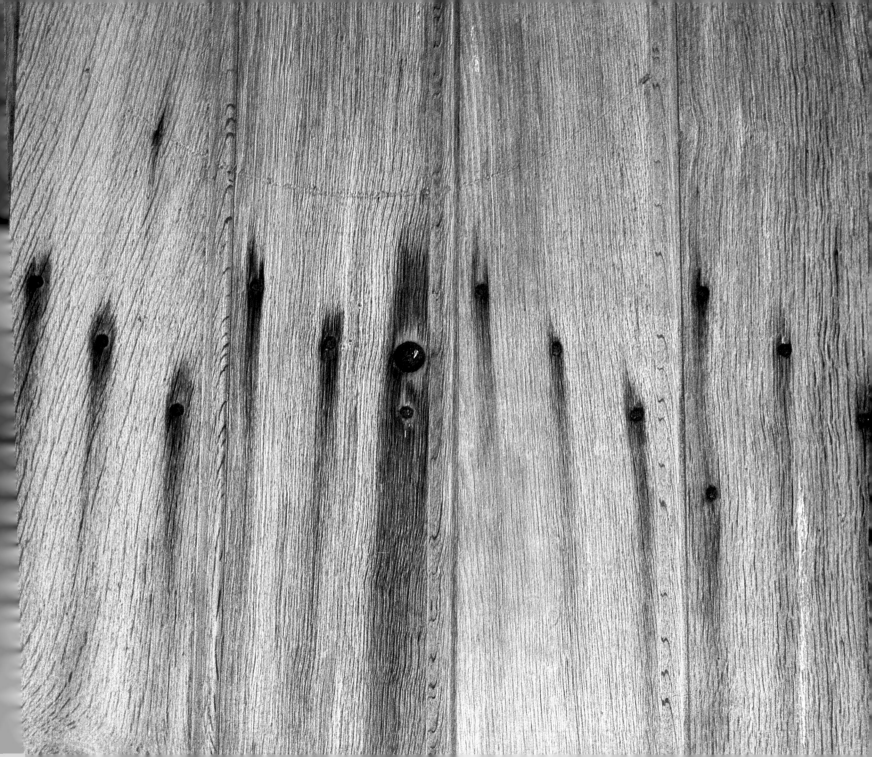

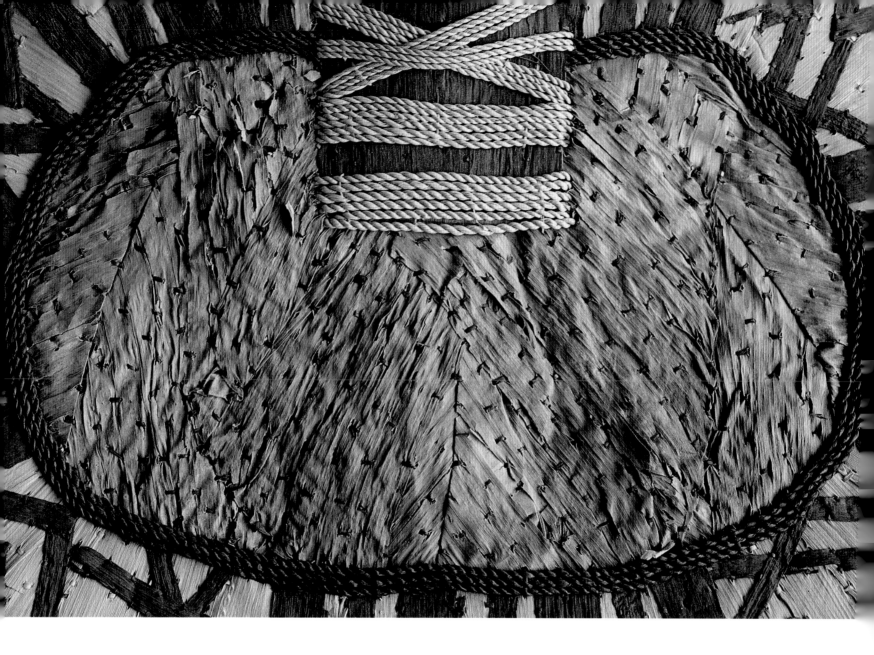

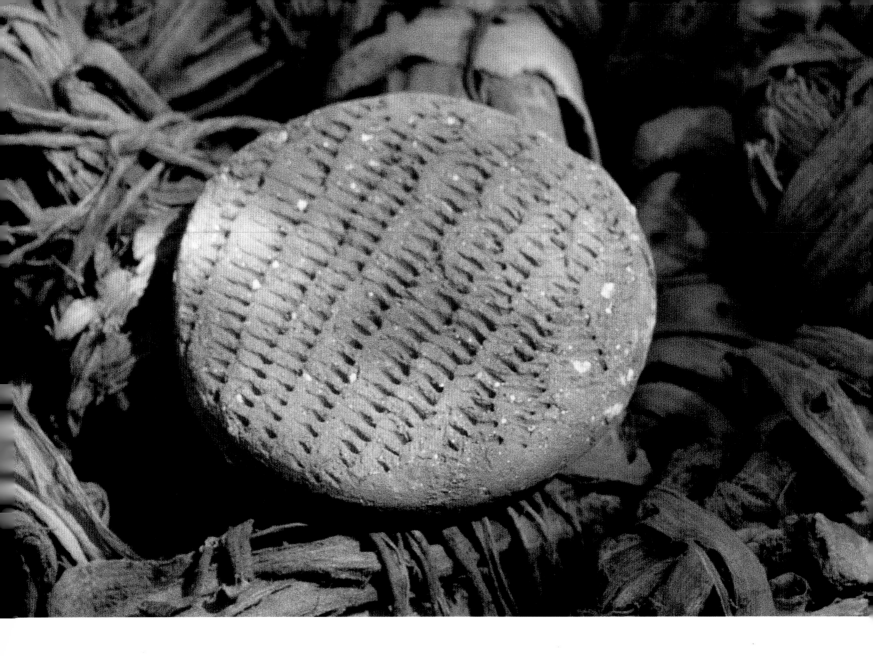

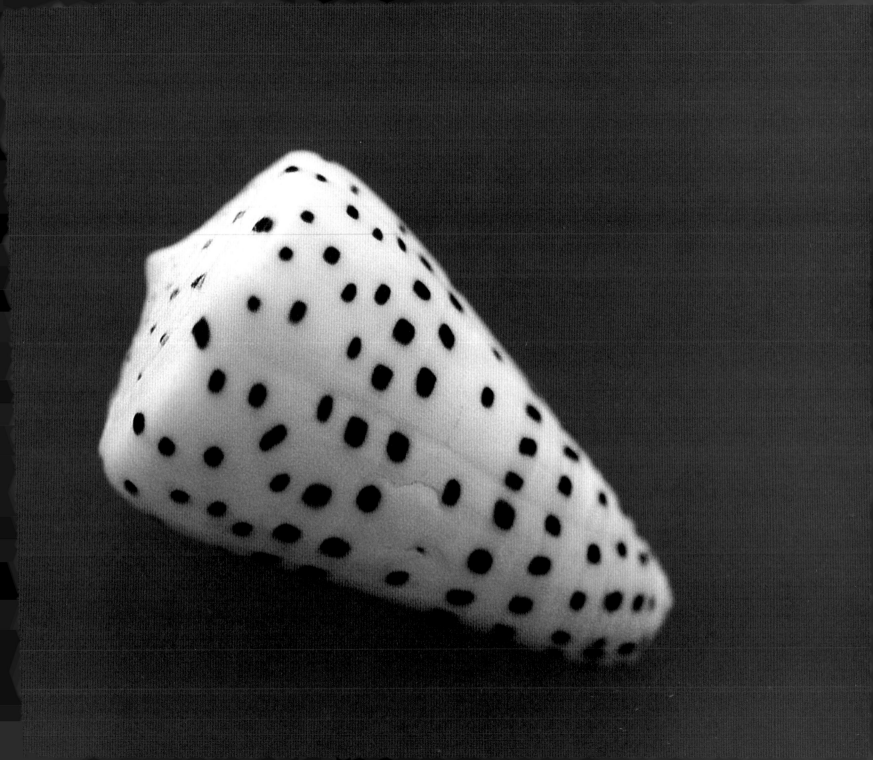

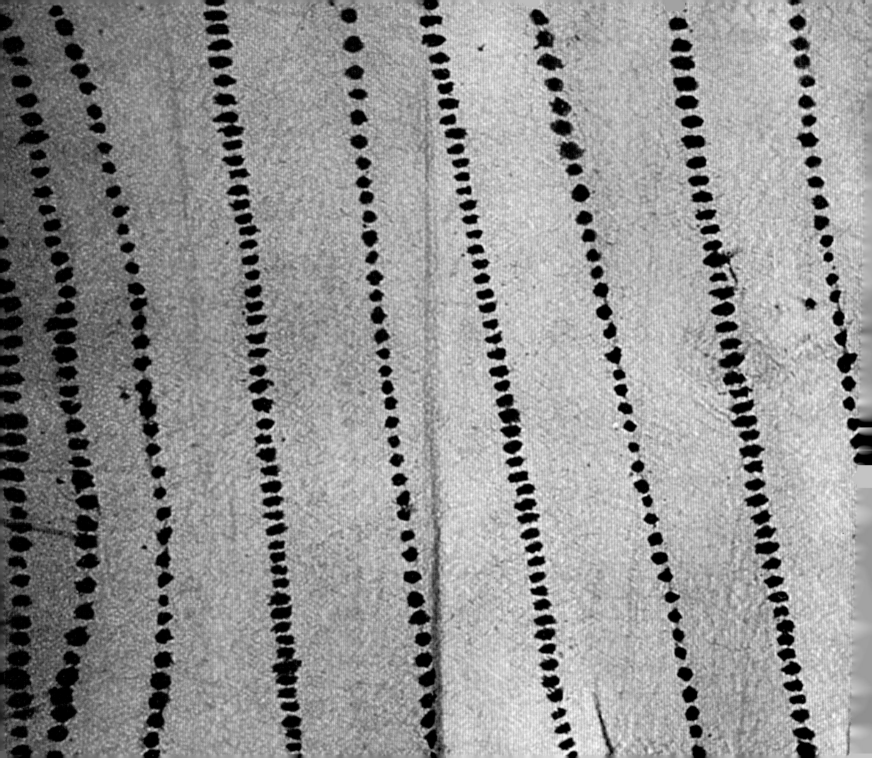

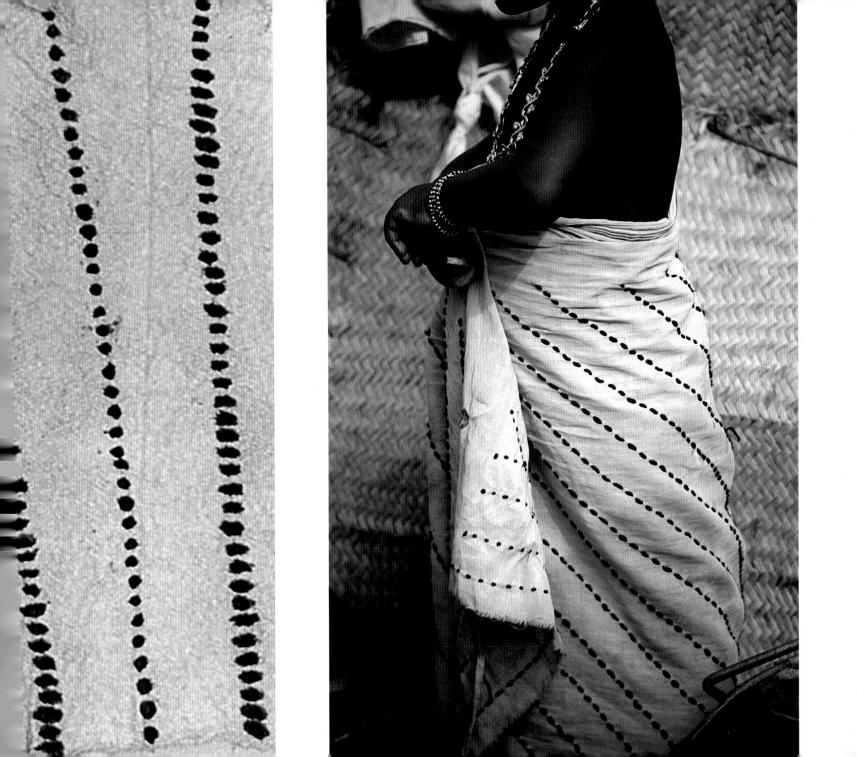

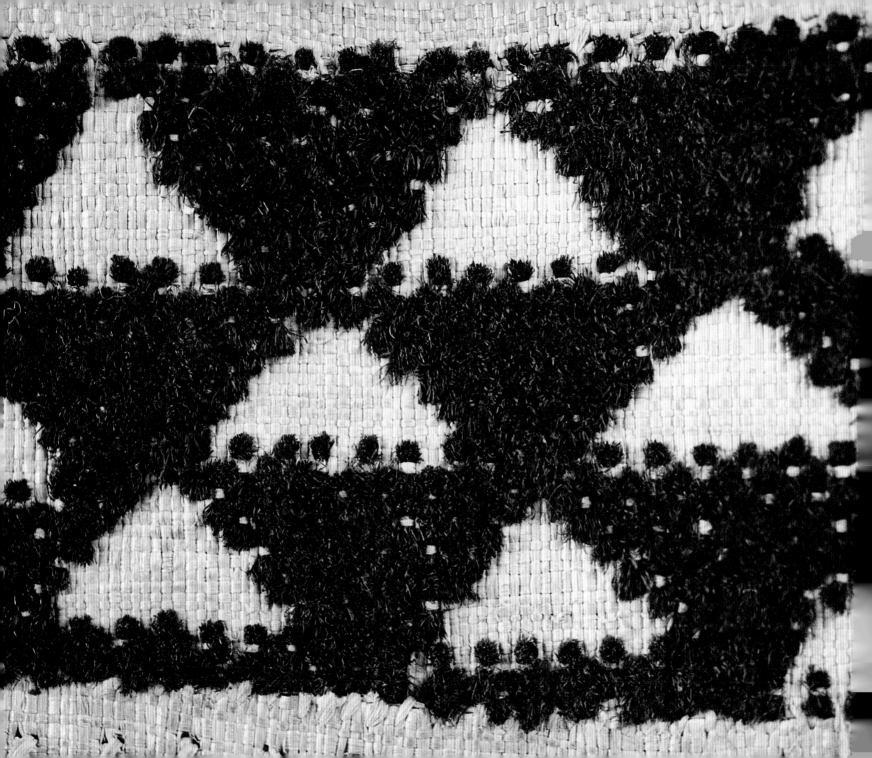

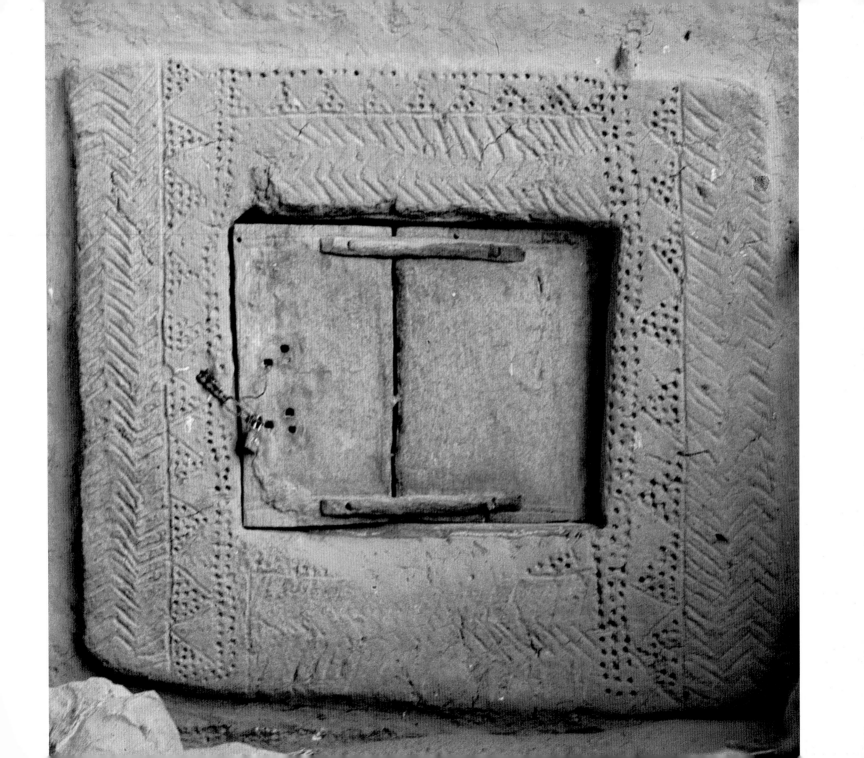

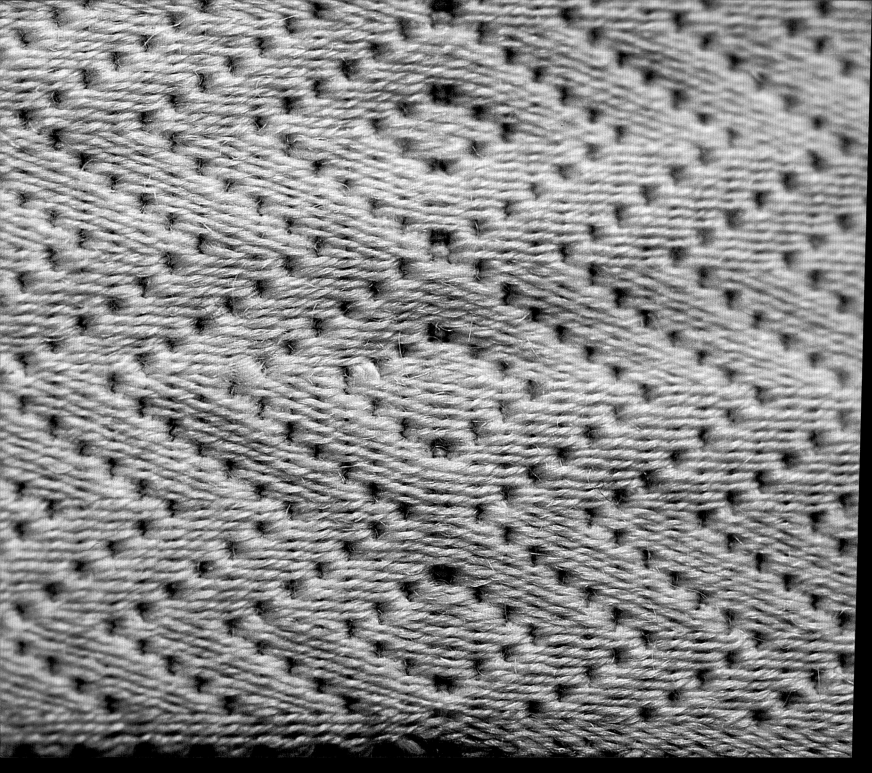

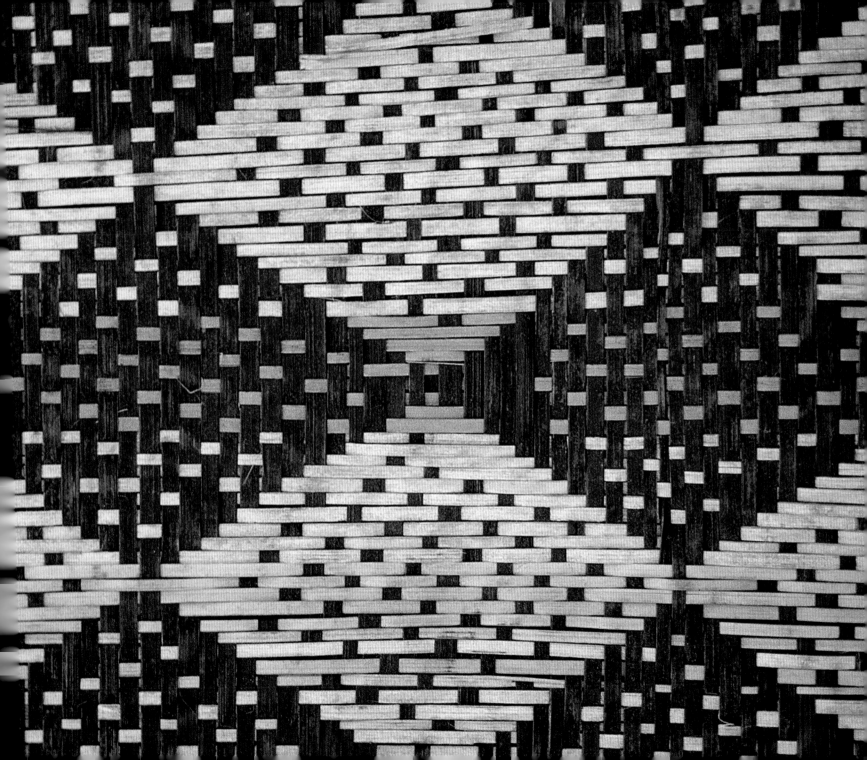

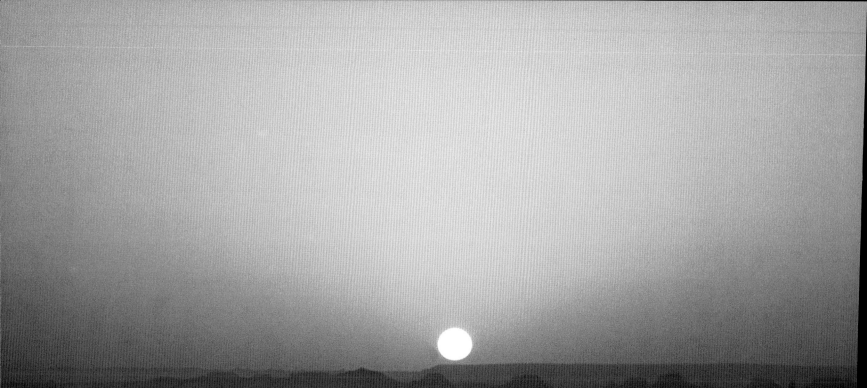

Dot and Line

The dot and the line are the two basic elements of graphic design. They serve not only as an aid in forming complex figures, but also lend themselves to numerous playful combinations. The arrangements that may be made simply with dots and lines have a sensitive and a powerful beauty.

The most spectacular phenomenon of dot and line may be found in nature during sunrise and sunset, when the golden disk rises from or merges into the horizon.

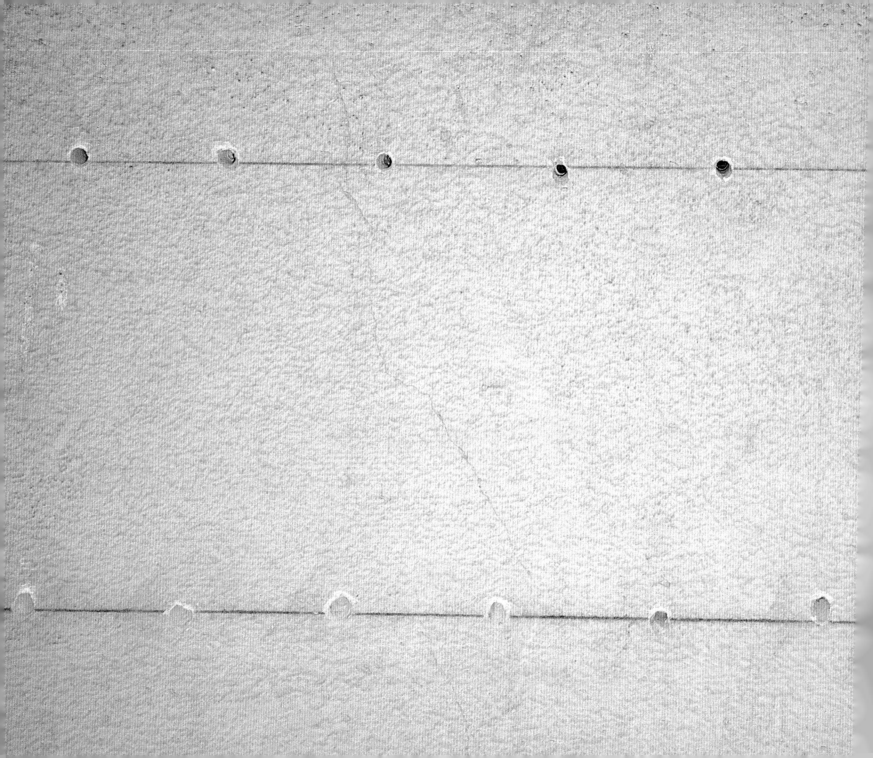

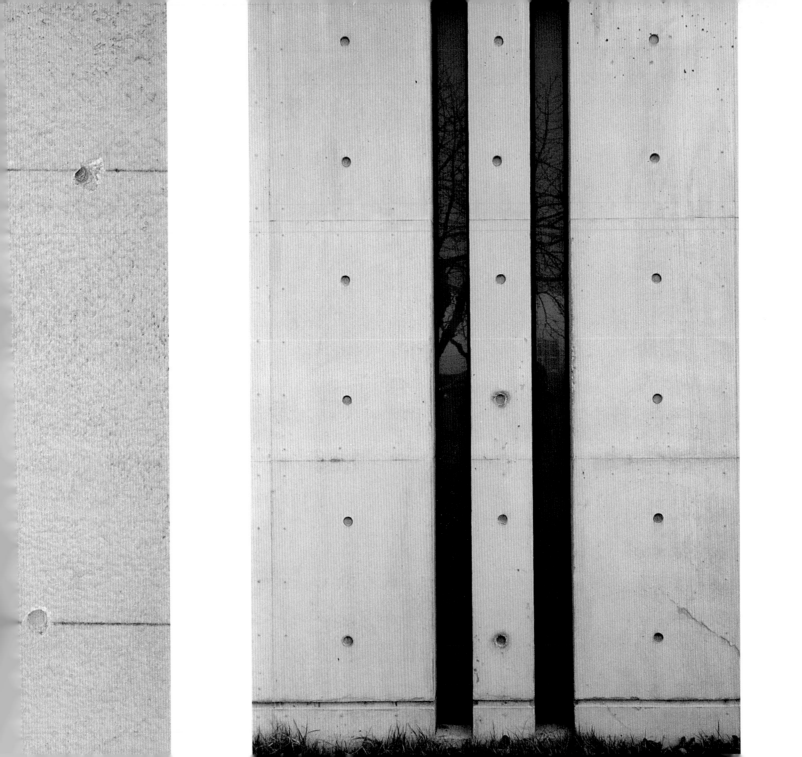

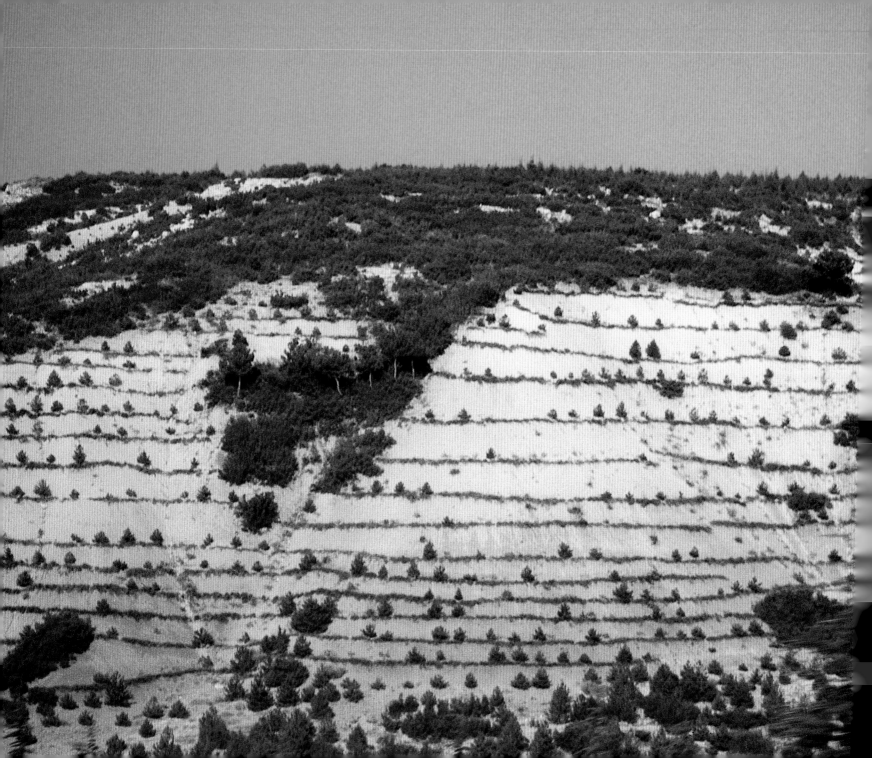

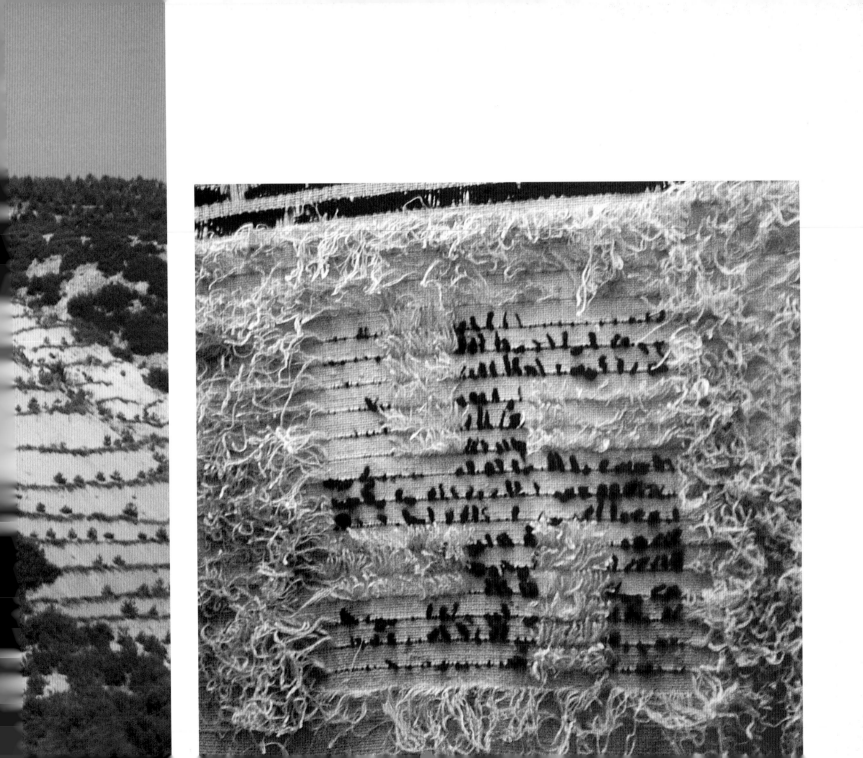

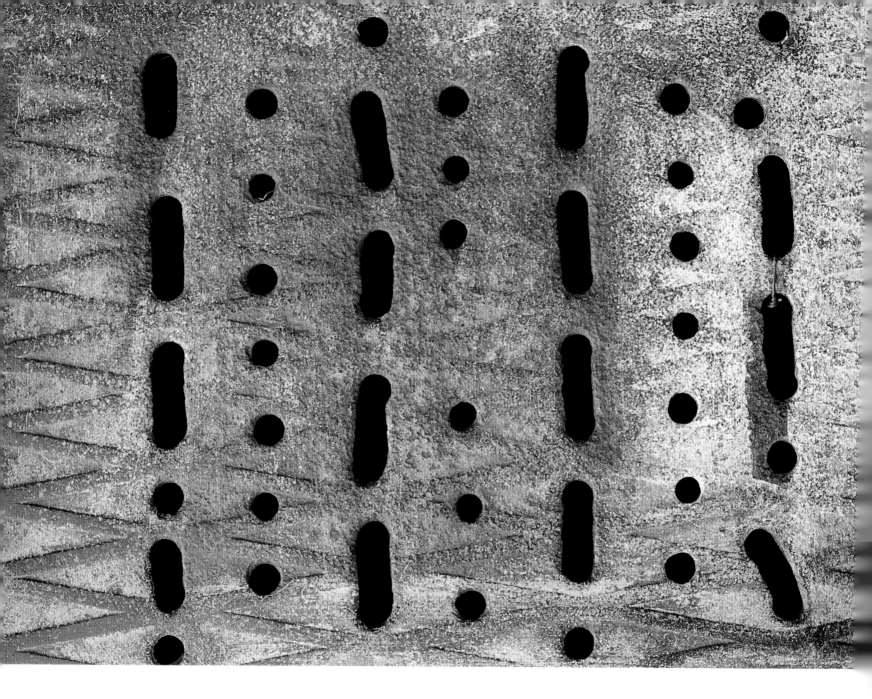

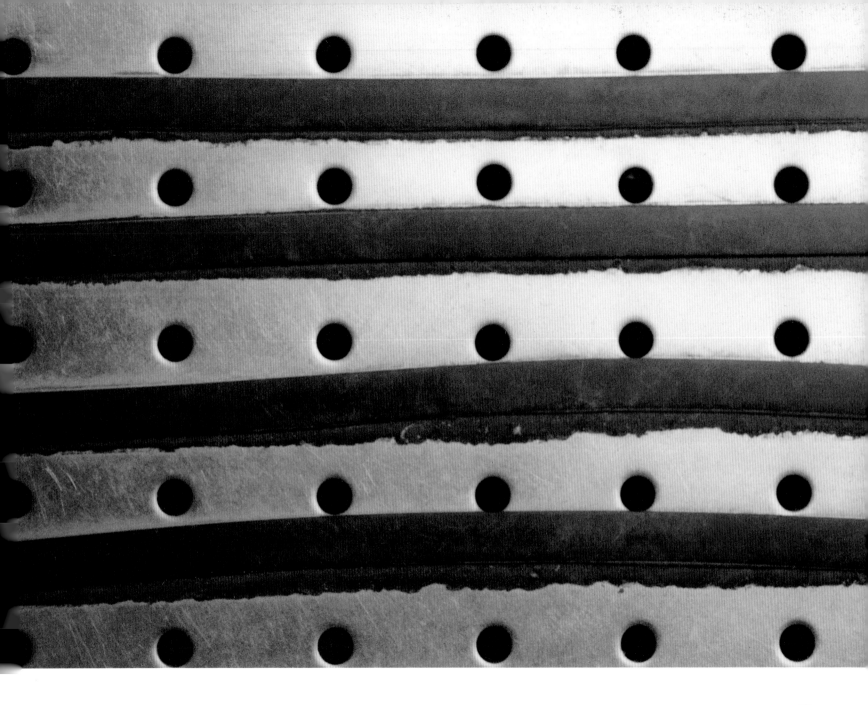

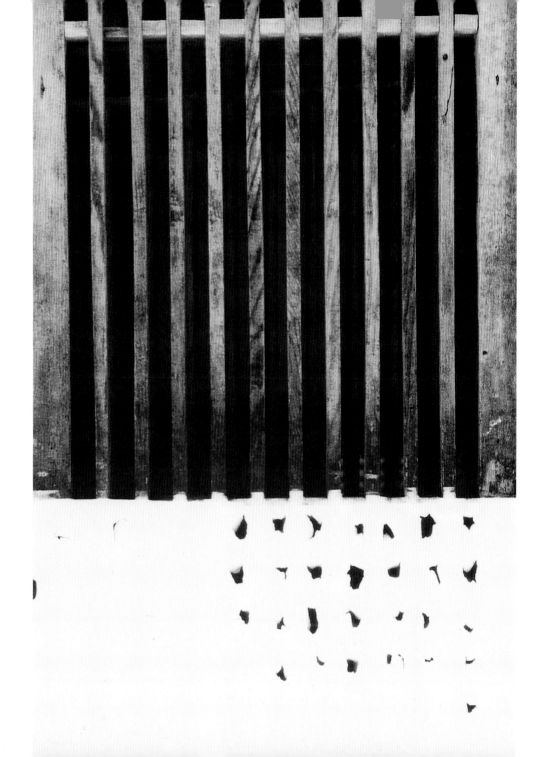

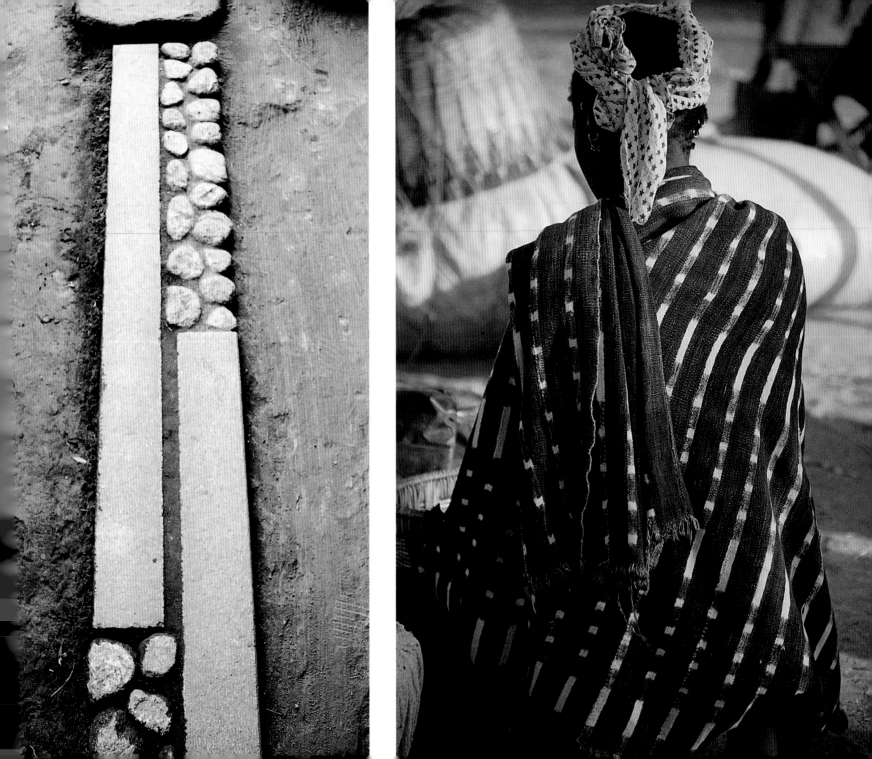

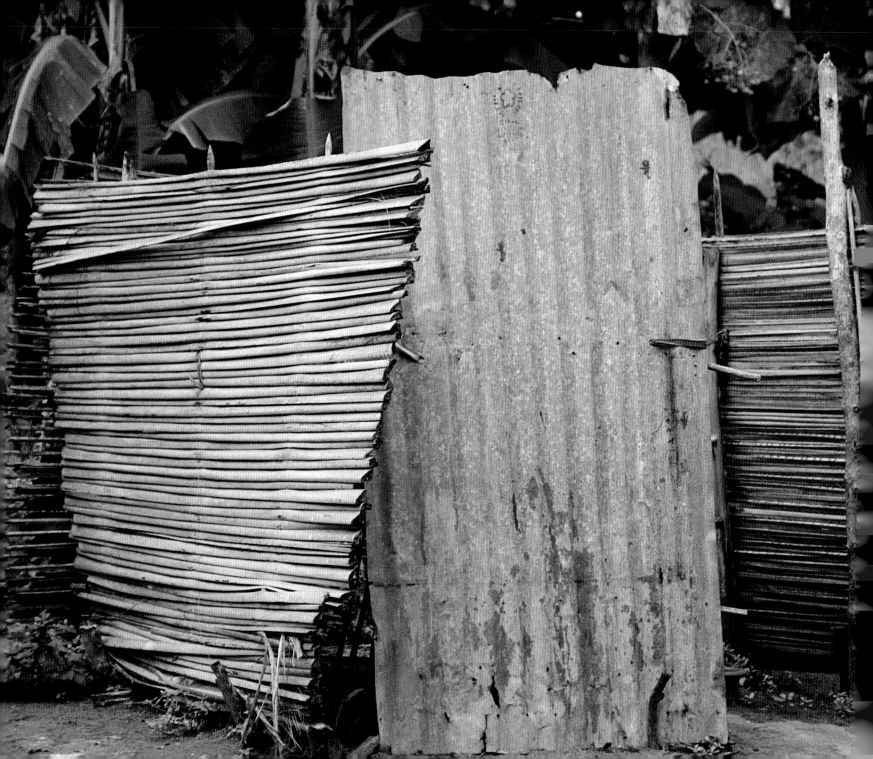

Lines

The first line that comes to mind is the straight one in our natural environment: the horizontal. Next are the vertical and the diagonal. The direction, length and width of lines are relative and depend on the perspective of the beholder.

The line is the best-suited element for rhythmic repetition and variation. As long as they run parallel, lines form a striped pattern. In many cultures lines are associated with a specific use or meaning and as such are part of a semiotic system. There are many examples, ranging from zebra crossings to prison clothes to bar codes.

Once set in motion, lines may go many ways and become very dynamic. In soft shapes, they flow freely as fluid, undulating waves, or curve into spirals. In sharp shapes, they bend like steps or arrowheads, zigzags and meanders, and make angles of any degree. Geometric figures, handwriting and squiggles are built up from flexible lines.

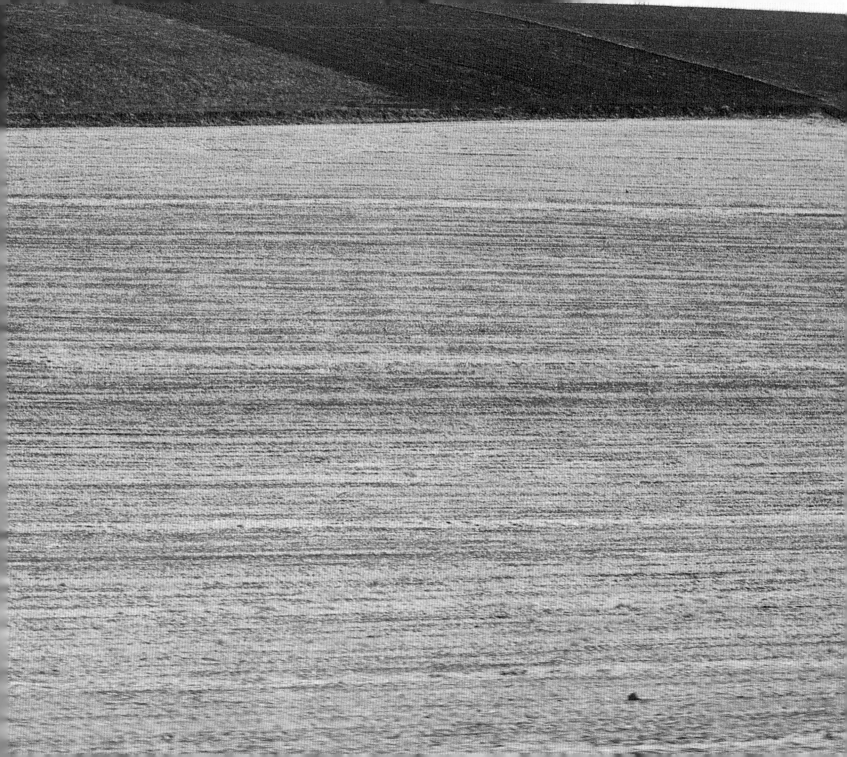

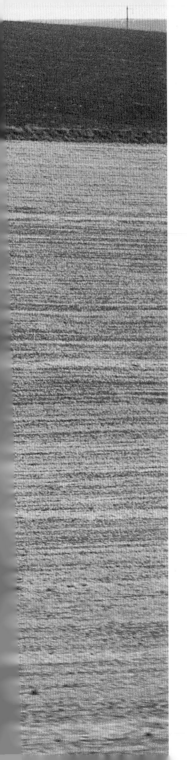
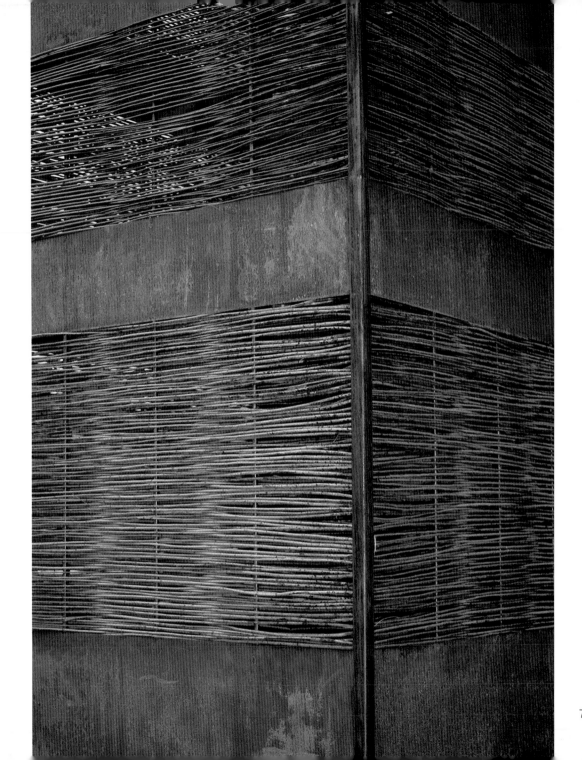

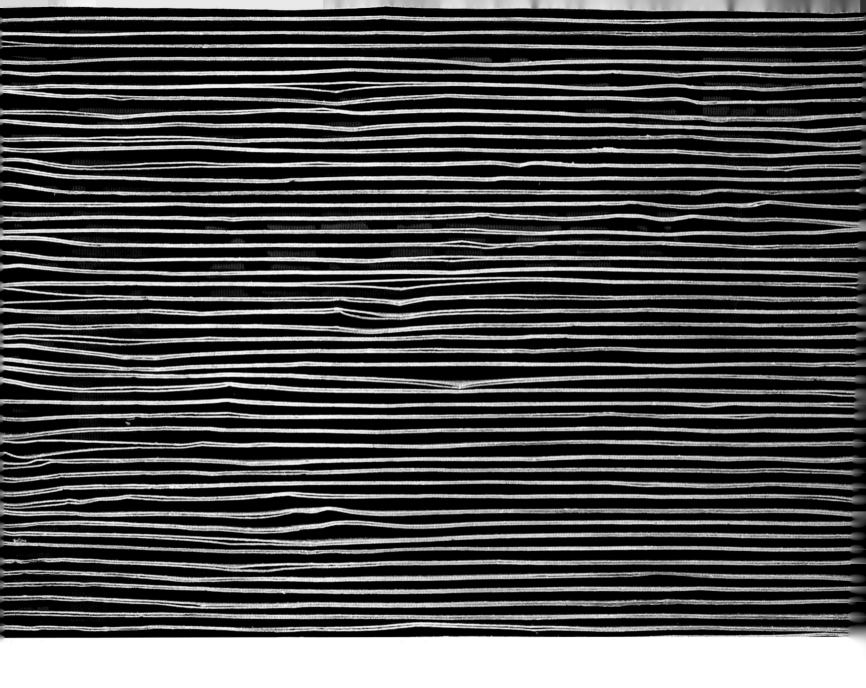

80

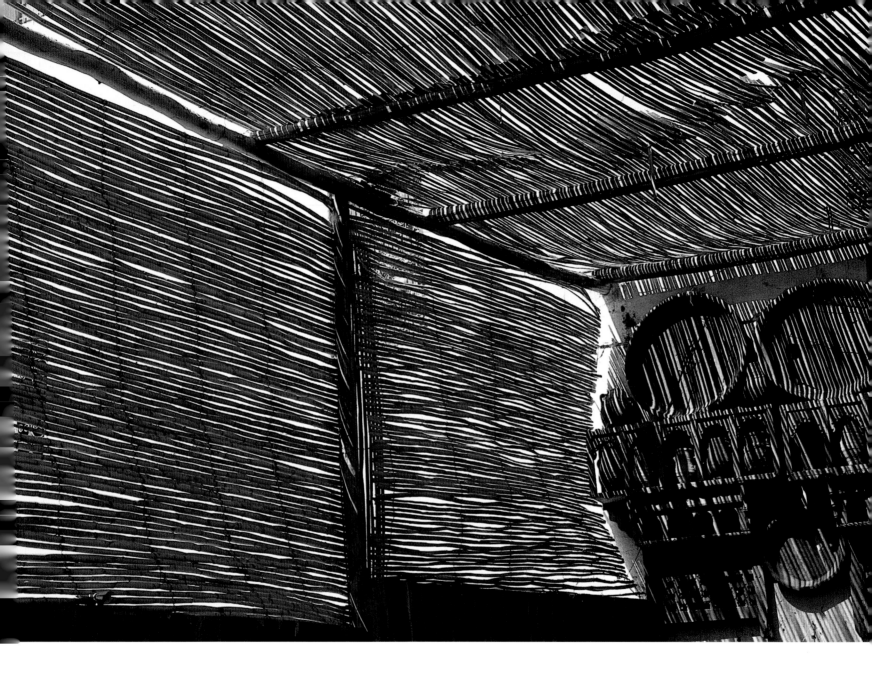

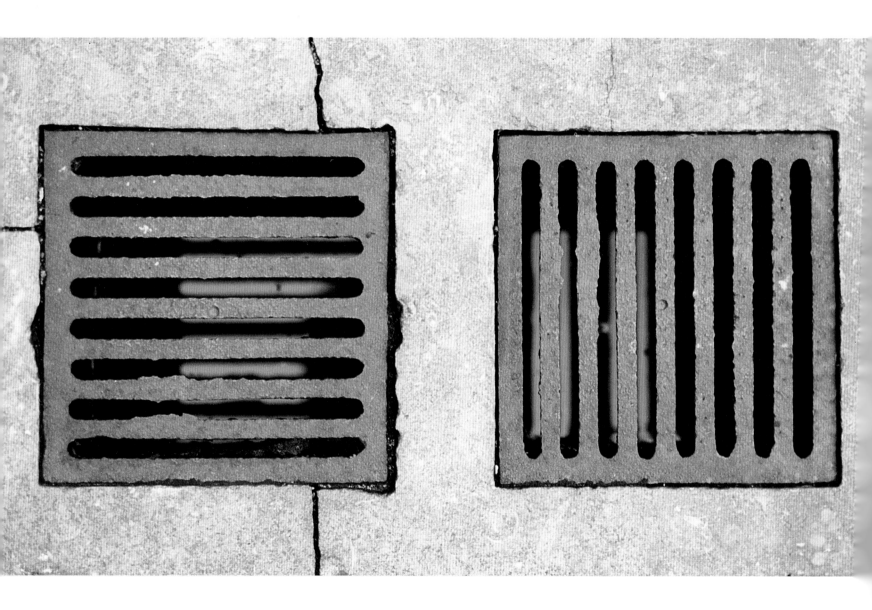

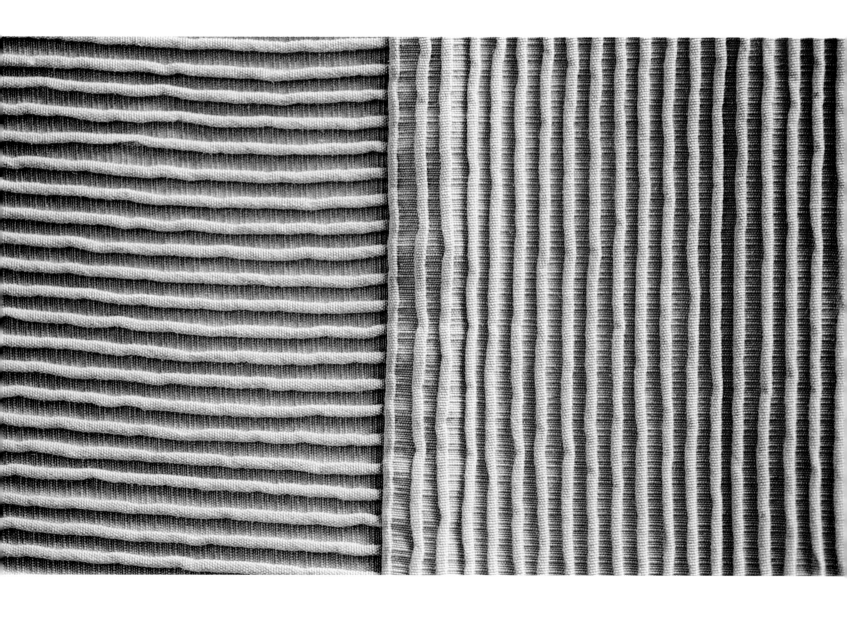

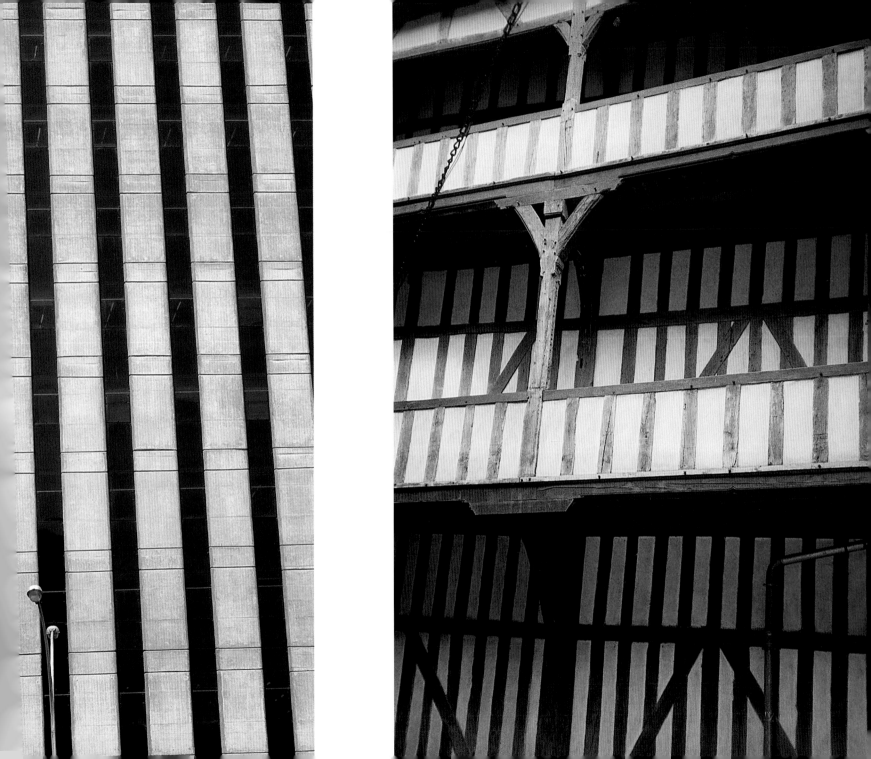

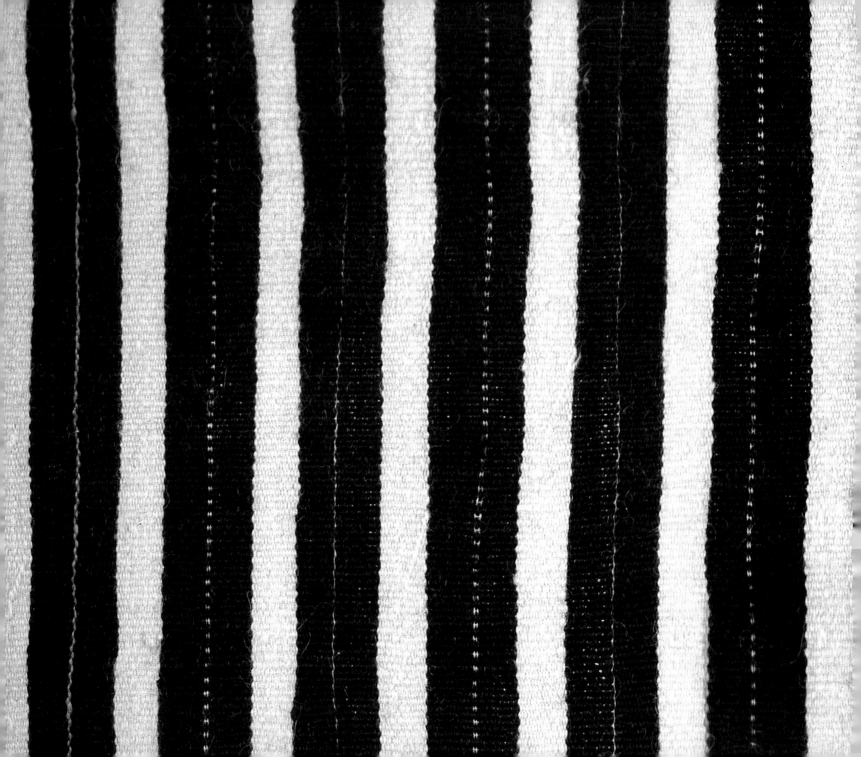

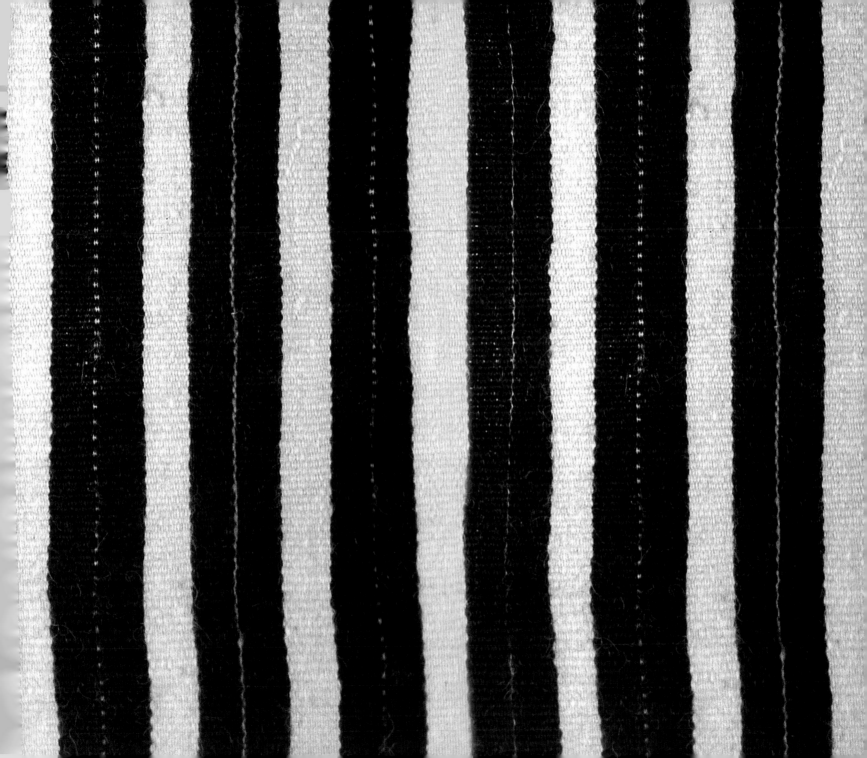

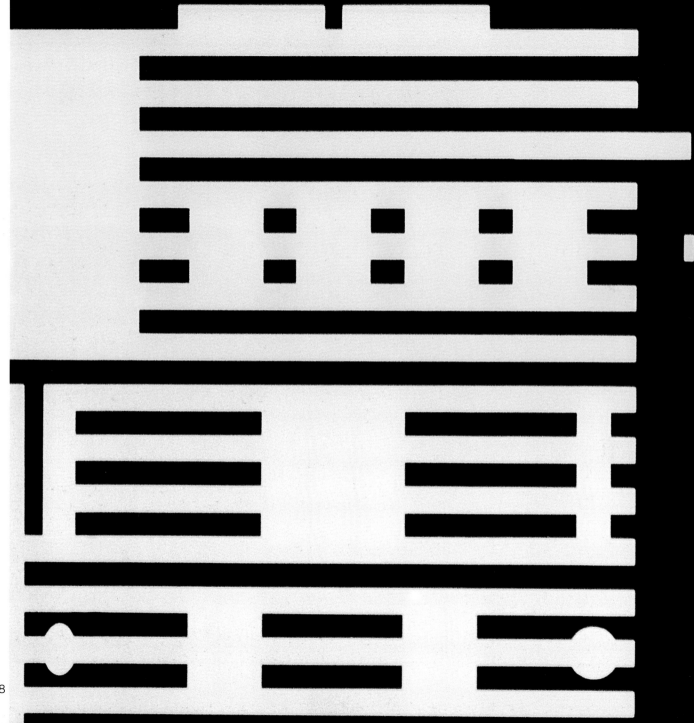

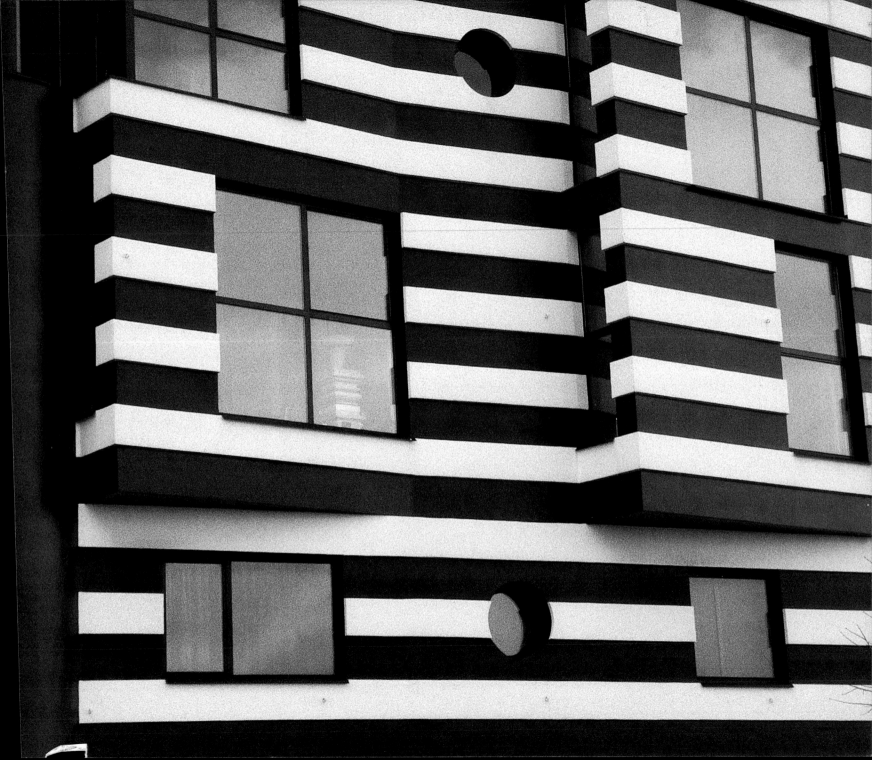

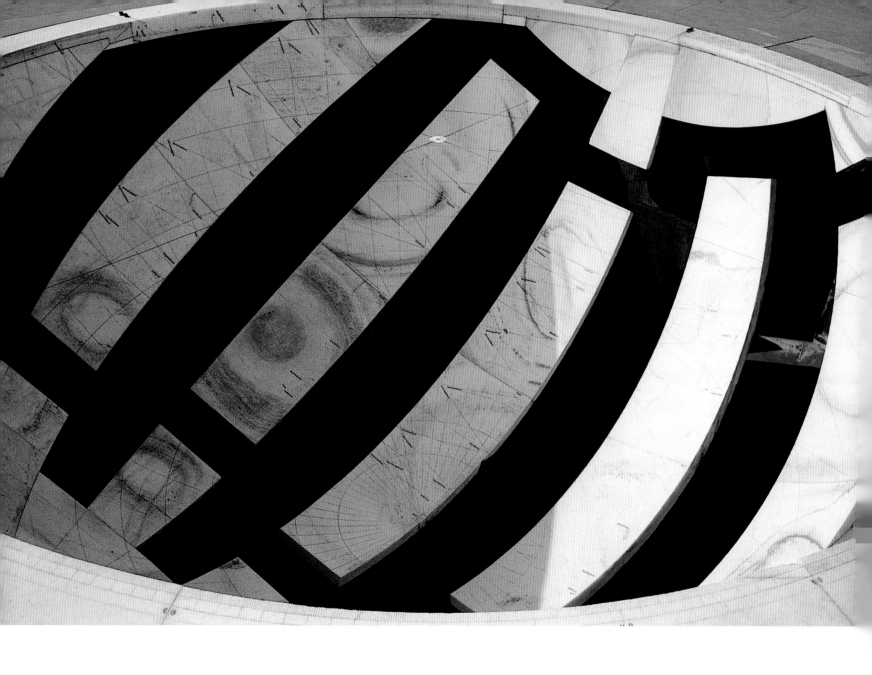

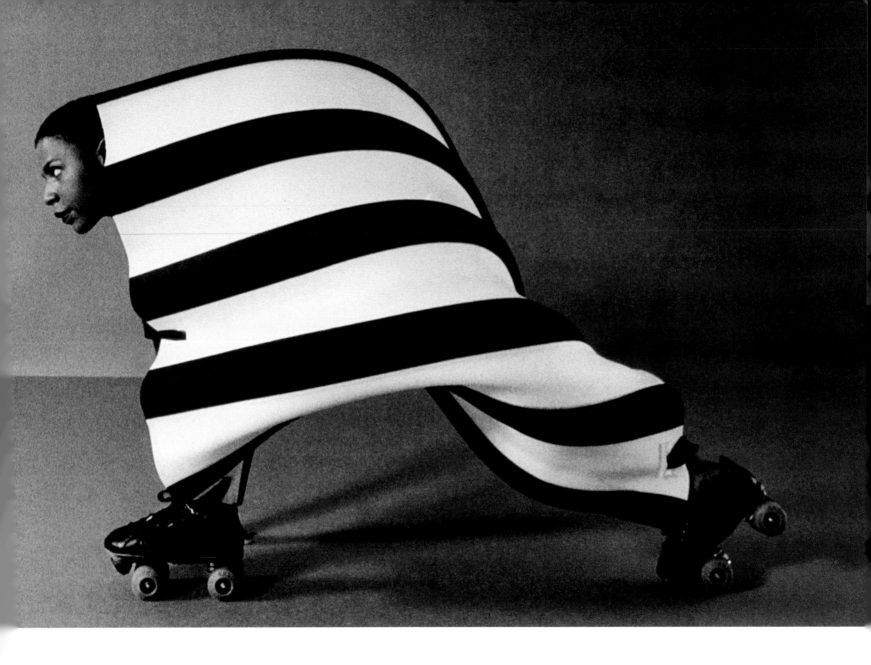

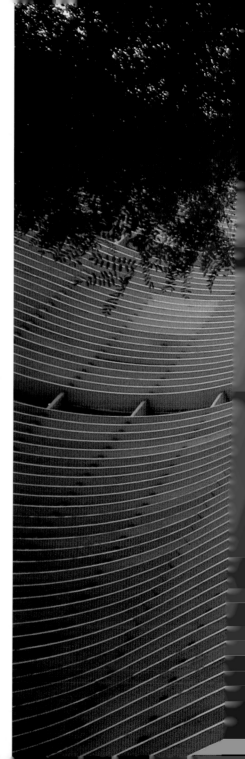

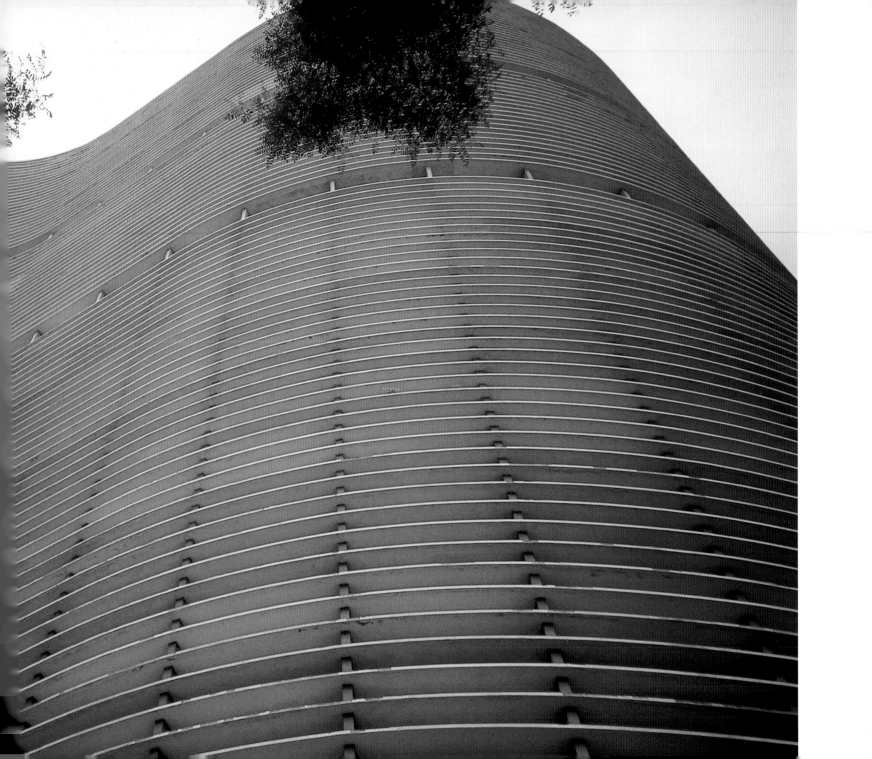

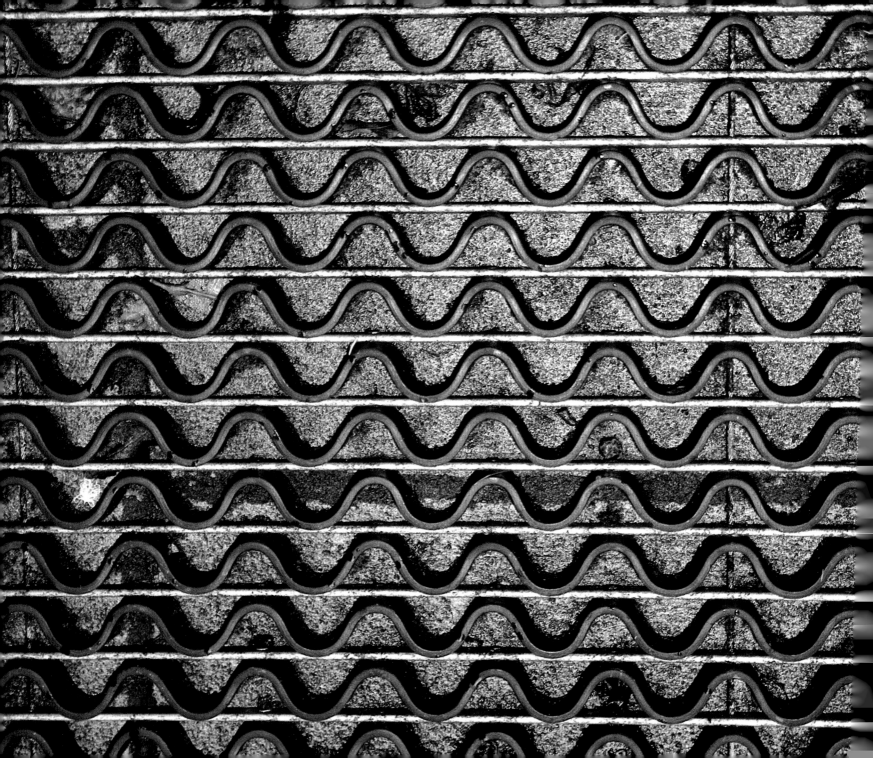

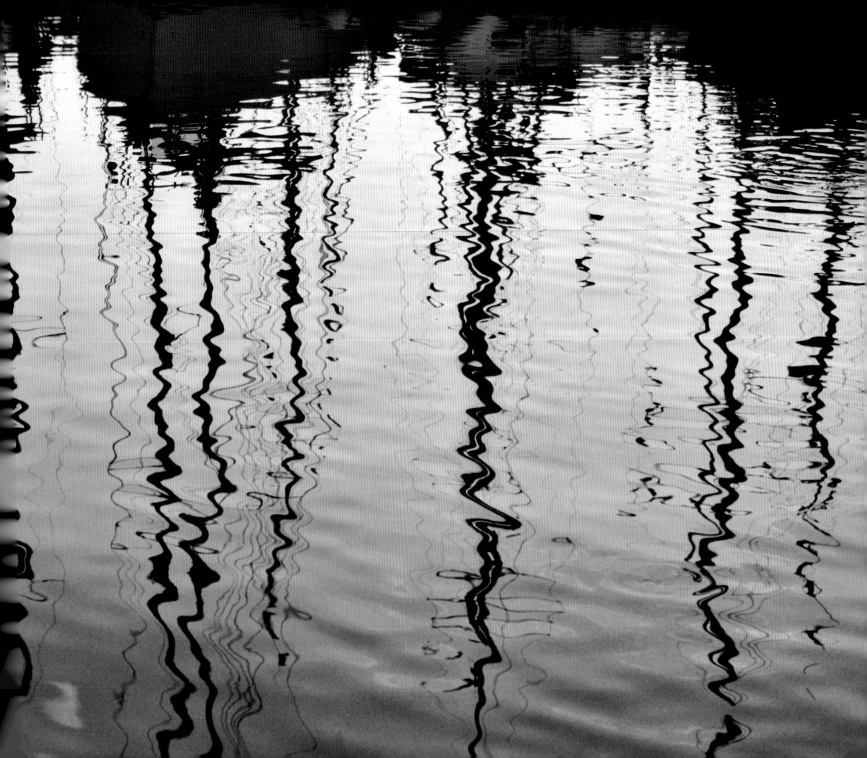

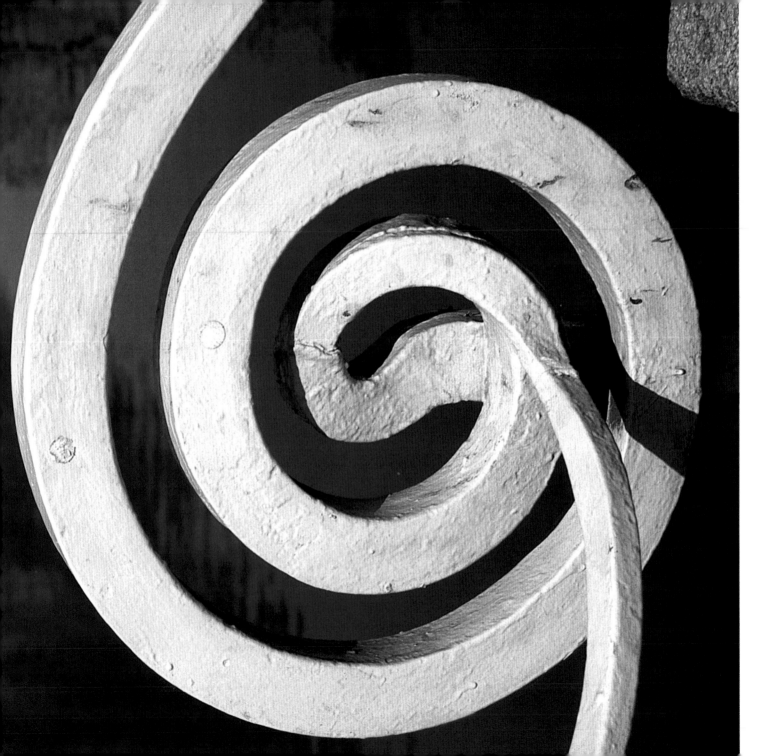

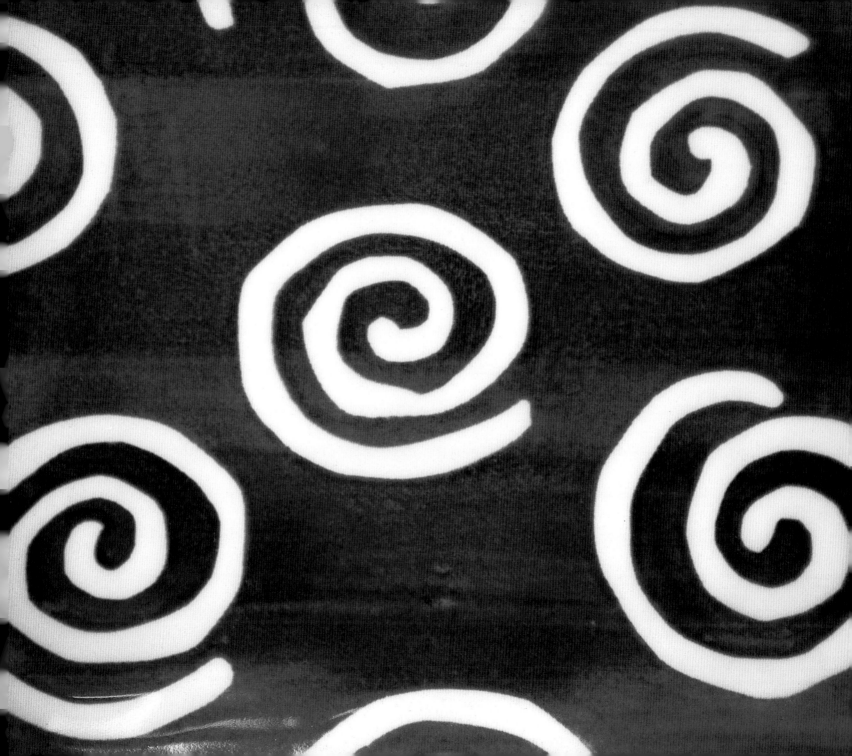

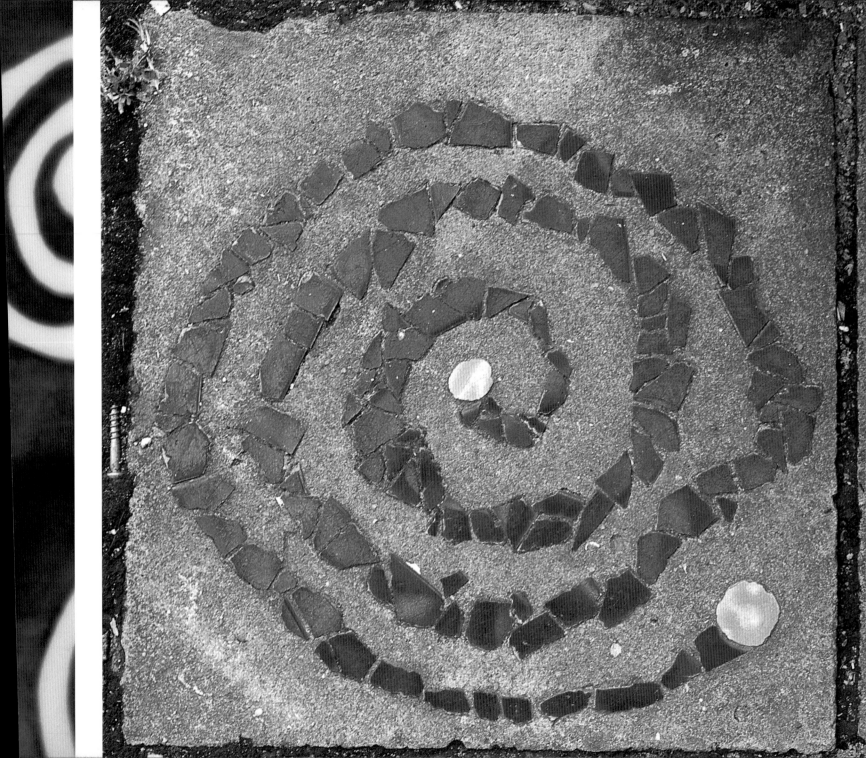

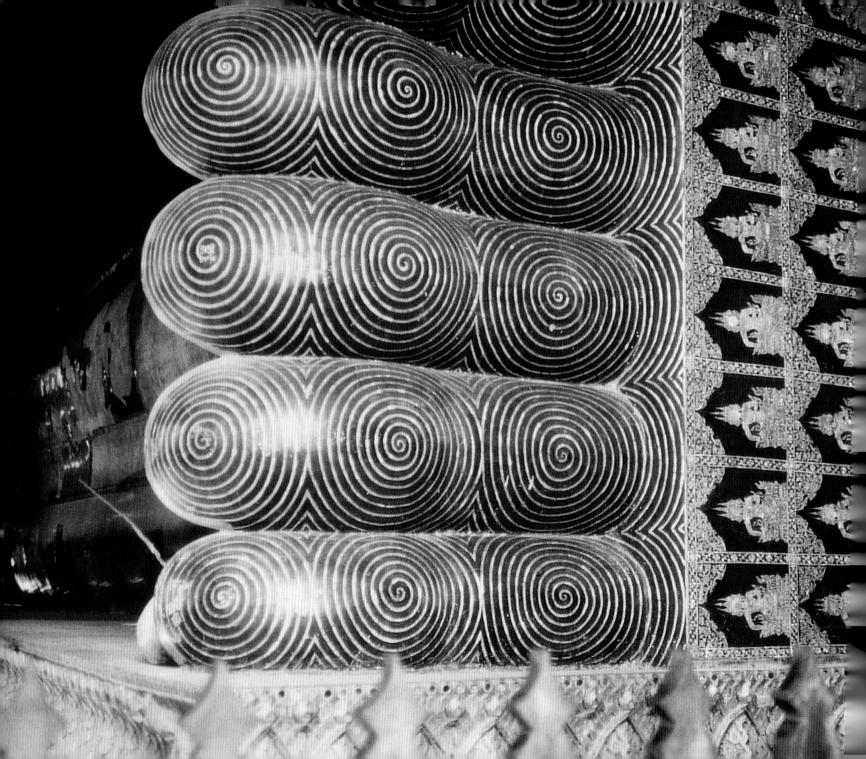

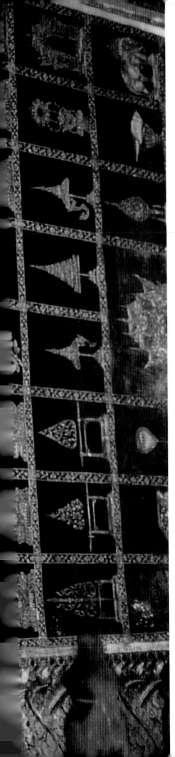
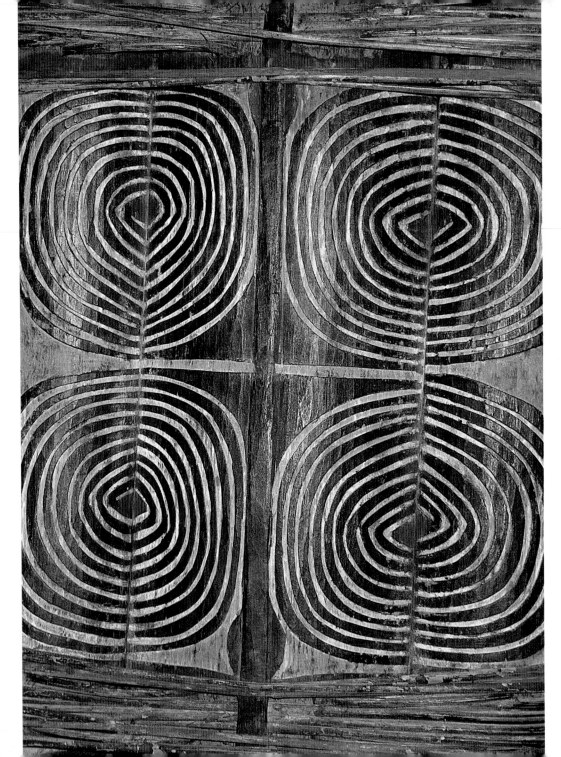

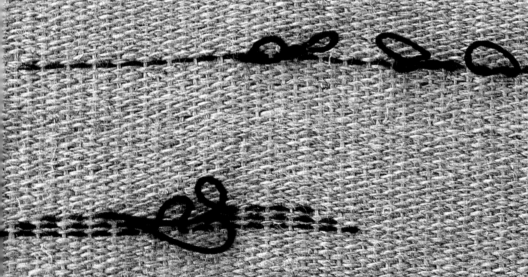
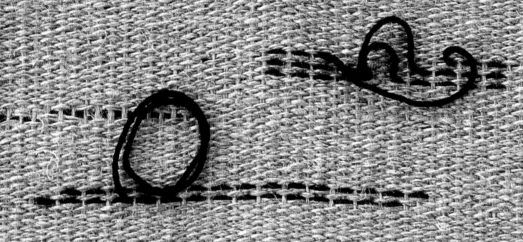

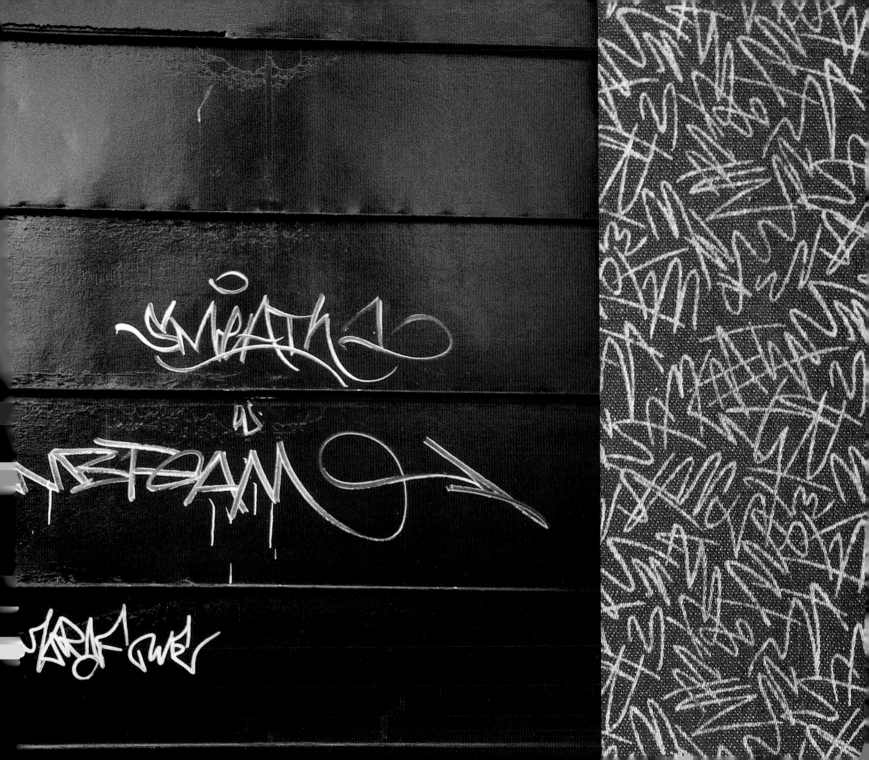

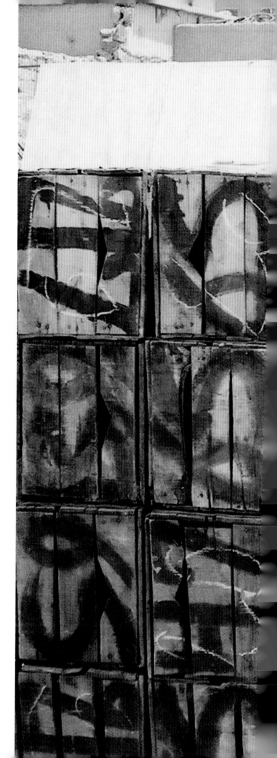

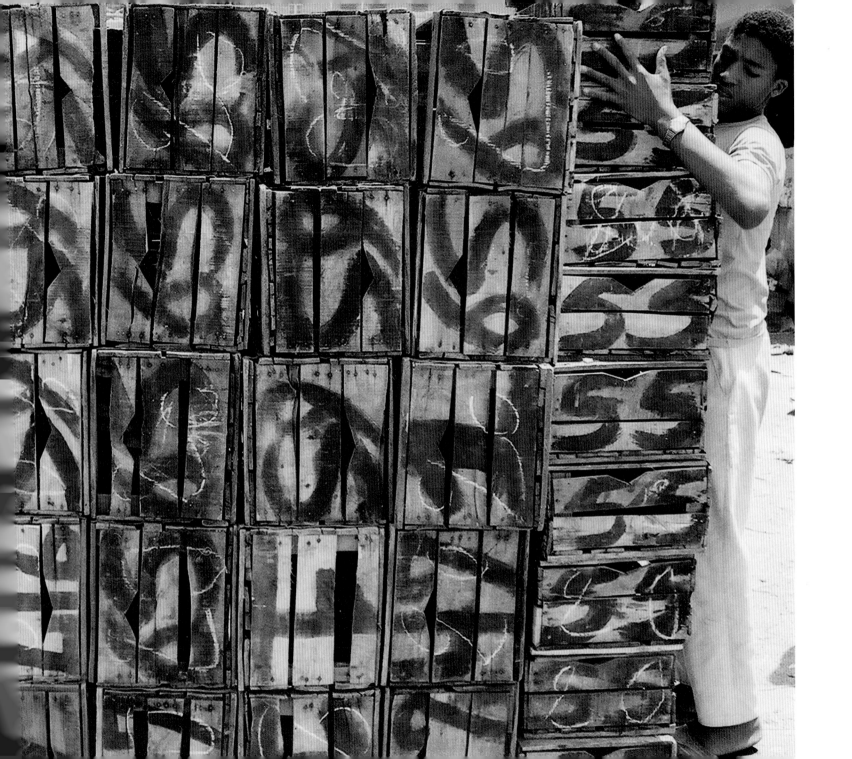

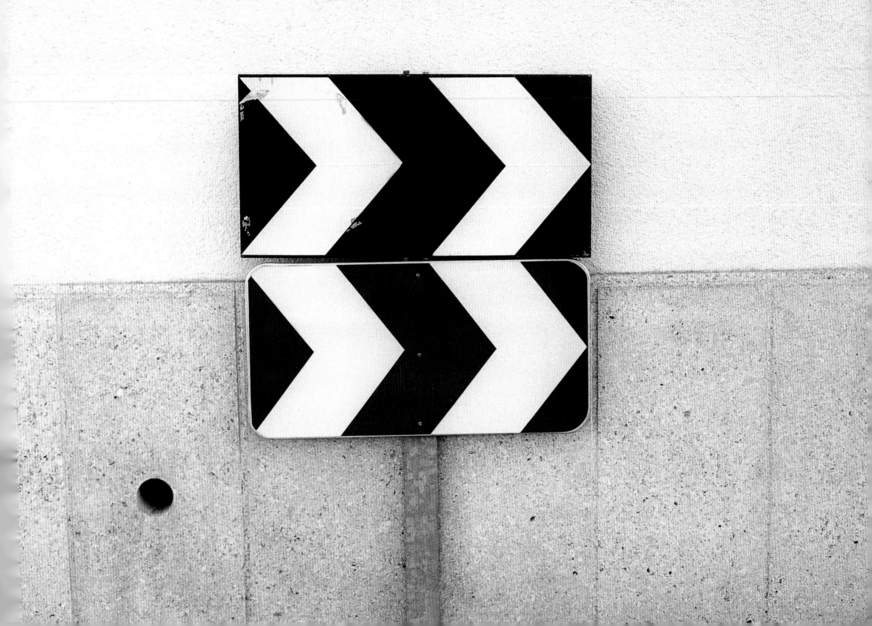

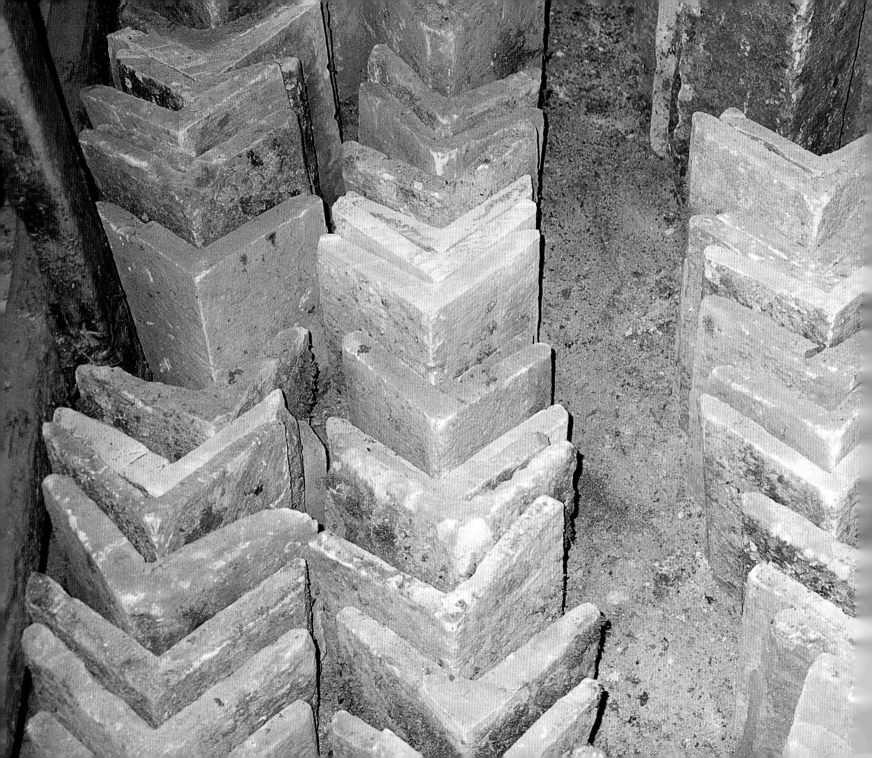

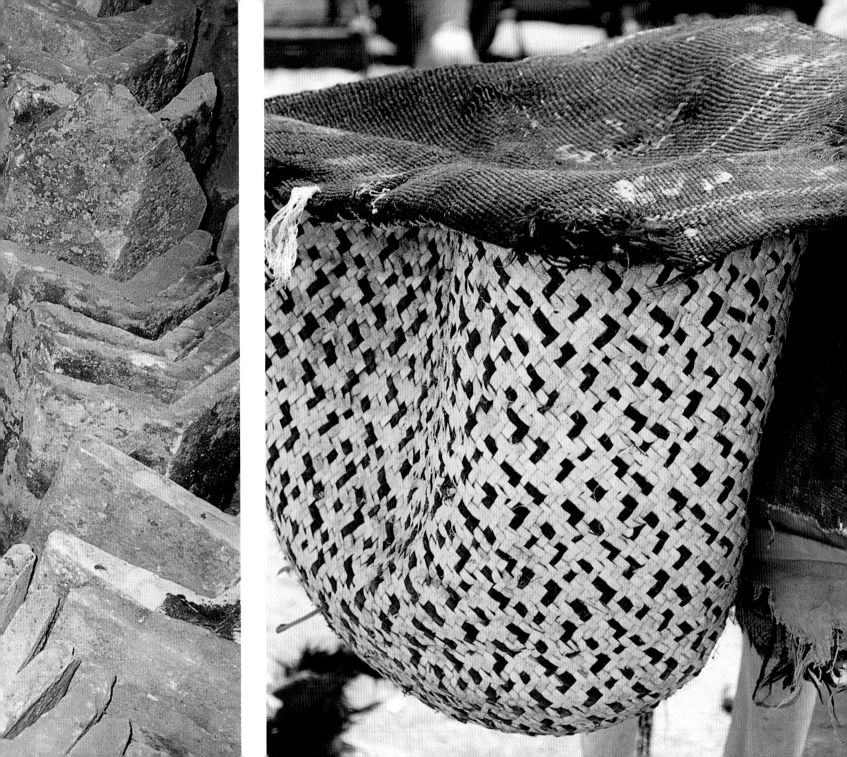

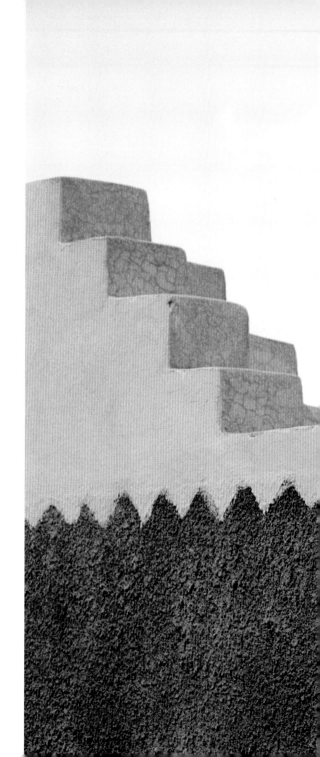

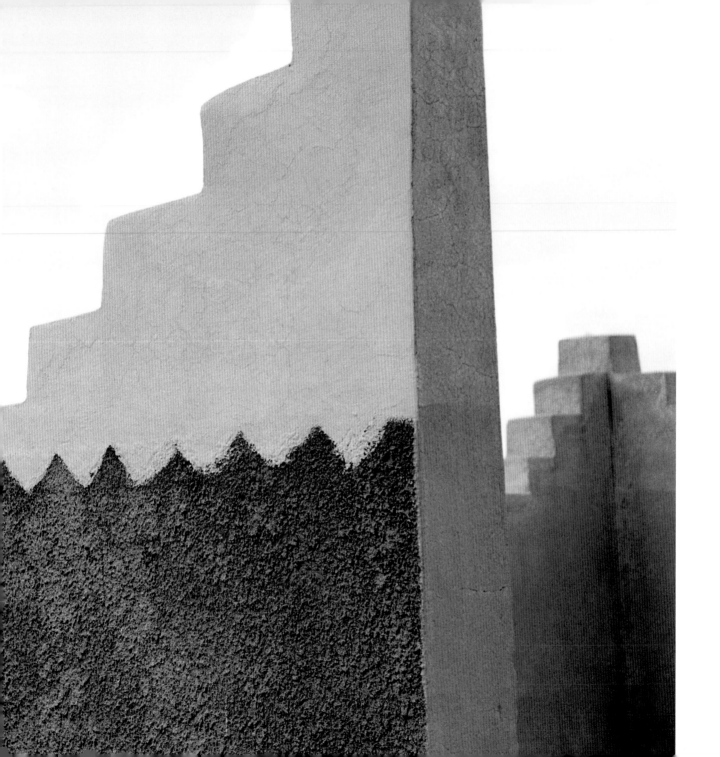

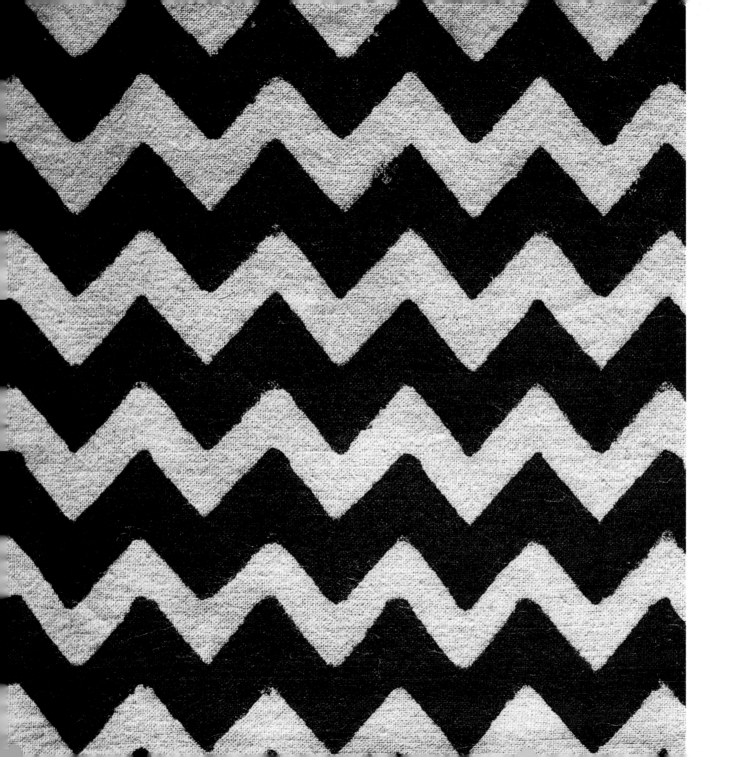

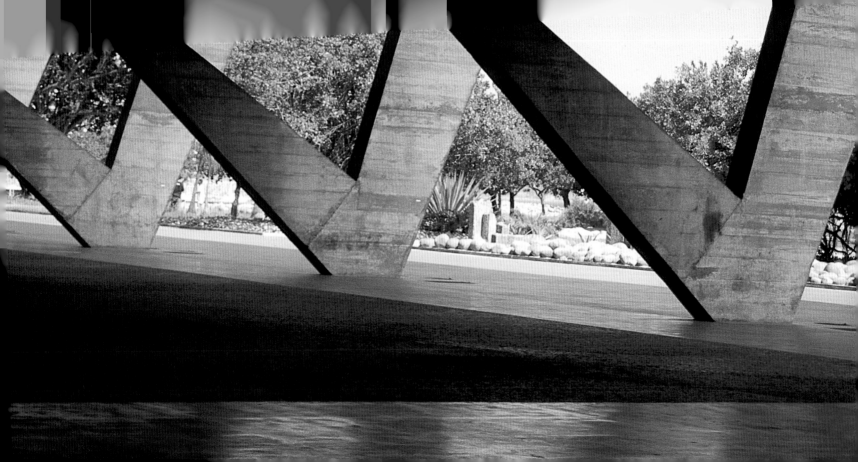

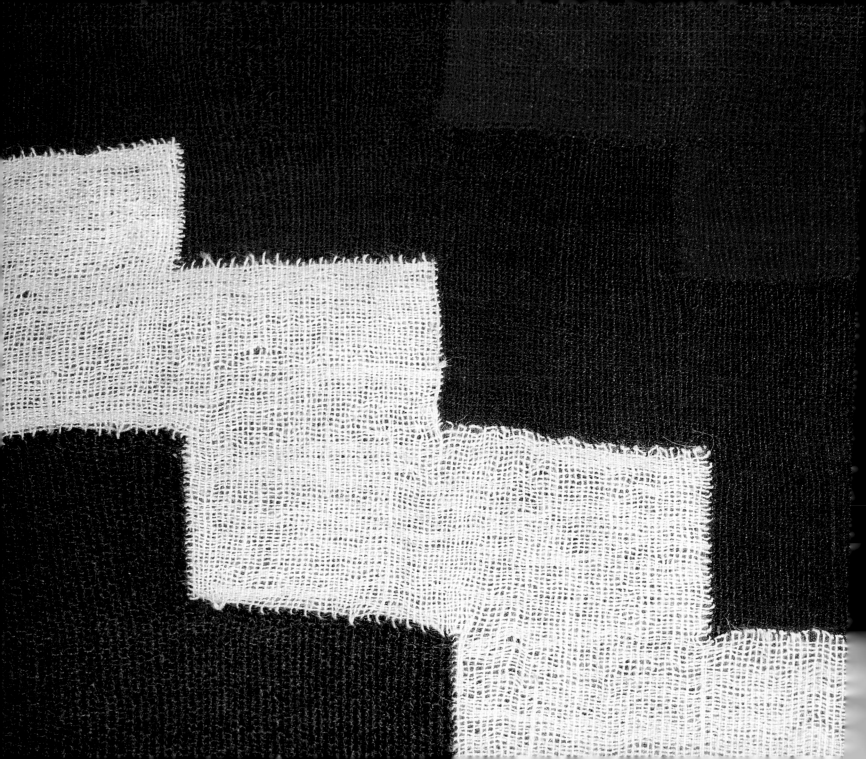

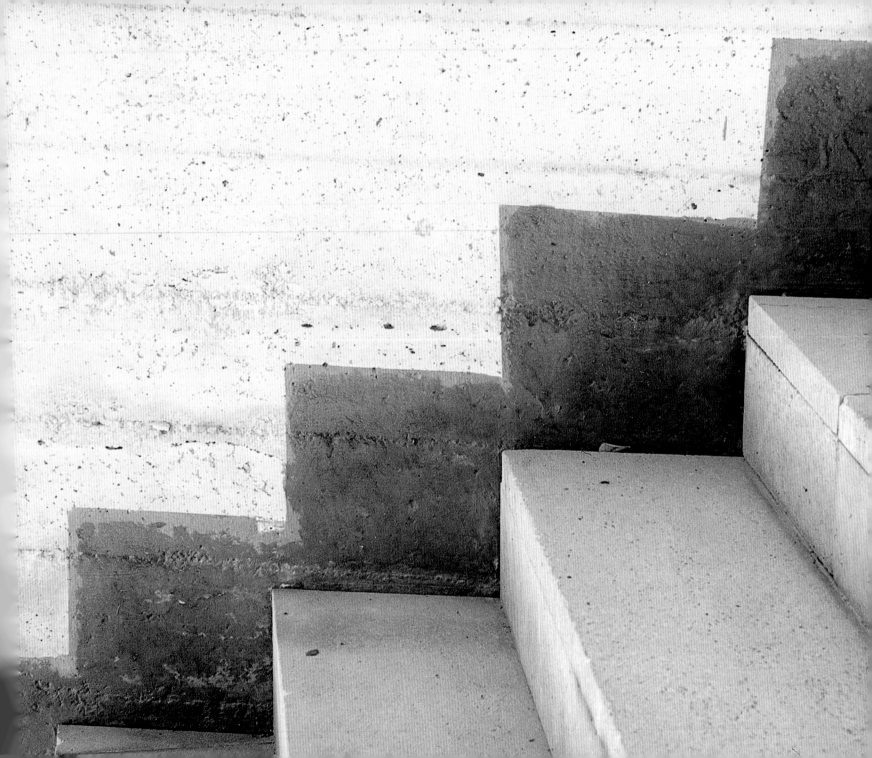

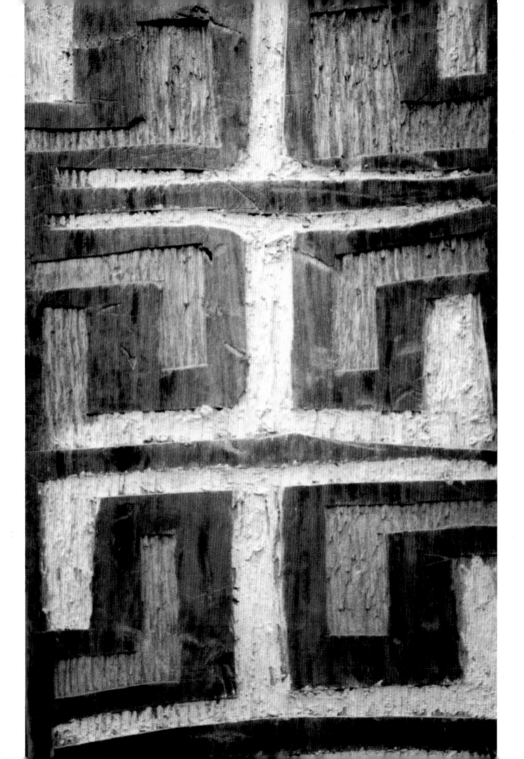

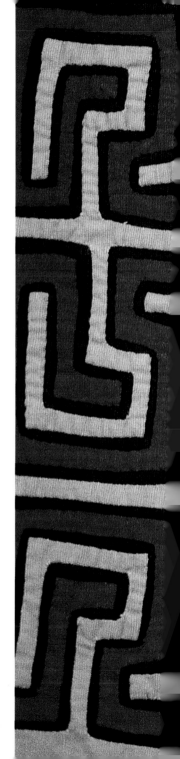

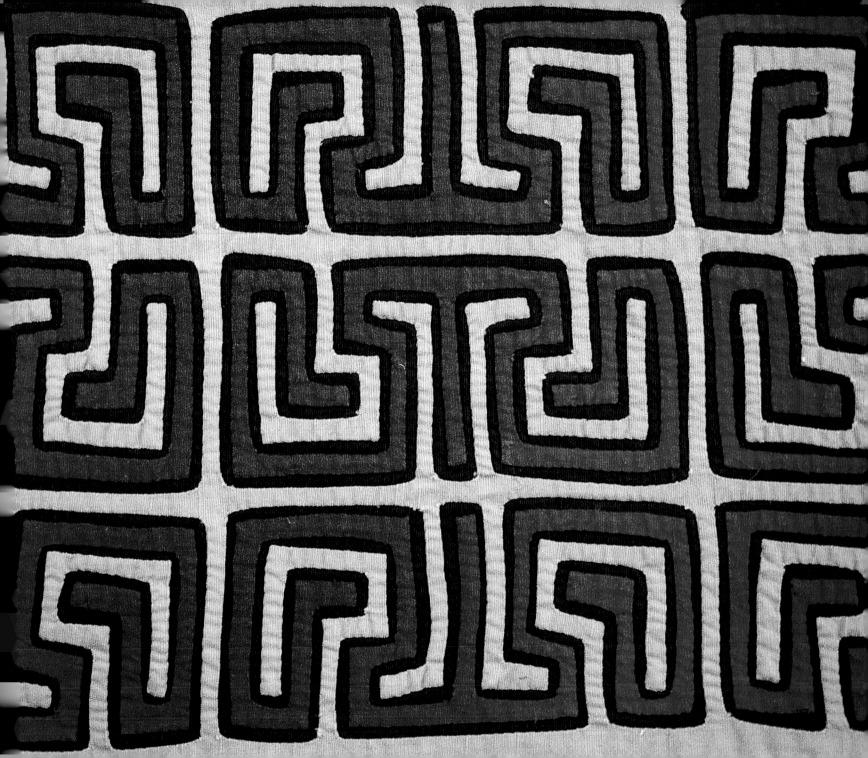

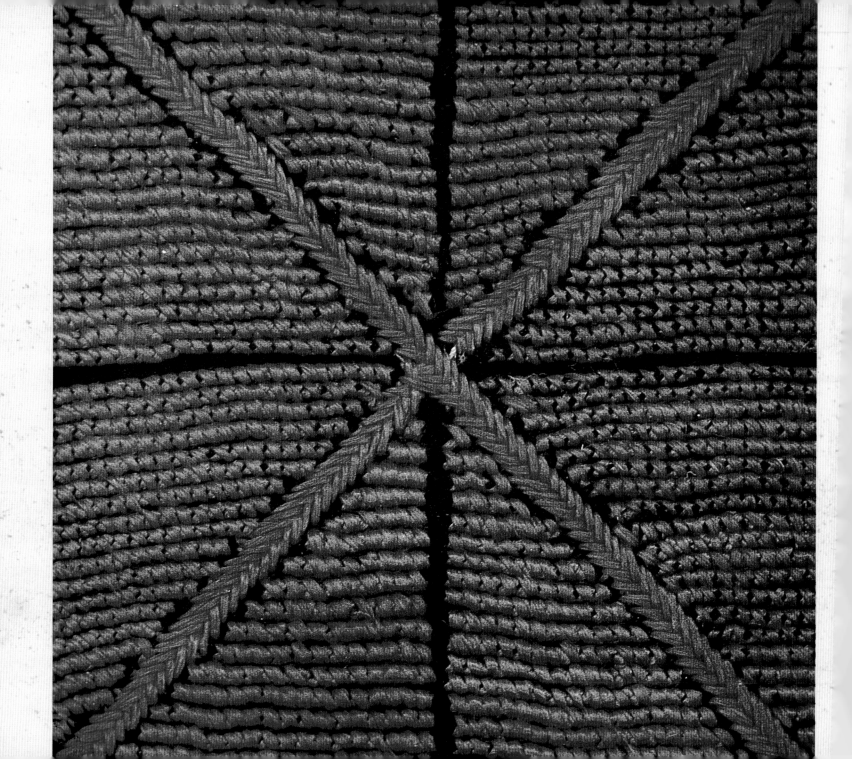

Crossing

The intersection of lines of limited length produces a cross. Depending on the direction and length of the lines, various forms of crosses may be produced. In different cultures and diverse situations, crosses may serve either as ideological symbols or as practical signs in communication.

The crossing of continuous straight lines results in grid patterns, lattice-work or net structures. These may be viewed with a focus on the interplay of lines, or on the meshes enclosed by the lines.

Crossing is part of the process of construction in weaving and plaiting by interlacing fibres or wire, and in woodwork by superimposing rods. Grids form the basic structure of graphic design in the layout of books and magazines. In many parts of the world, the grid pattern used by urban planners provides an easy orientation system.

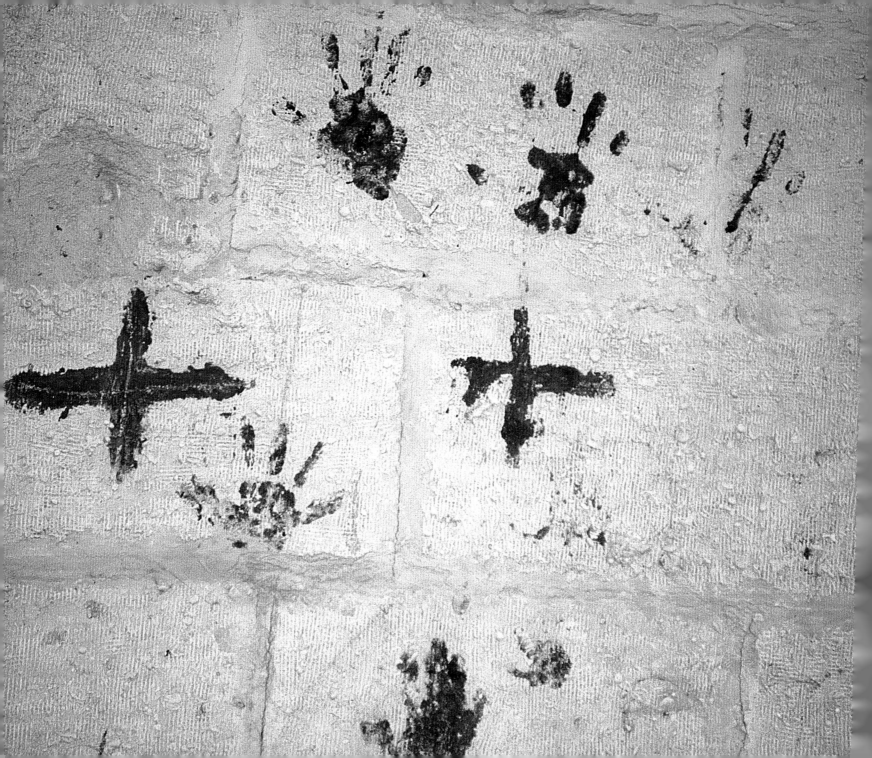

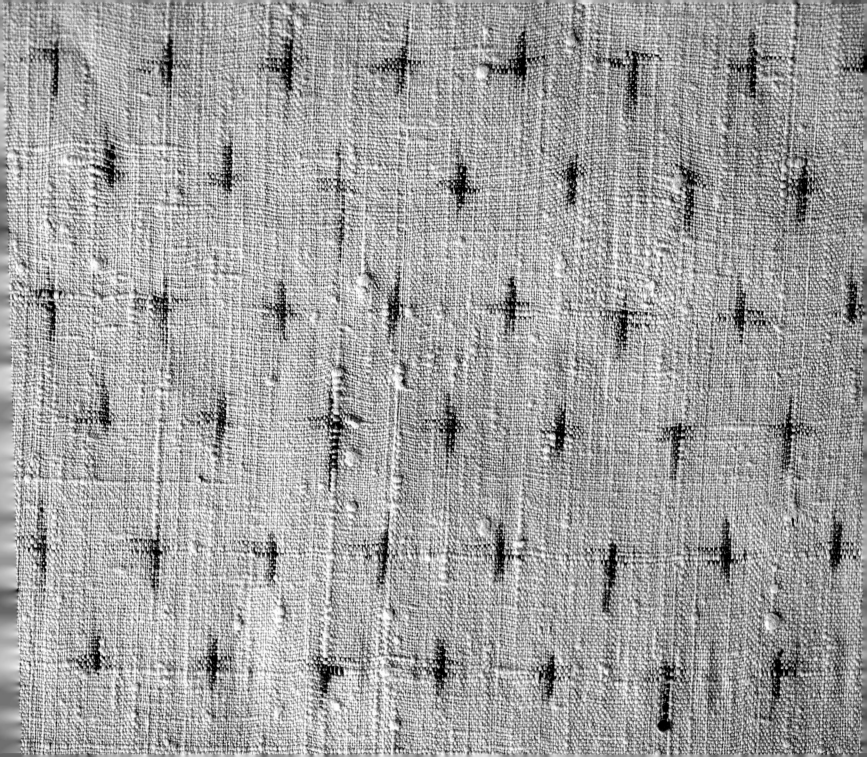

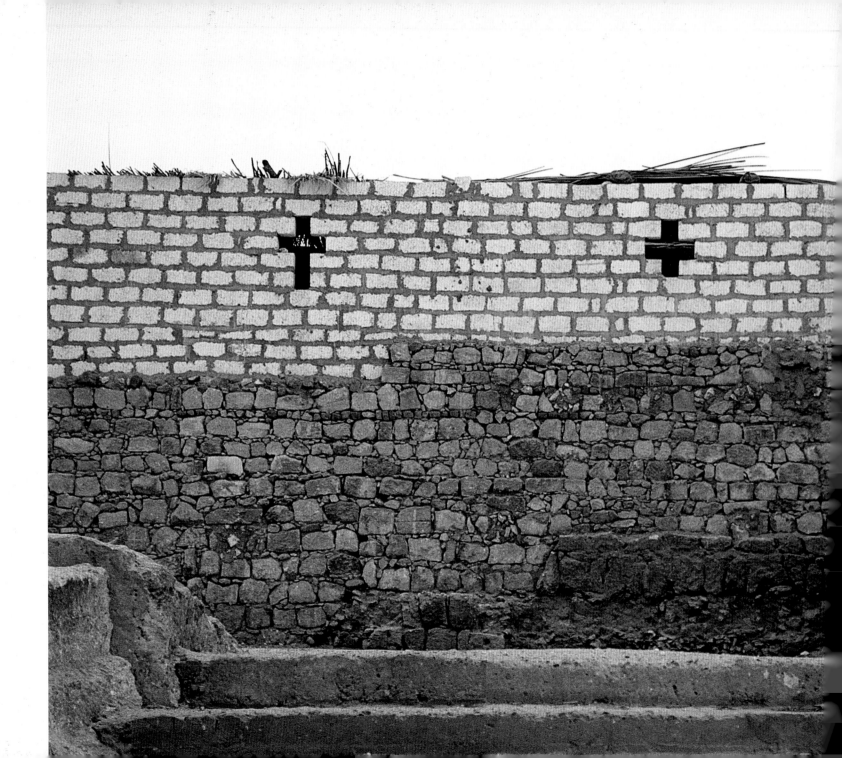

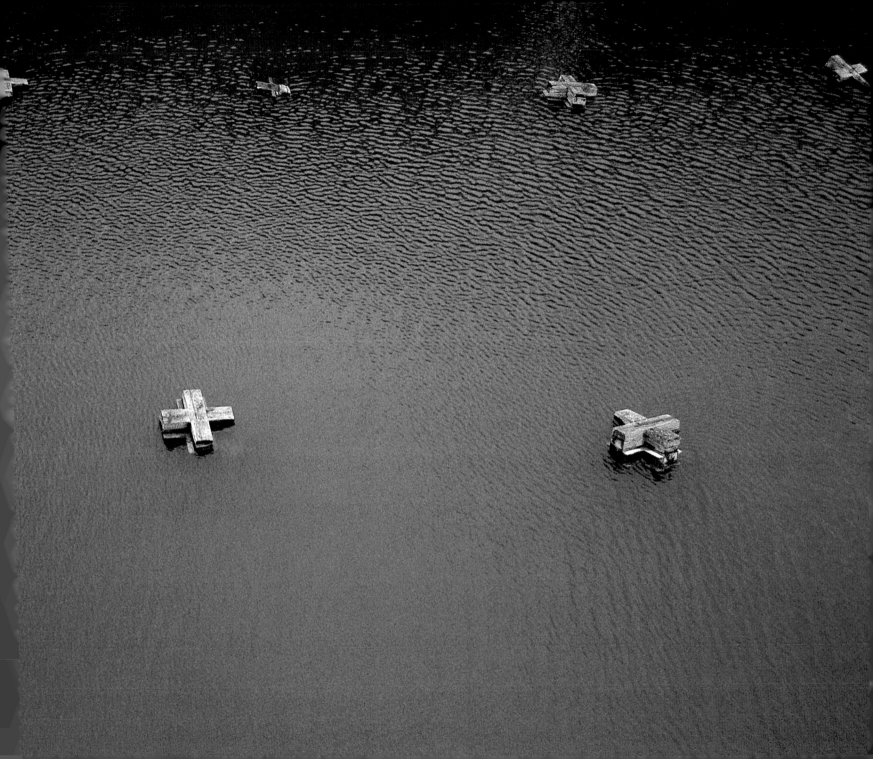

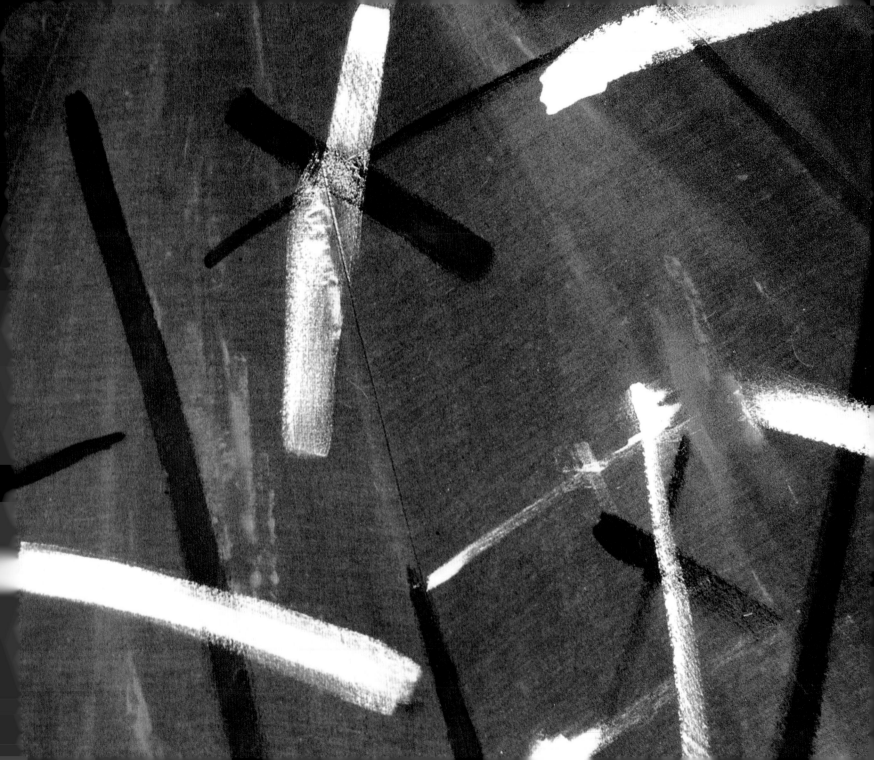

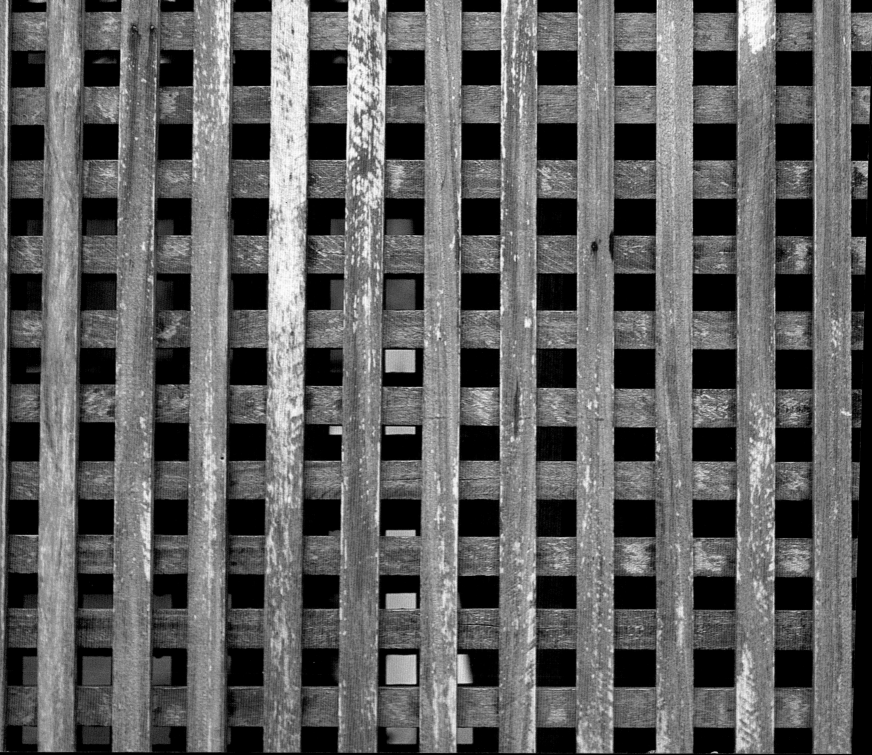

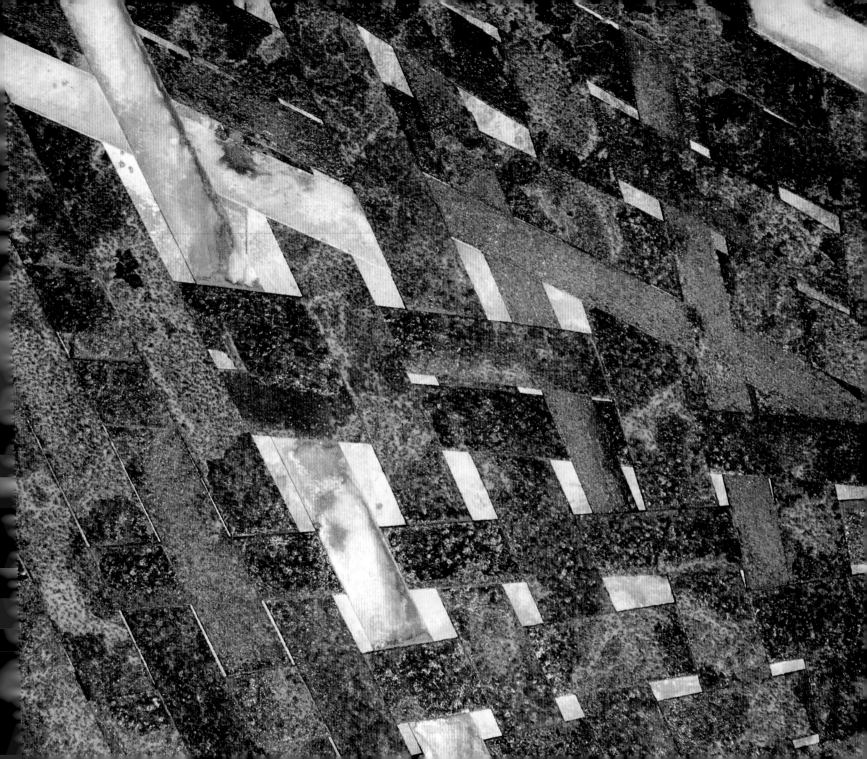

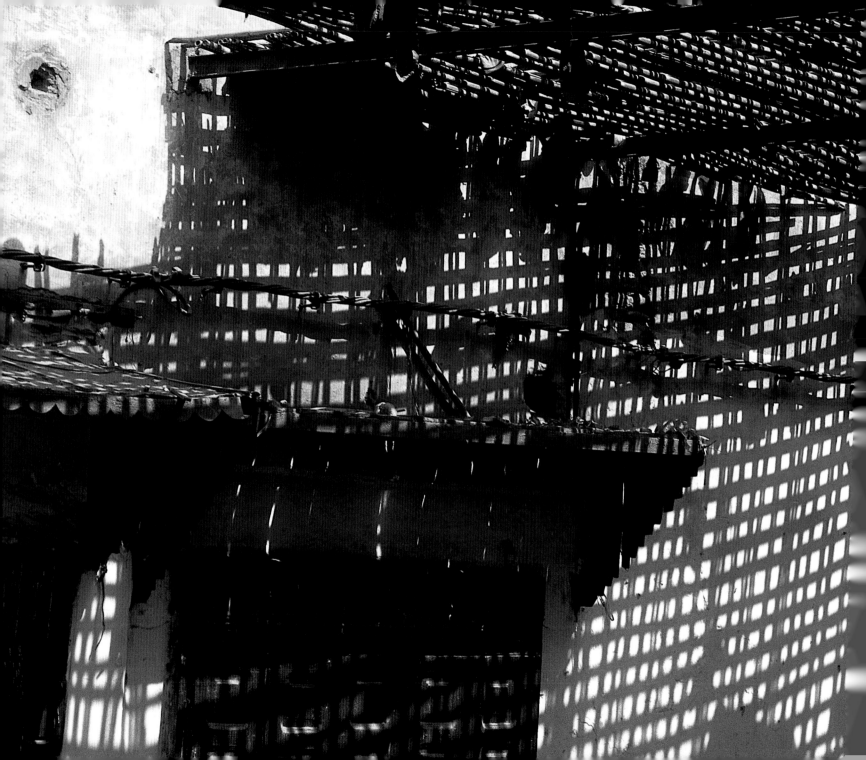

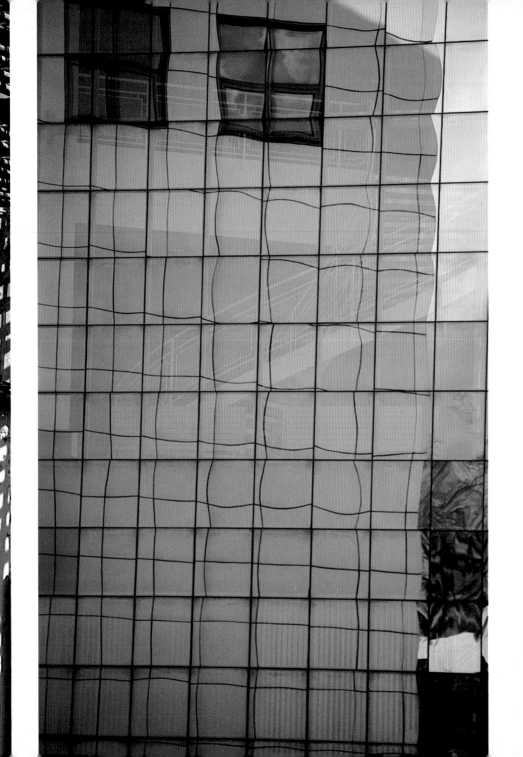

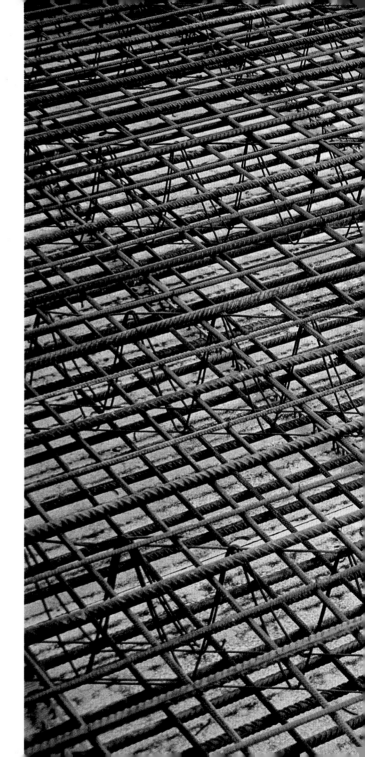

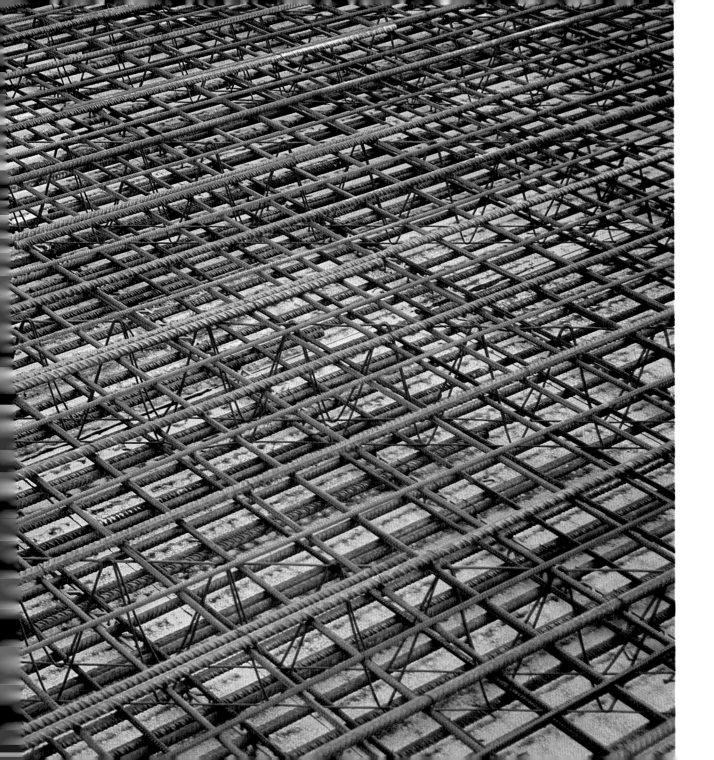

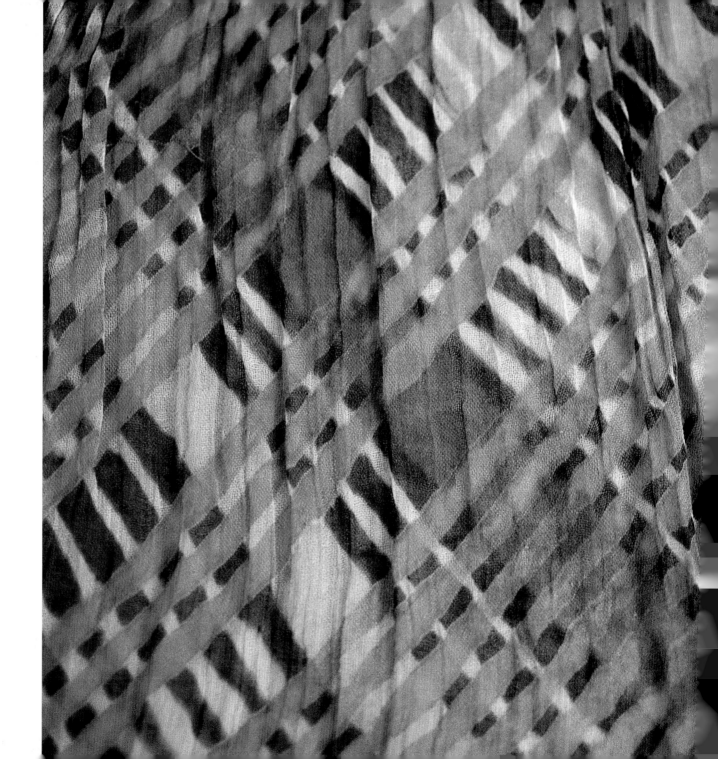

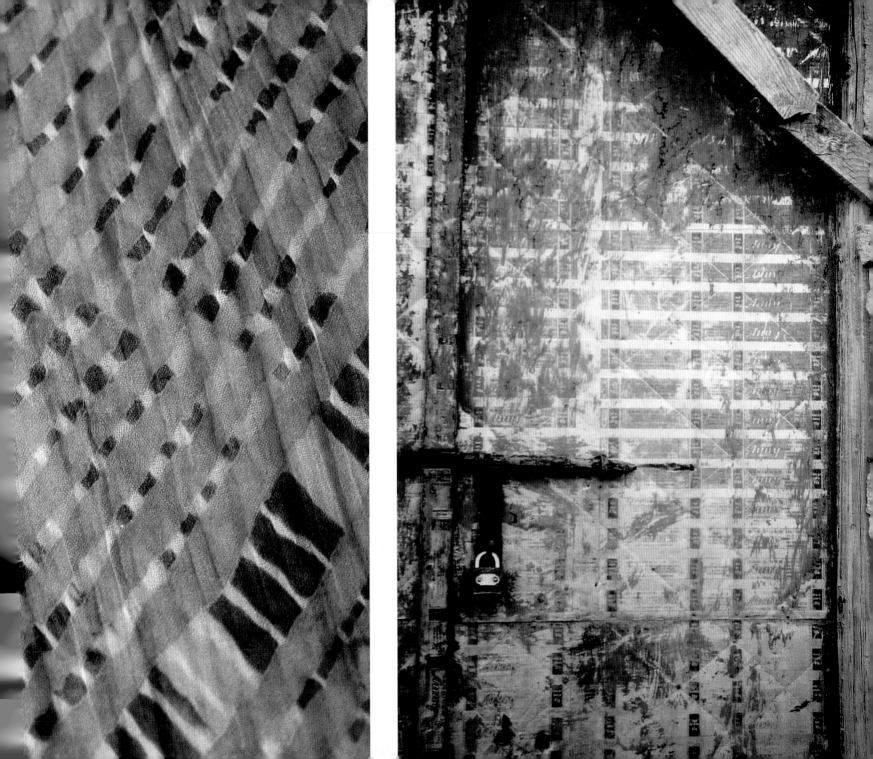

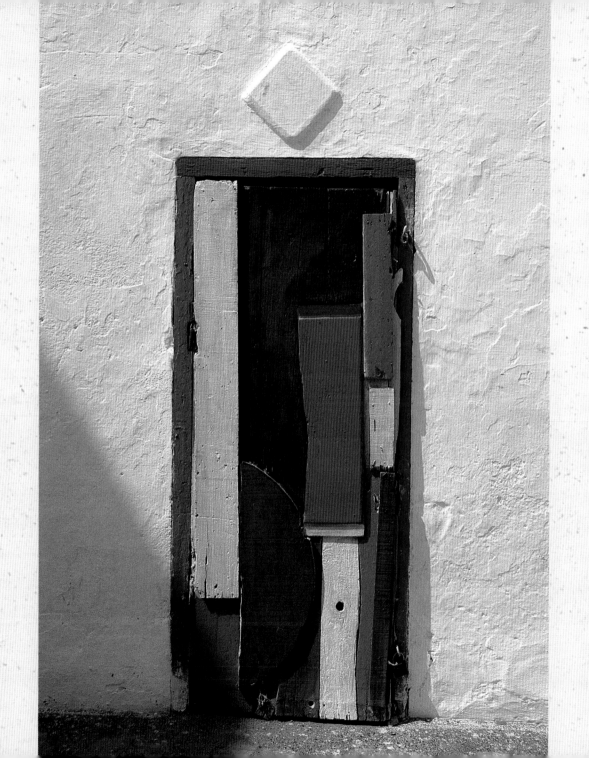

Planes

Crossing lines produce basic geometric figures, such as rectangles, squares, lozenges and triangles. If the lines are not emphasized by a contrasting colour or a bold style, the enclosed geometric forms dominate as planes. Geometric planes also occur in isolation or independently as a result of a single dynamic, self-closing line.

The physical environment appears in two-dimensional images once it is captured in pictures or graphic representation. Thus geometric forms may appear from optical effects brought about by the incidence of light or colour change. They may also appear as interlocking motifs. By switching one's focus, different optical effects may be seen. For instance, one and the same pattern may at first look convex, then – after a change of focus – concave. Similarly, a pattern may at first appear to be in the foreground, then in the background.

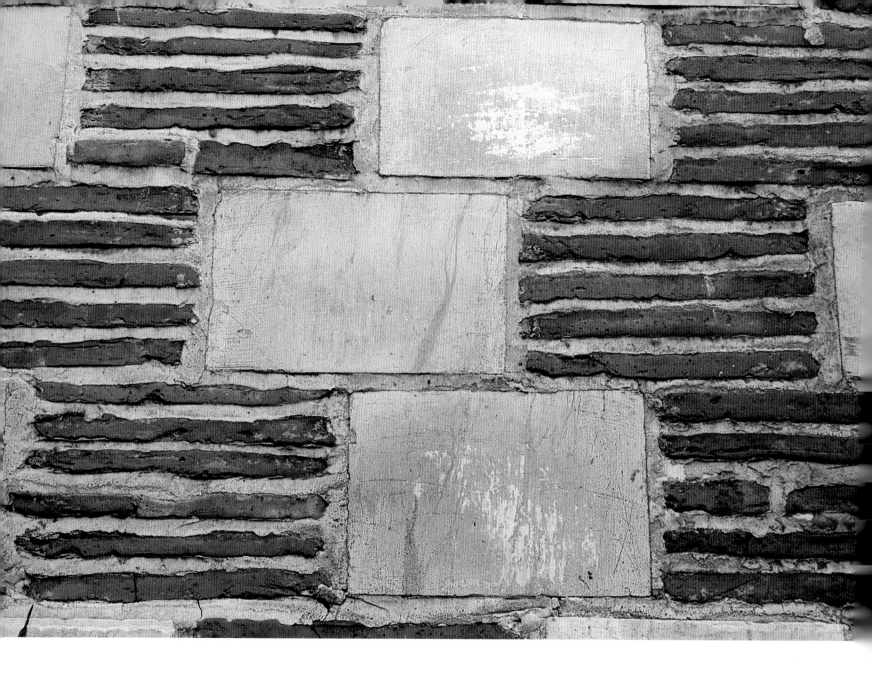

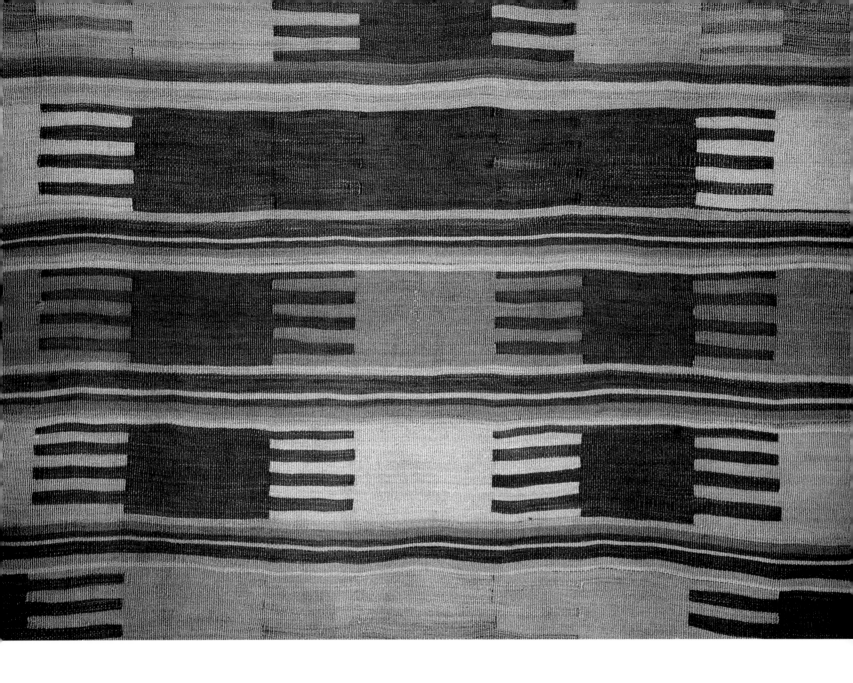

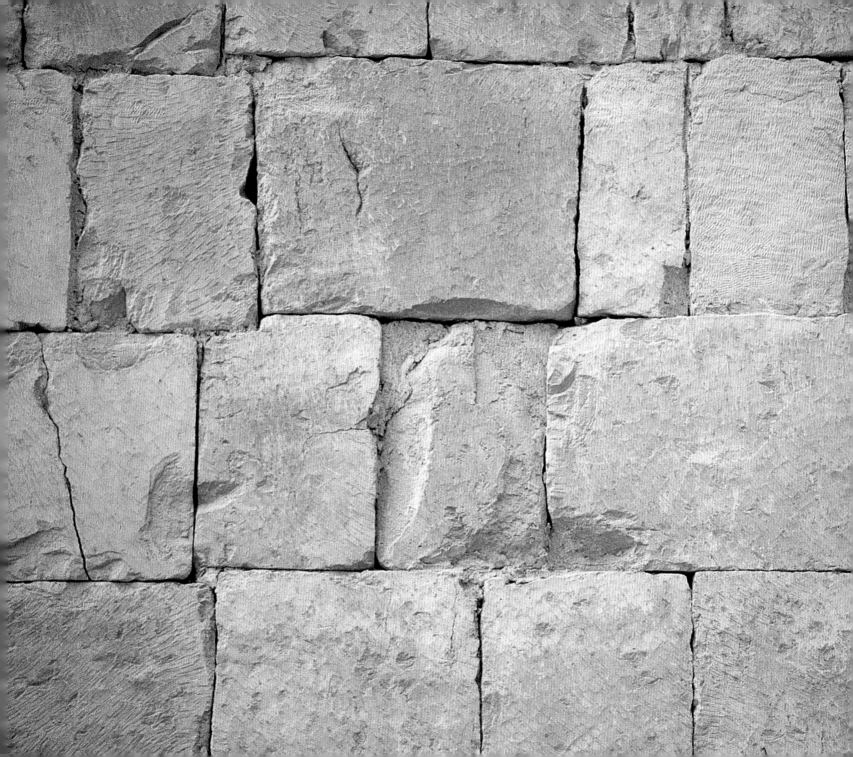

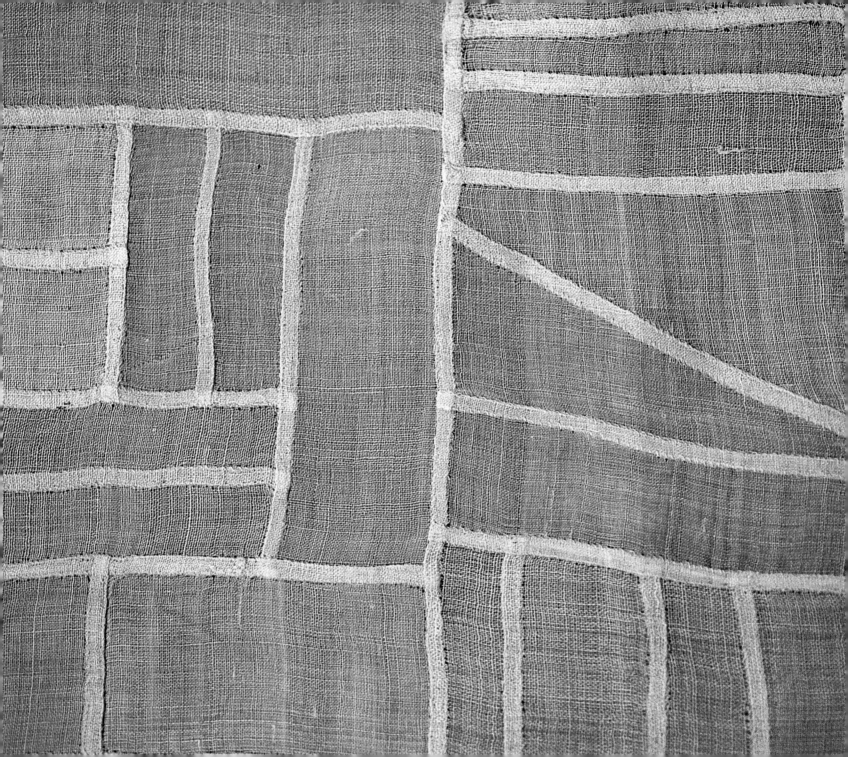

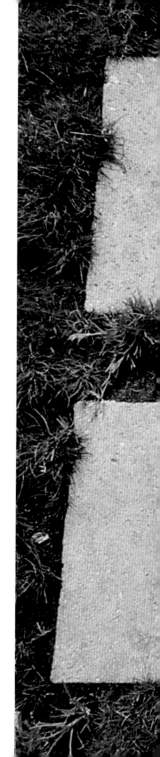

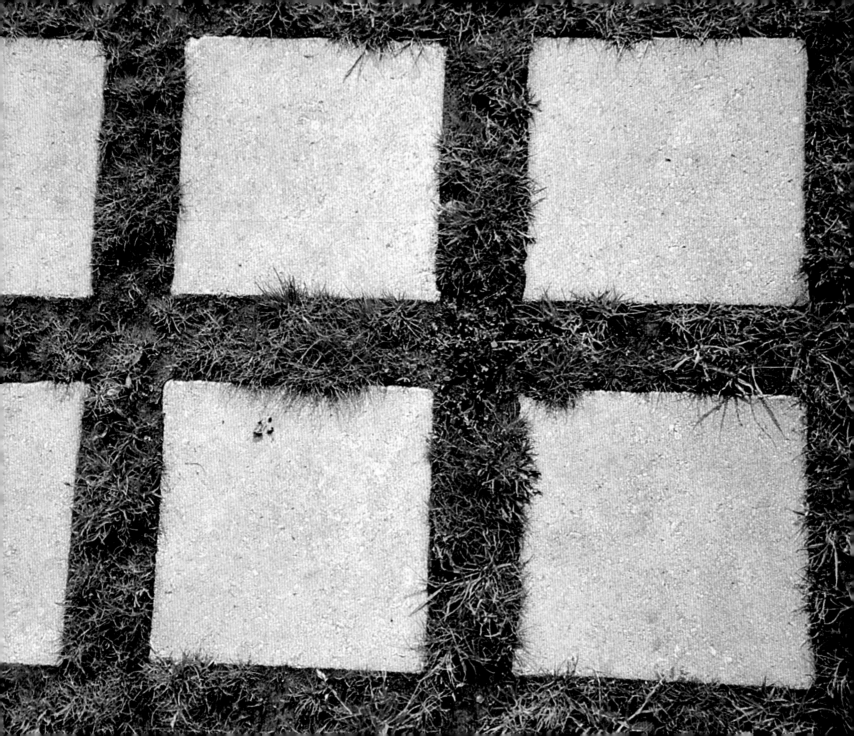

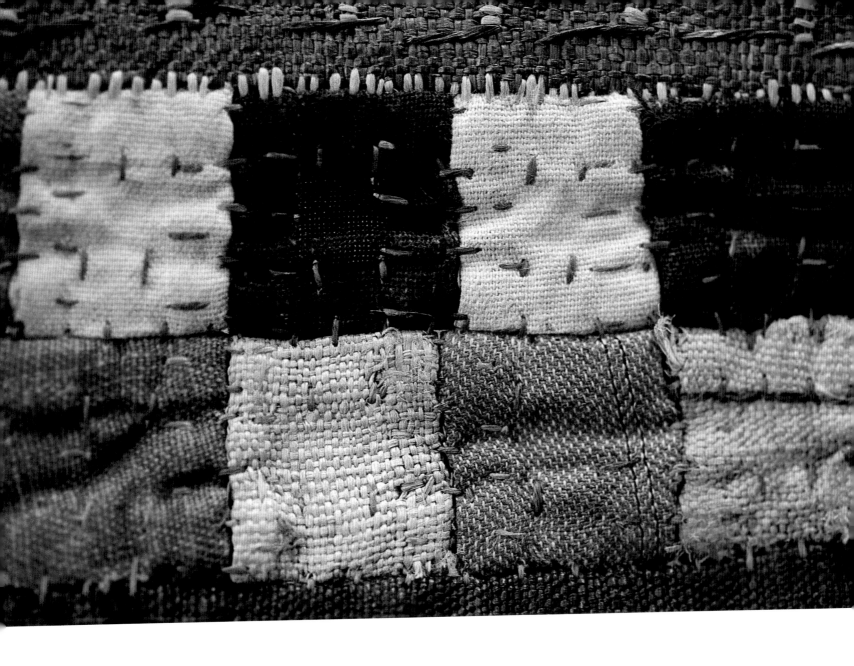

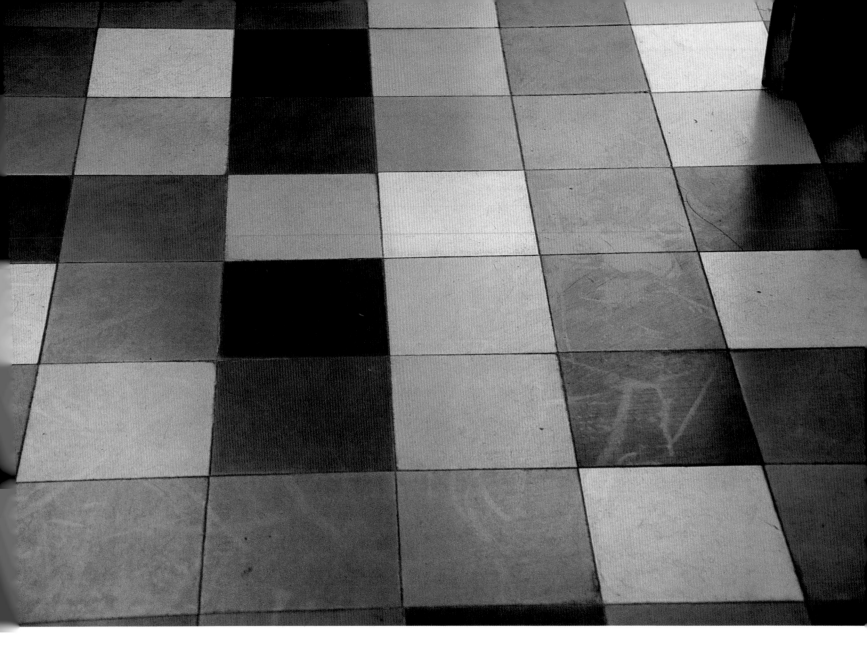

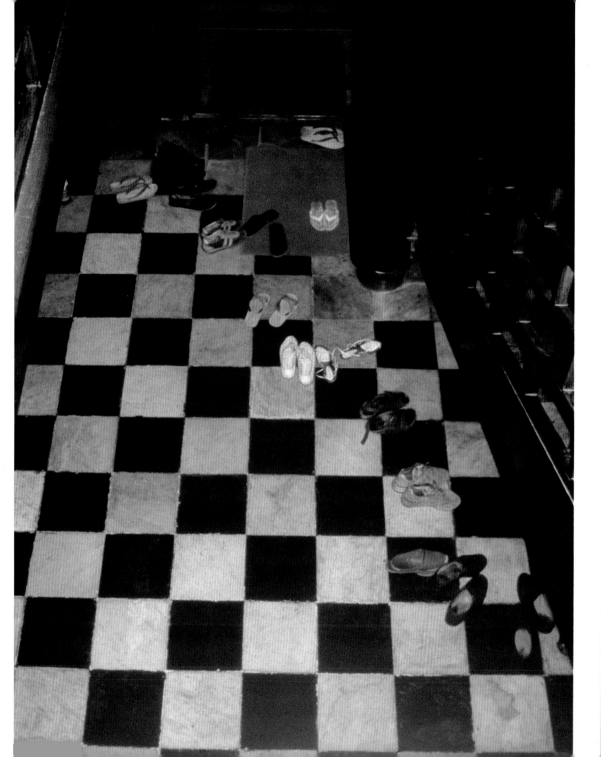
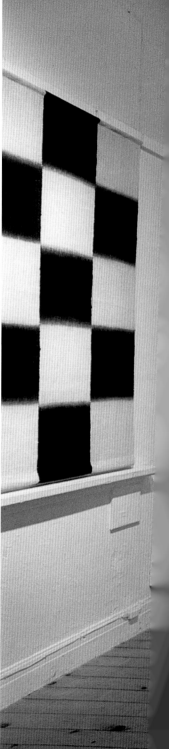

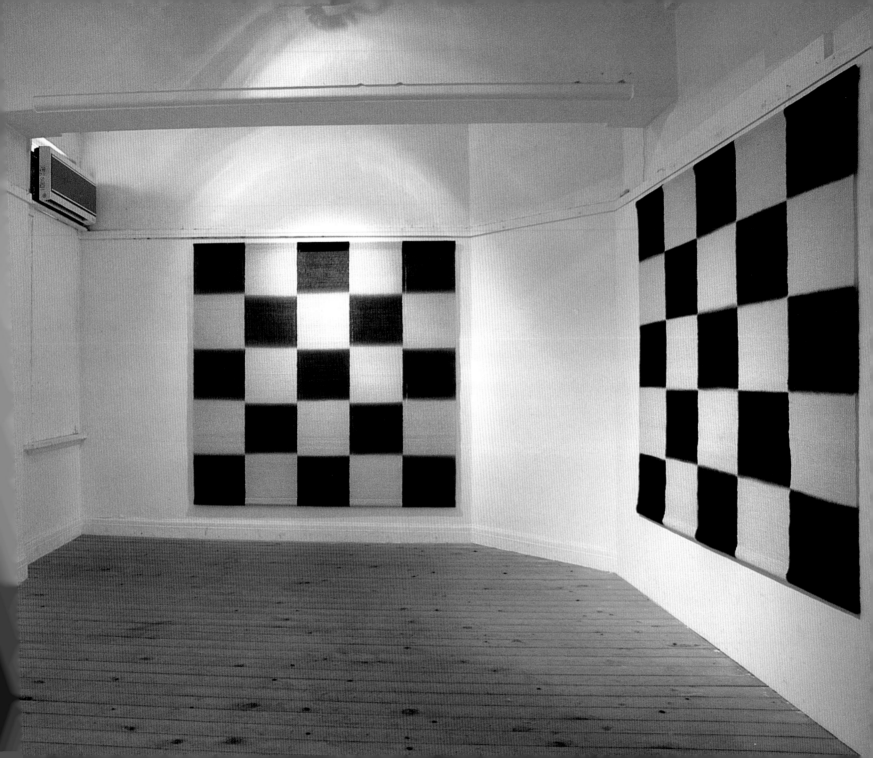

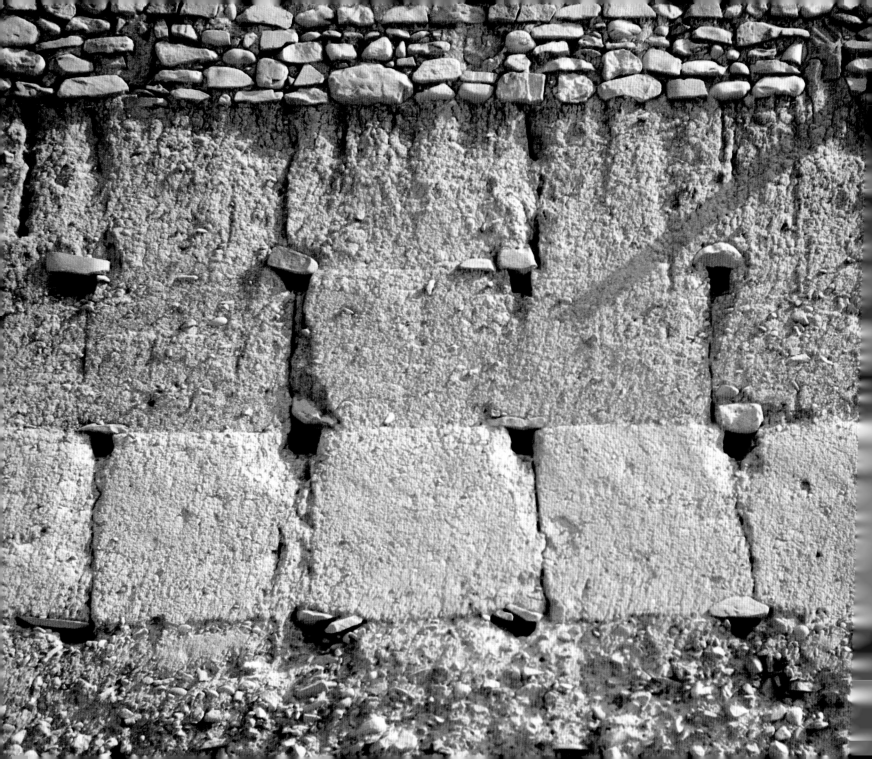

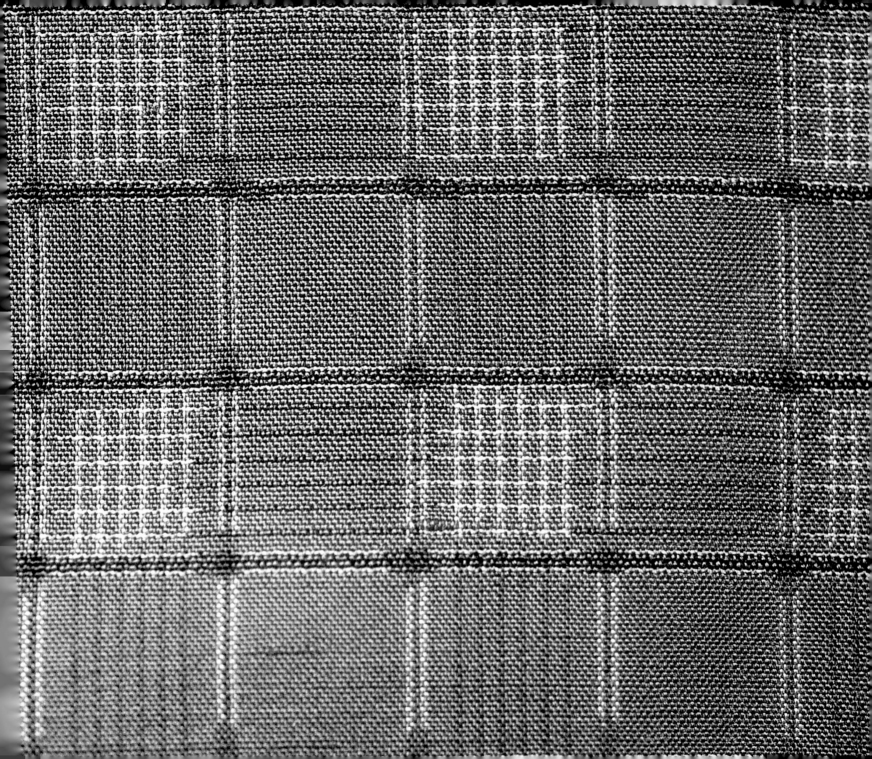

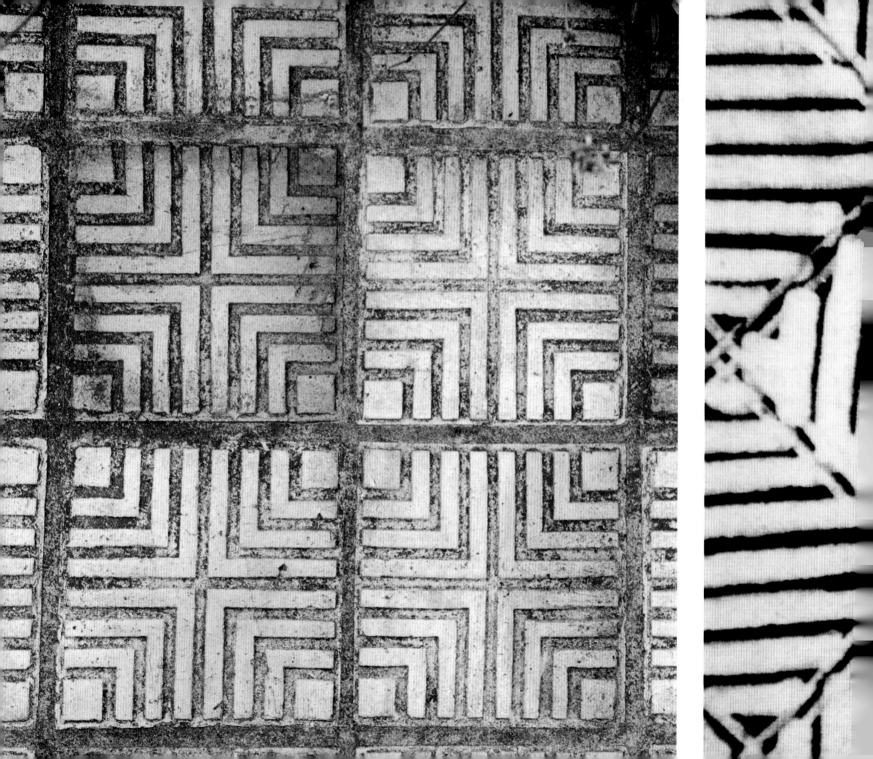

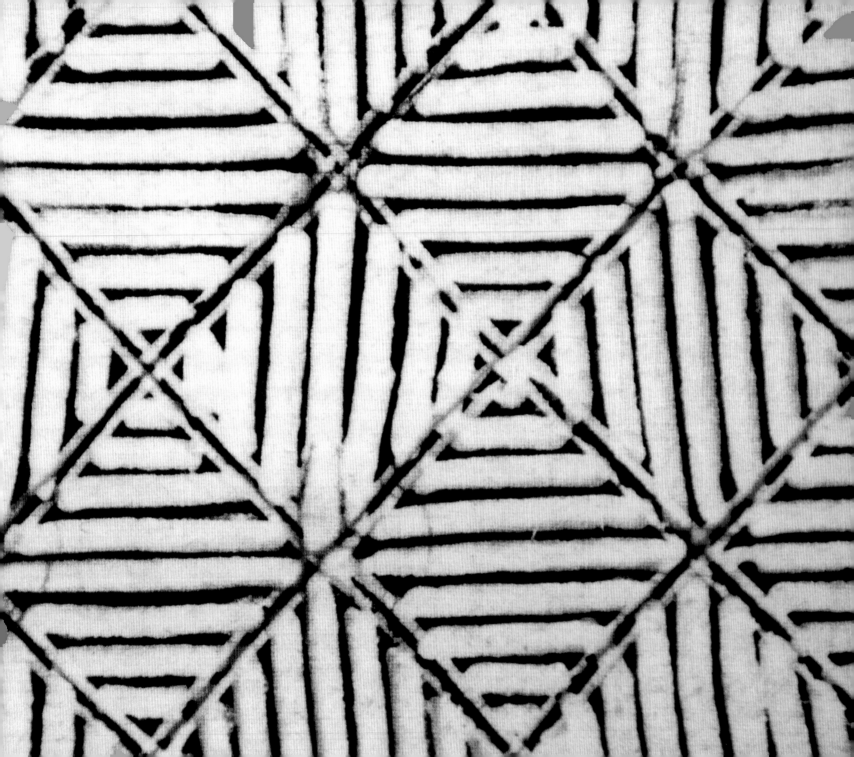

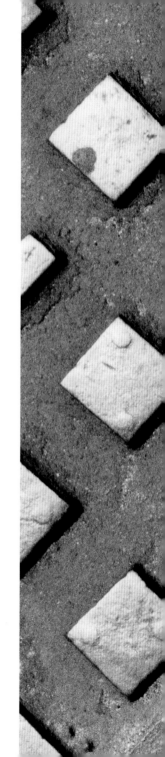

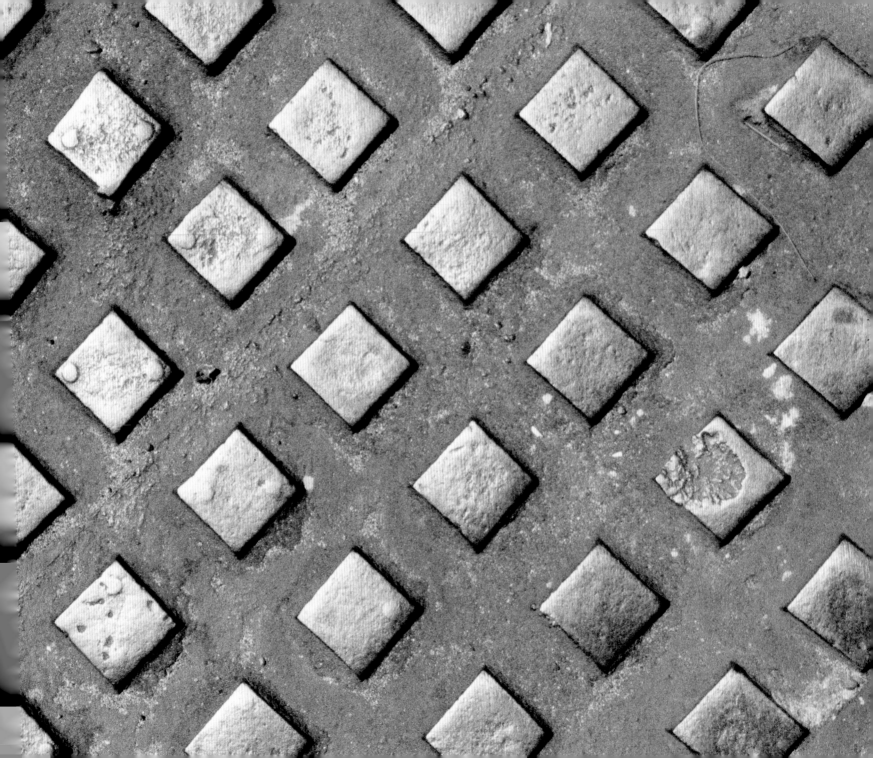

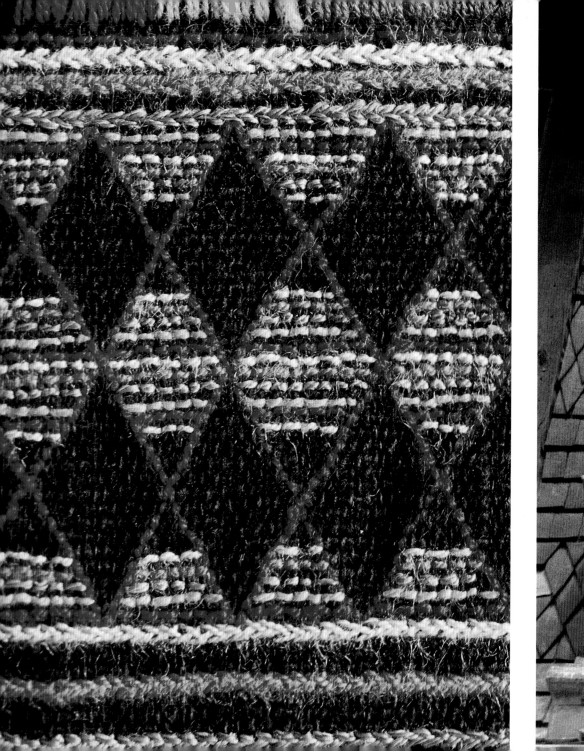
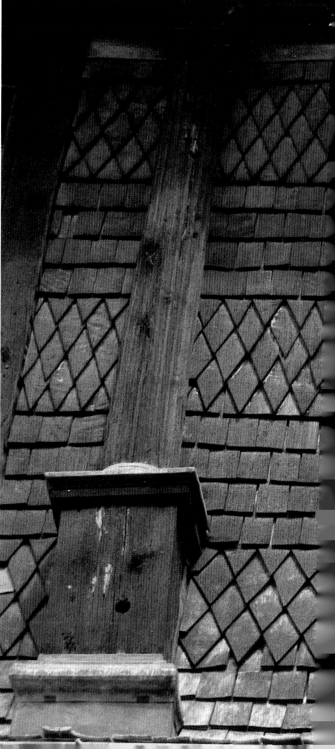

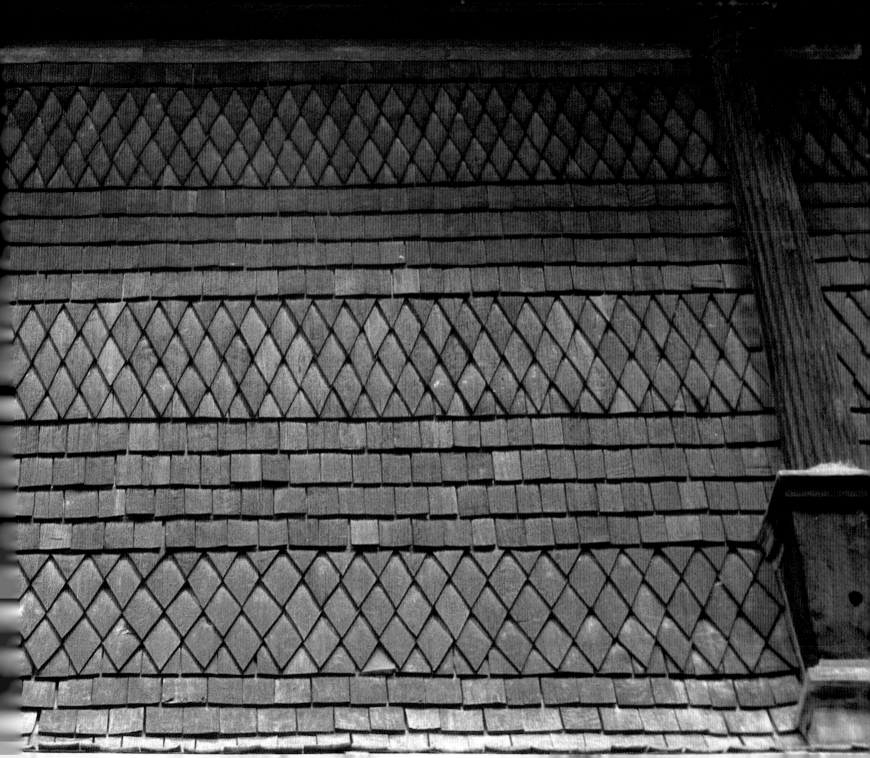

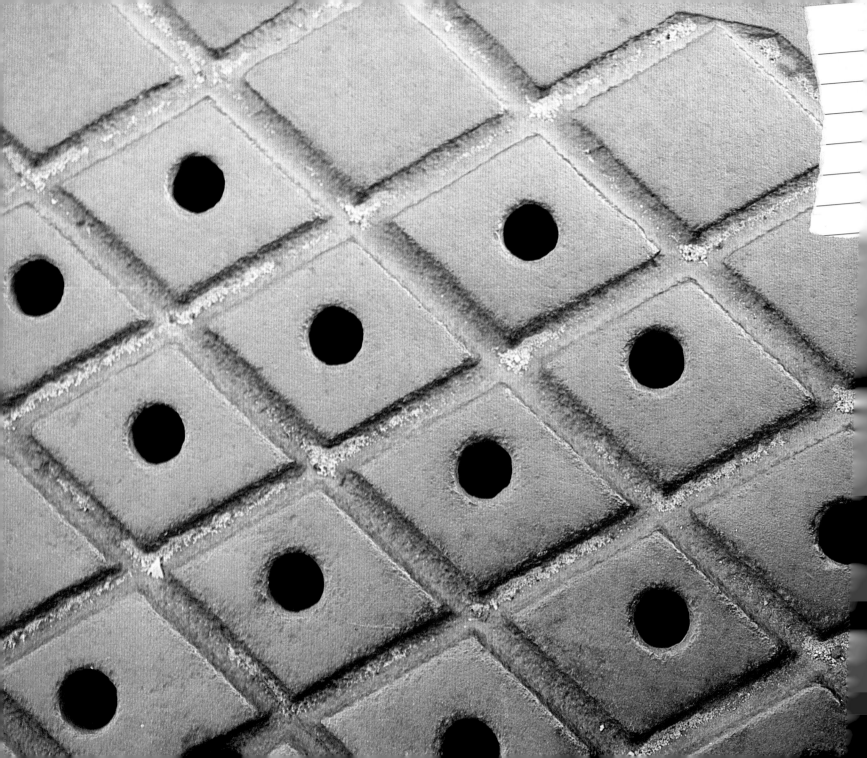

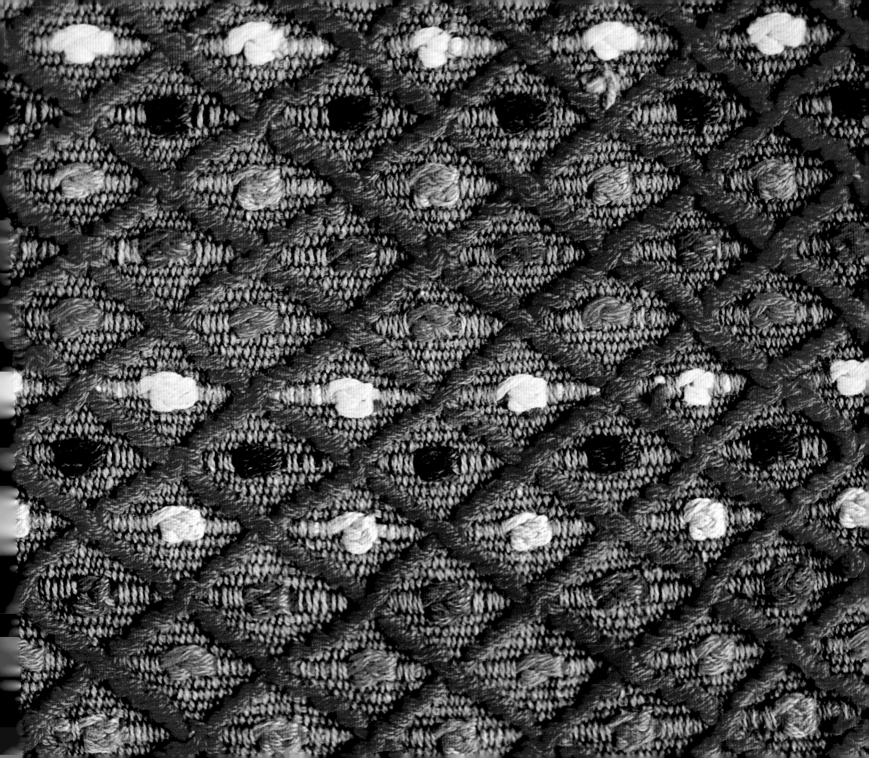

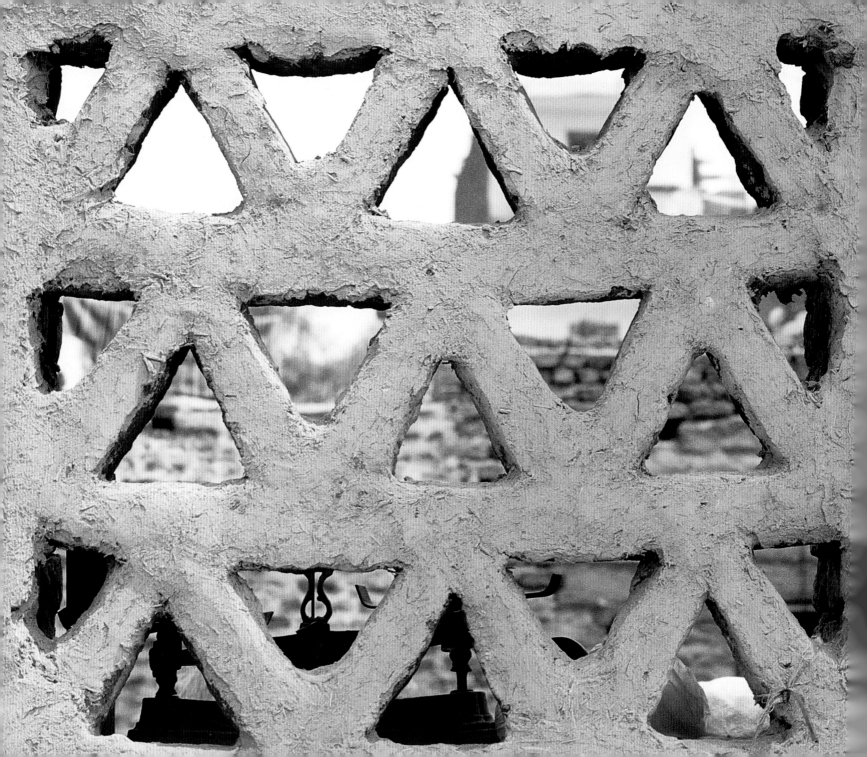

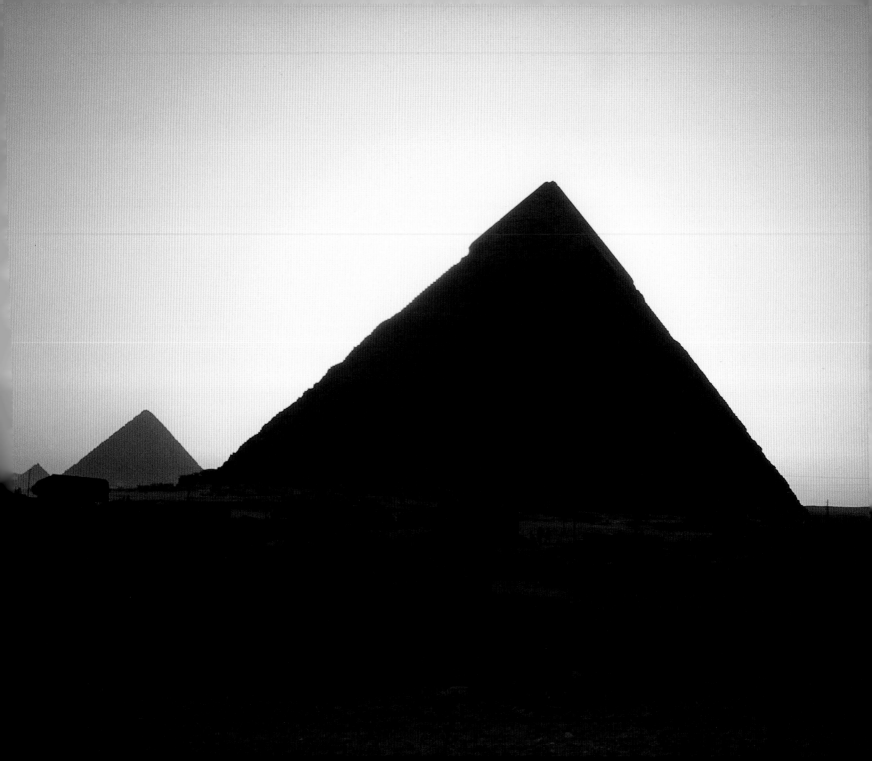

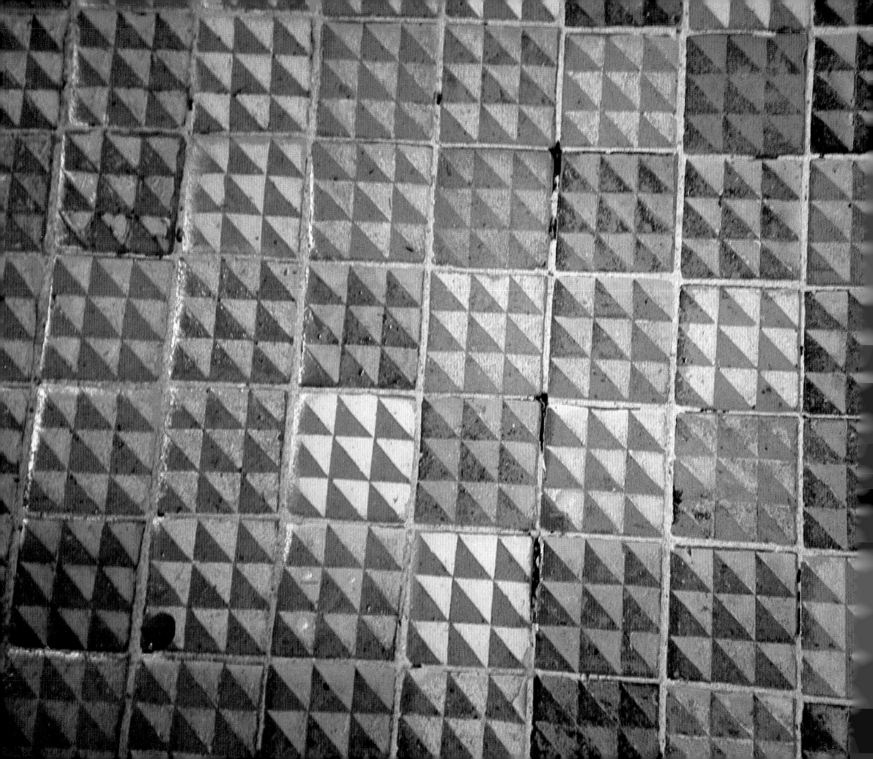

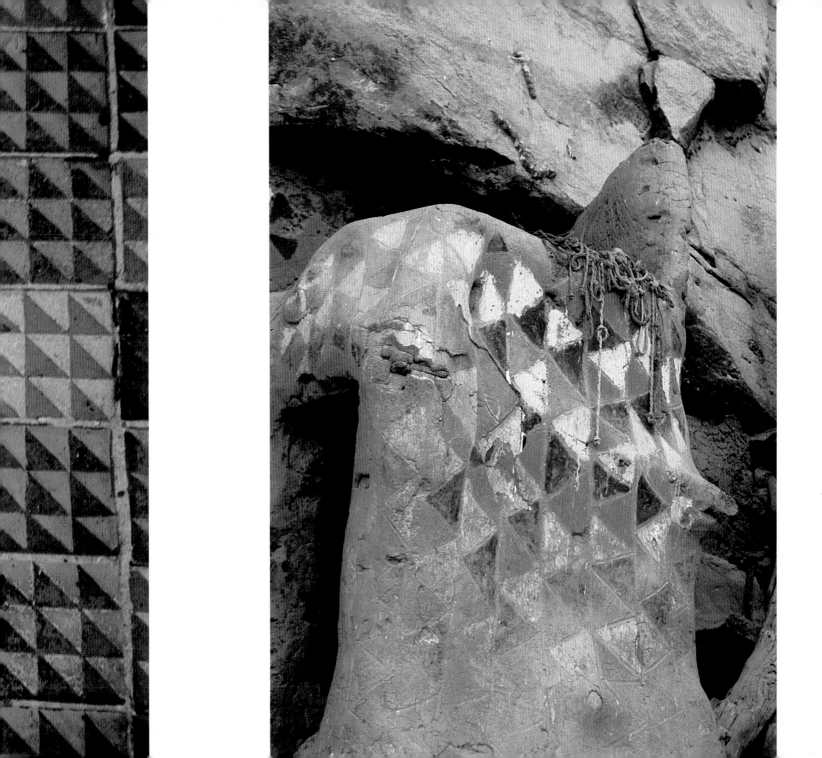

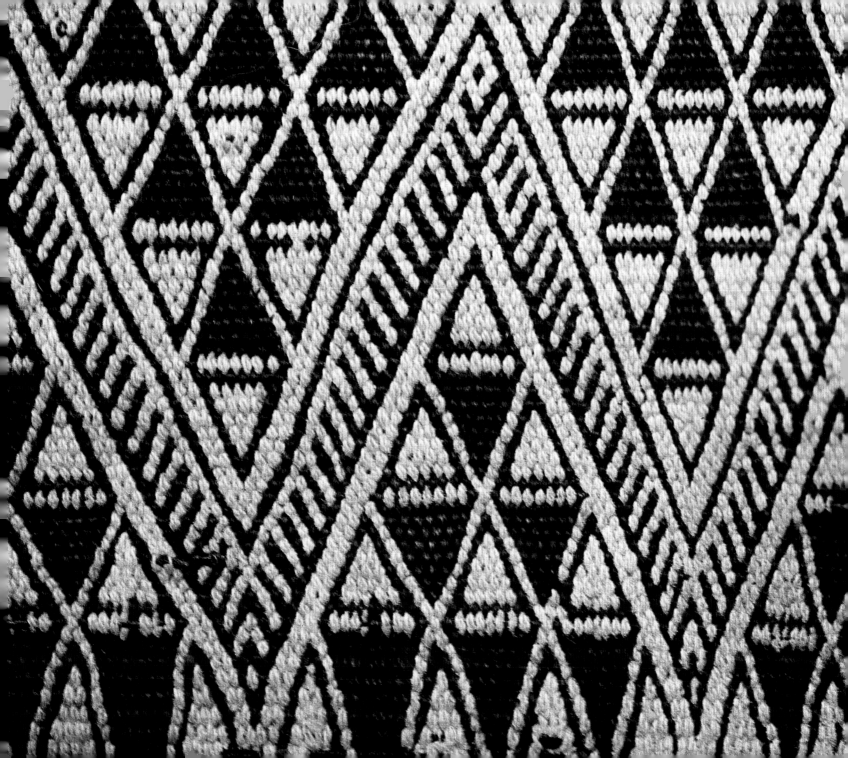

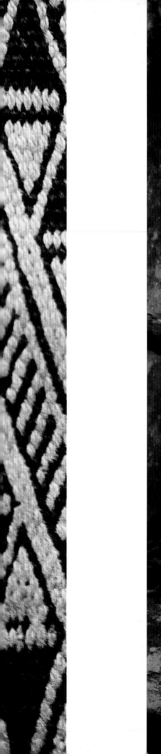

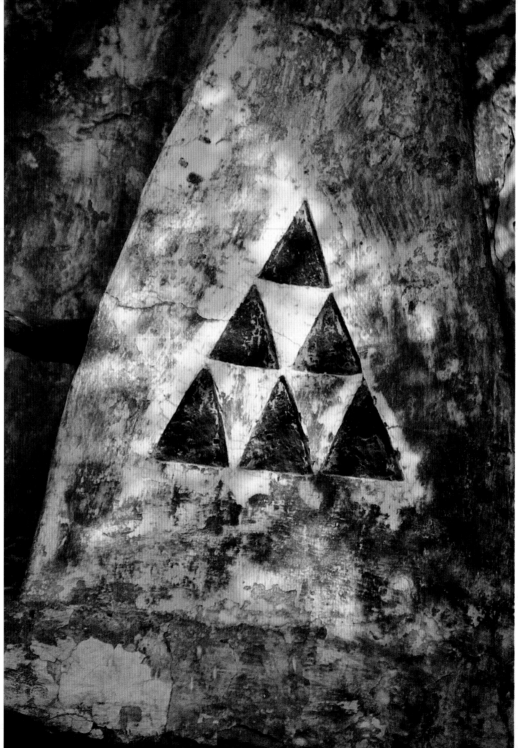

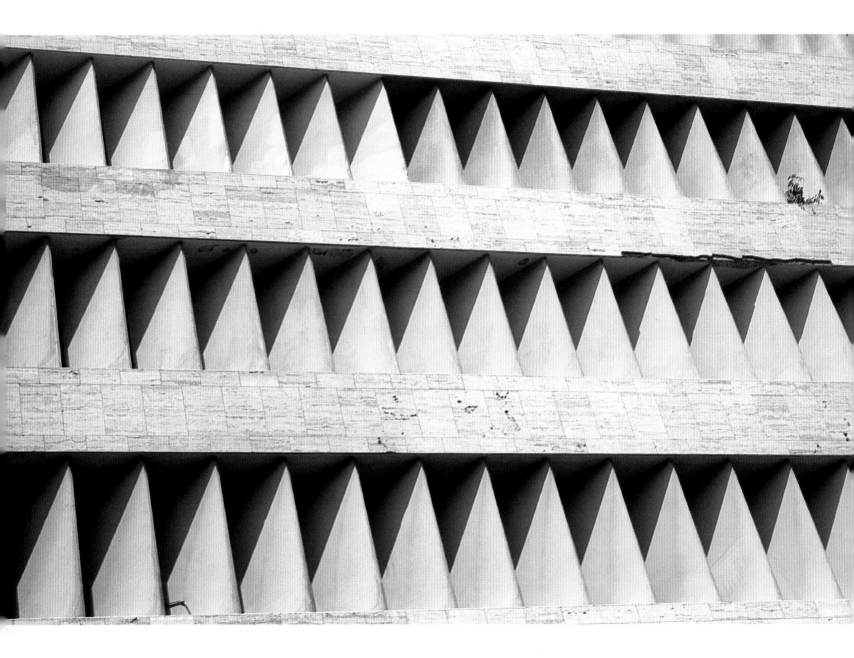

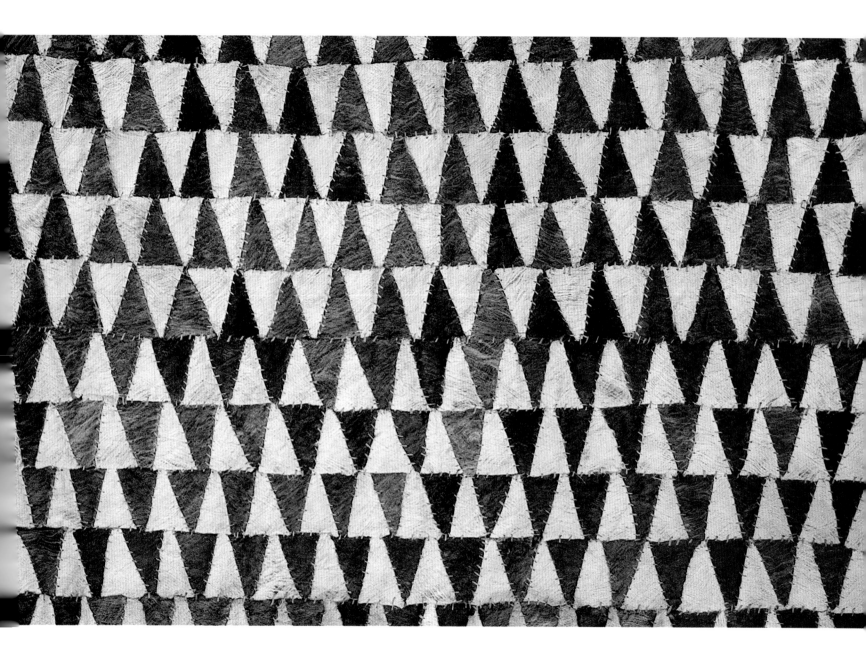

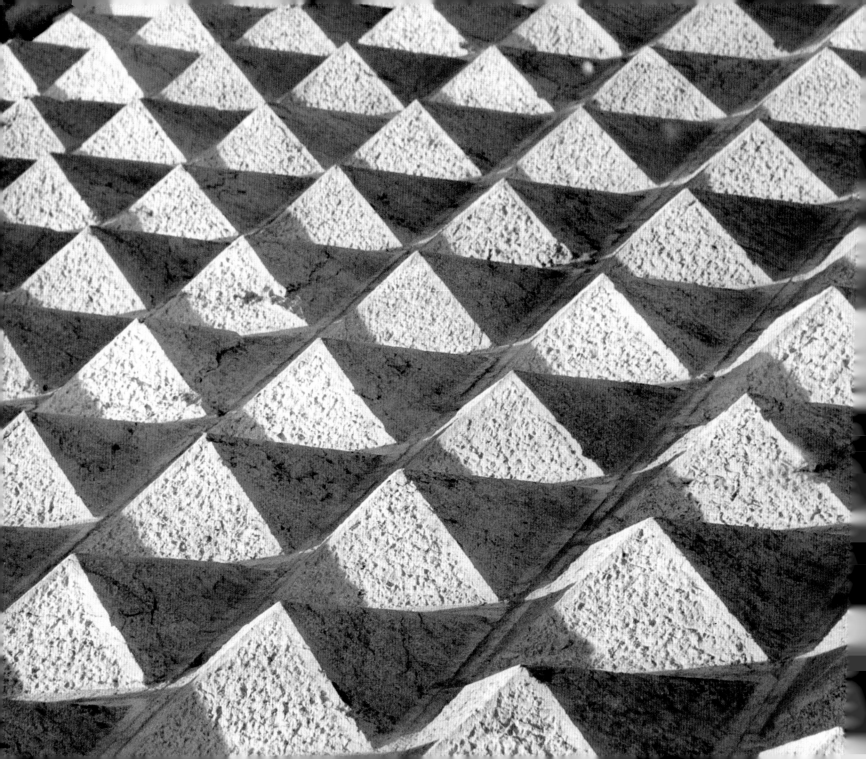

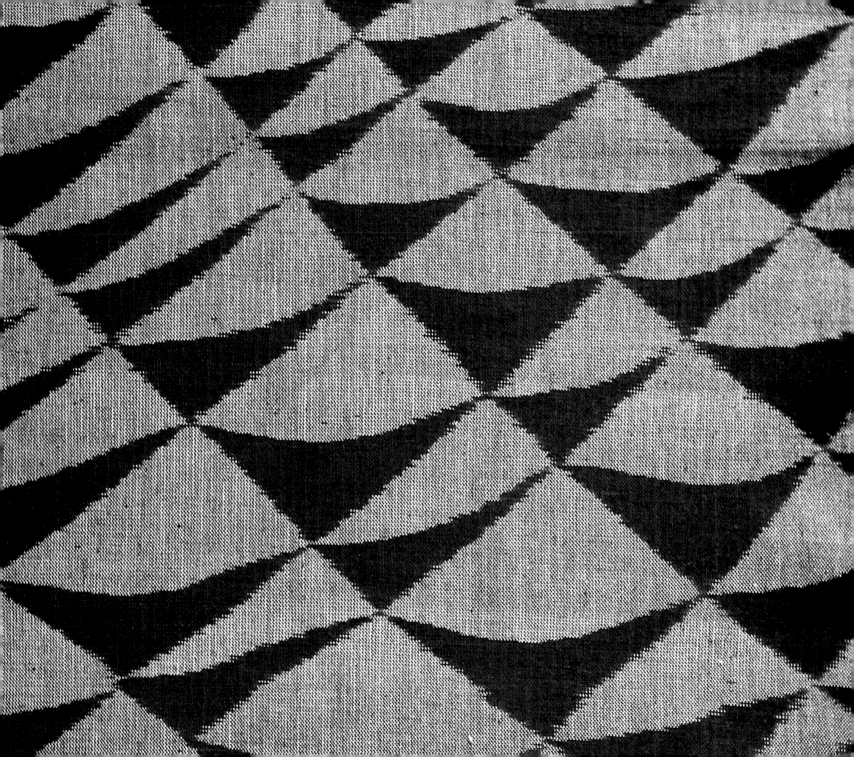

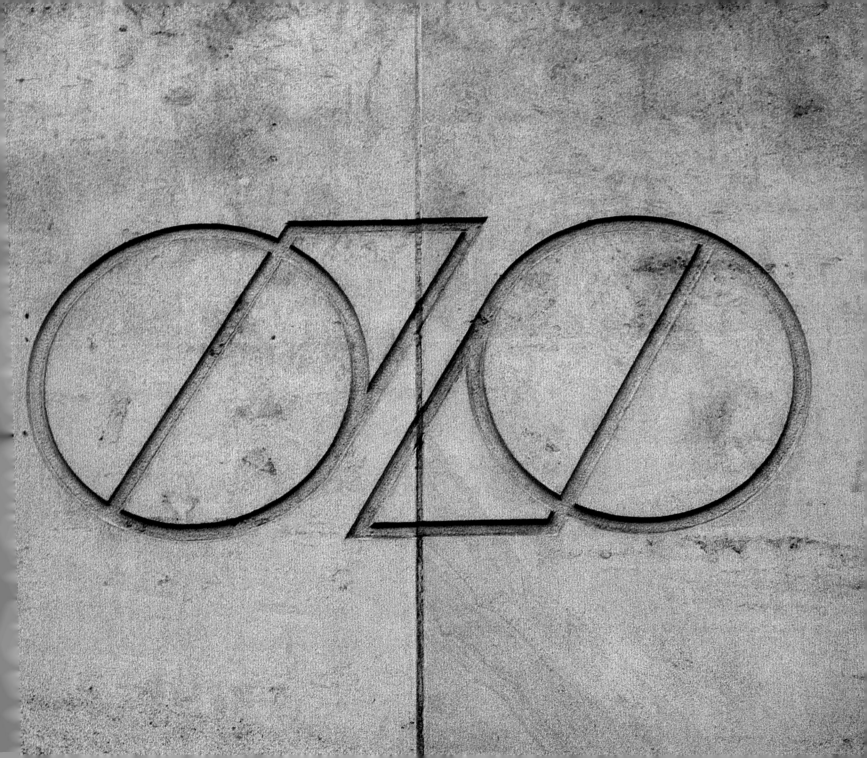

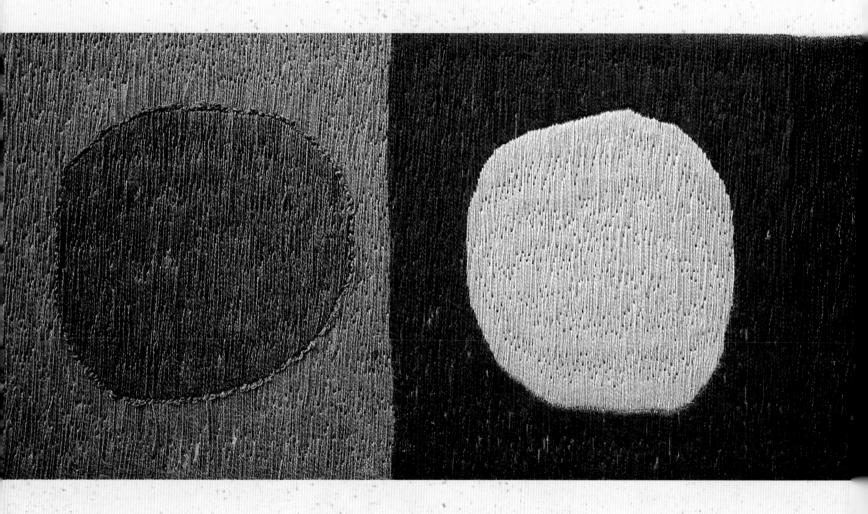

Circles

Among the geometric figures the circle holds an exceptional position. Seemingly without beginning or end, the circle expresses neither direction nor orientation. By its intrinsic form, the circle is associated with cyclical processes.

When the focus is its circumference, the circle is seen as a closed line forming a round plane or a hole, either filled or empty. If the circular line gets bolder, the circle is perceived as a ring. Depending on the observer's perspective, the circle may appear to be an oval. The centre may be marked by a dot, from which concentric lines turn the circle into a wheel. Concentric circles are easily confused with the spiral, the latter not being immediately recognized as a single, winding line.

The circle is the most all-embracing form of the universal design elements, because it may be regarded as a magnified dot, as a circular line - made of tiny dots strung together - or as a round plane.

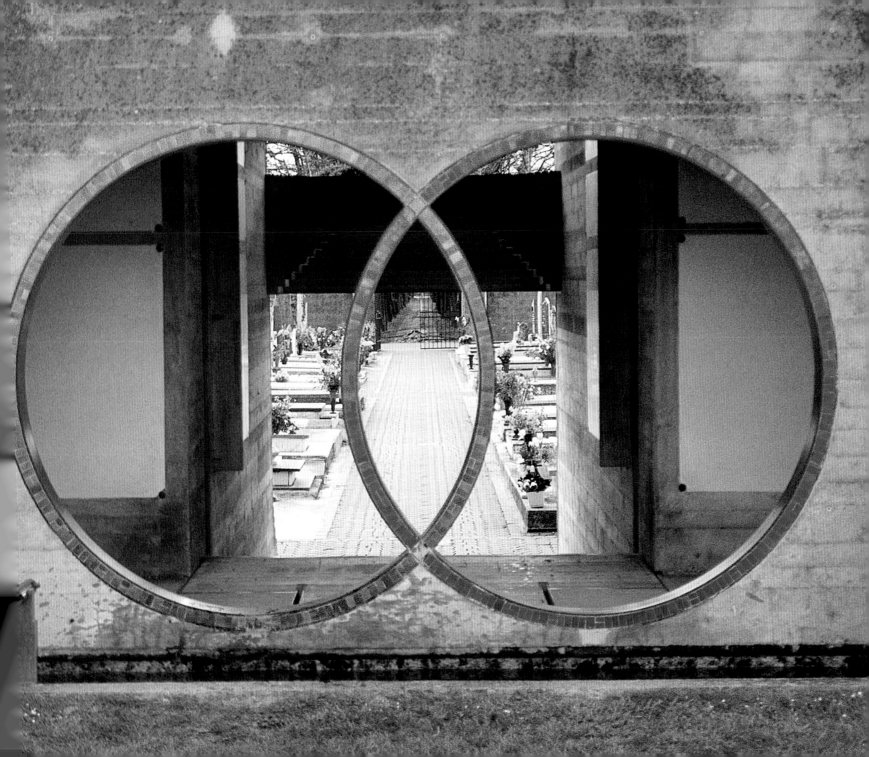

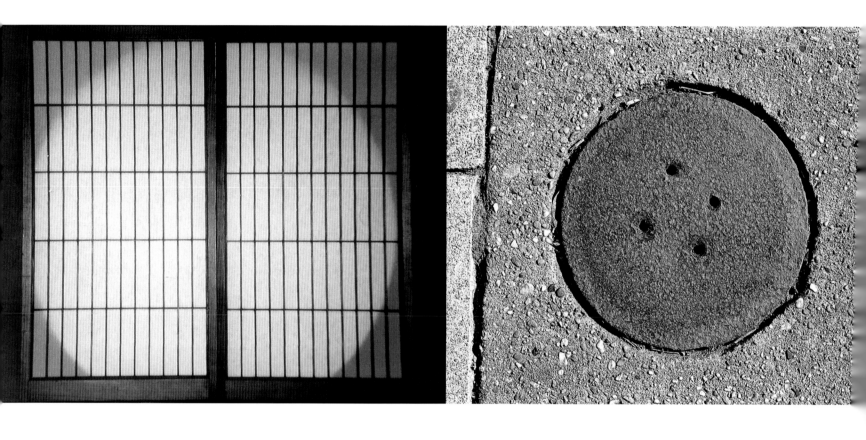

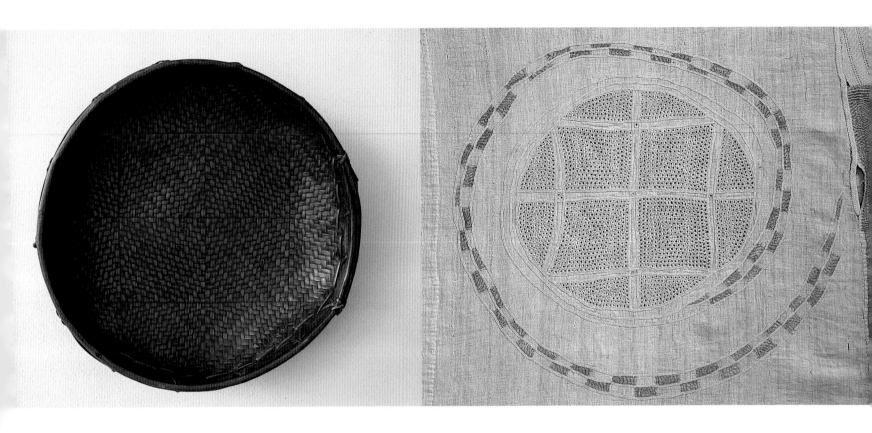

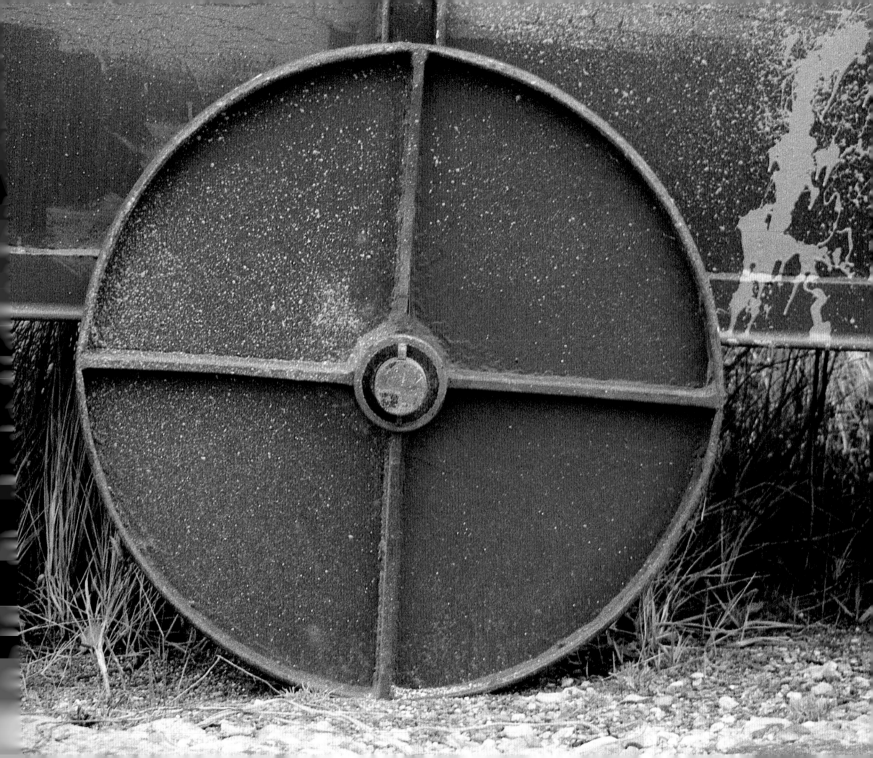

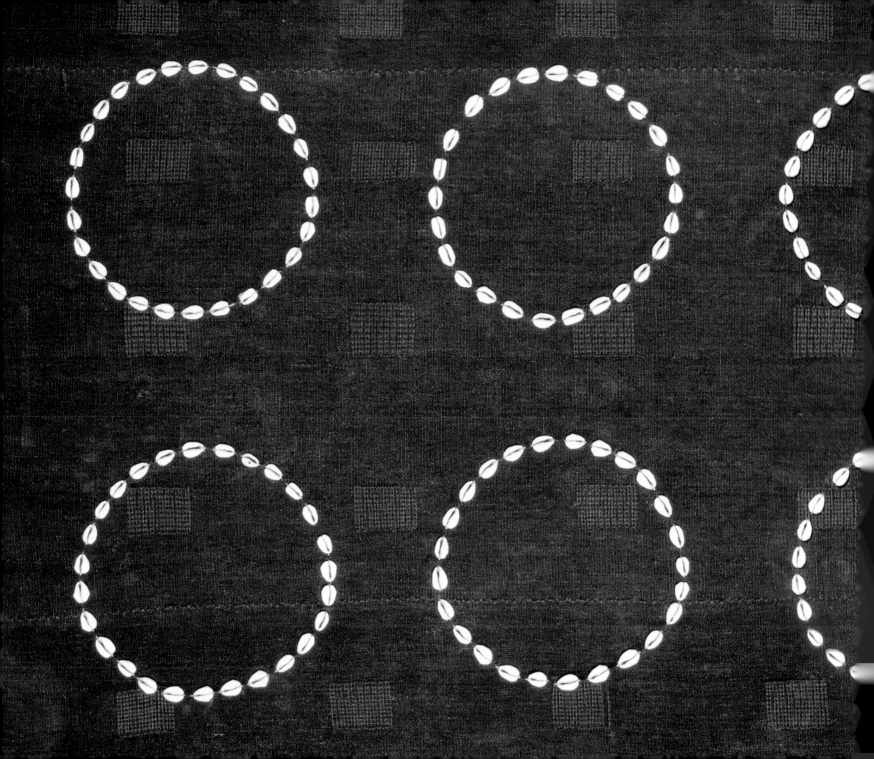

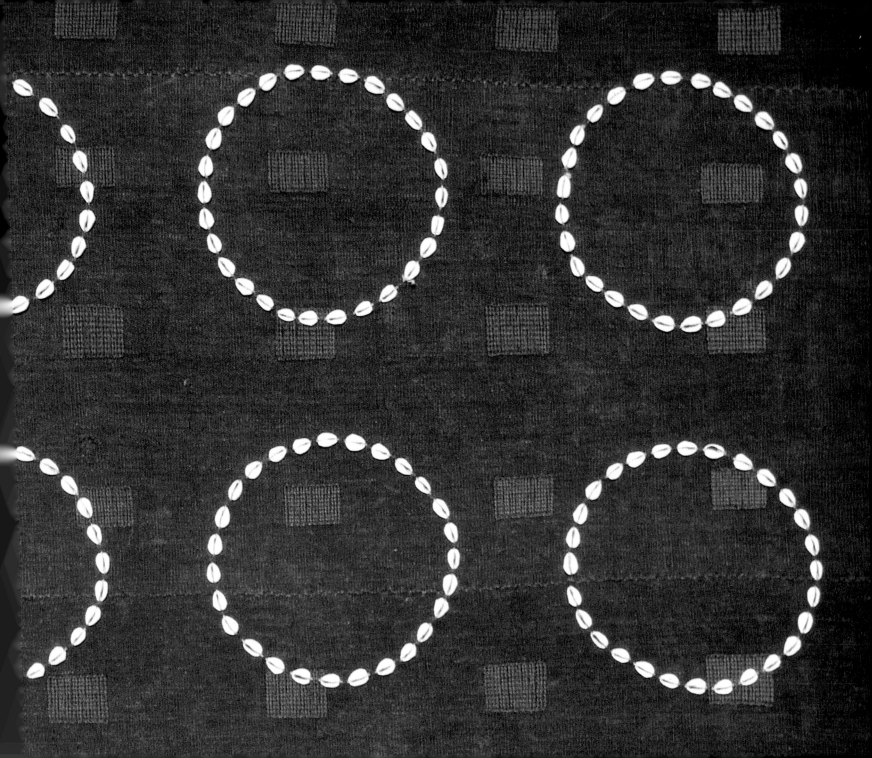

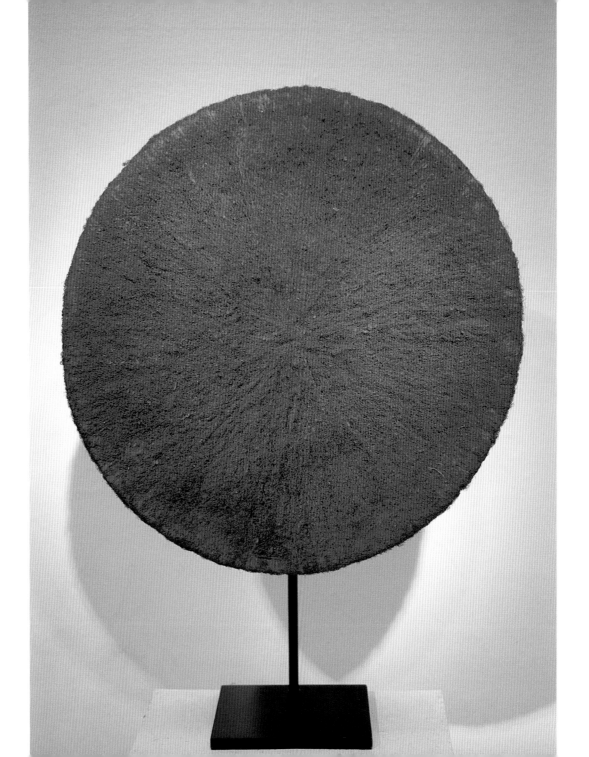

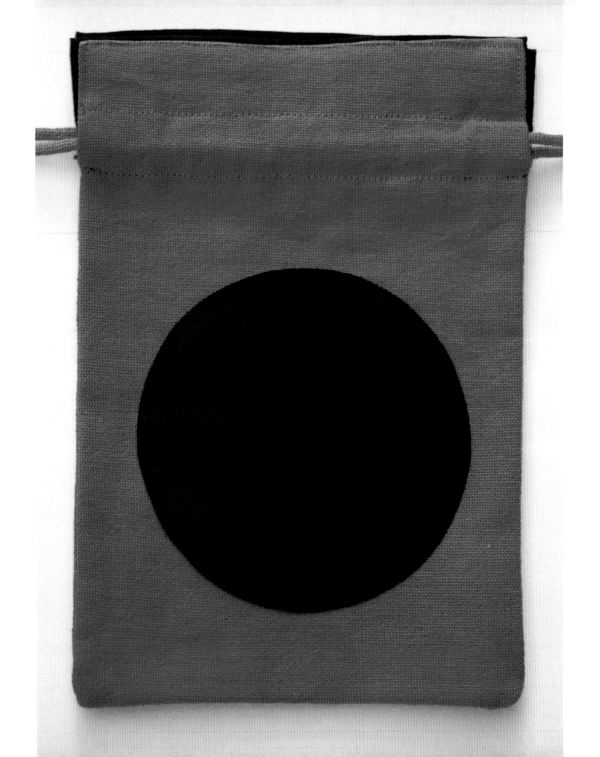

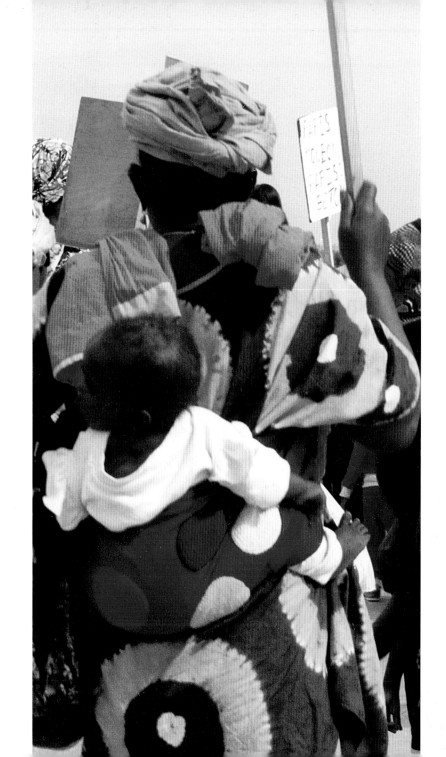

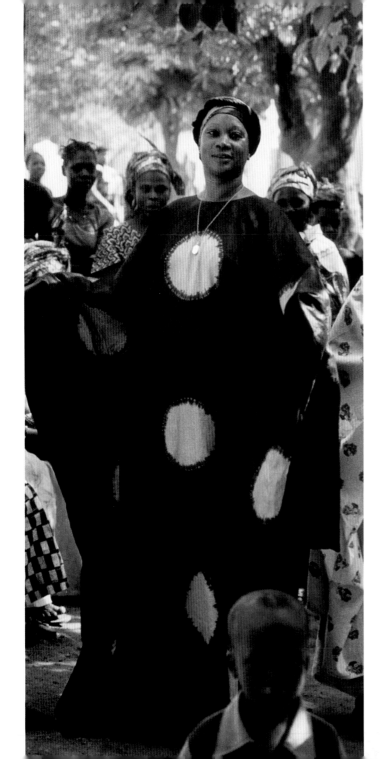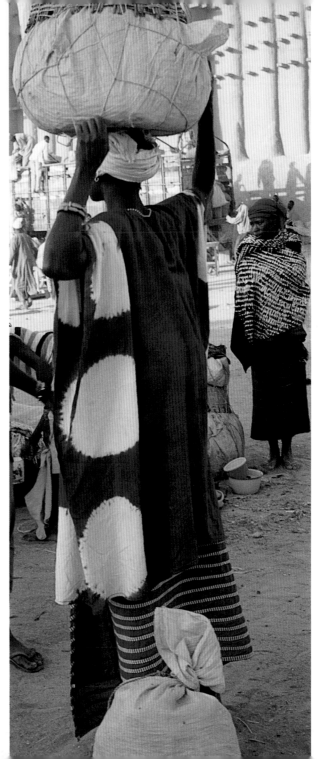

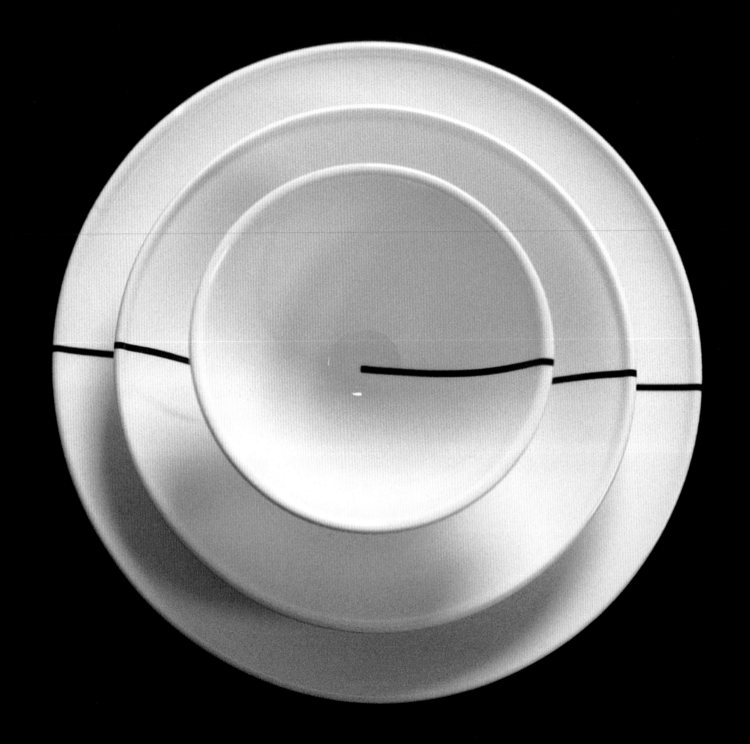

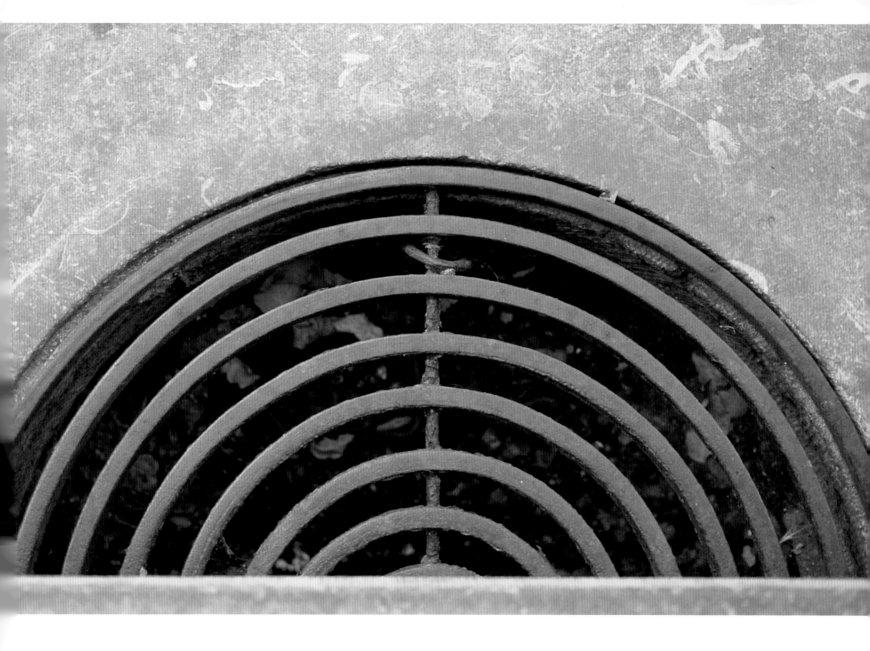

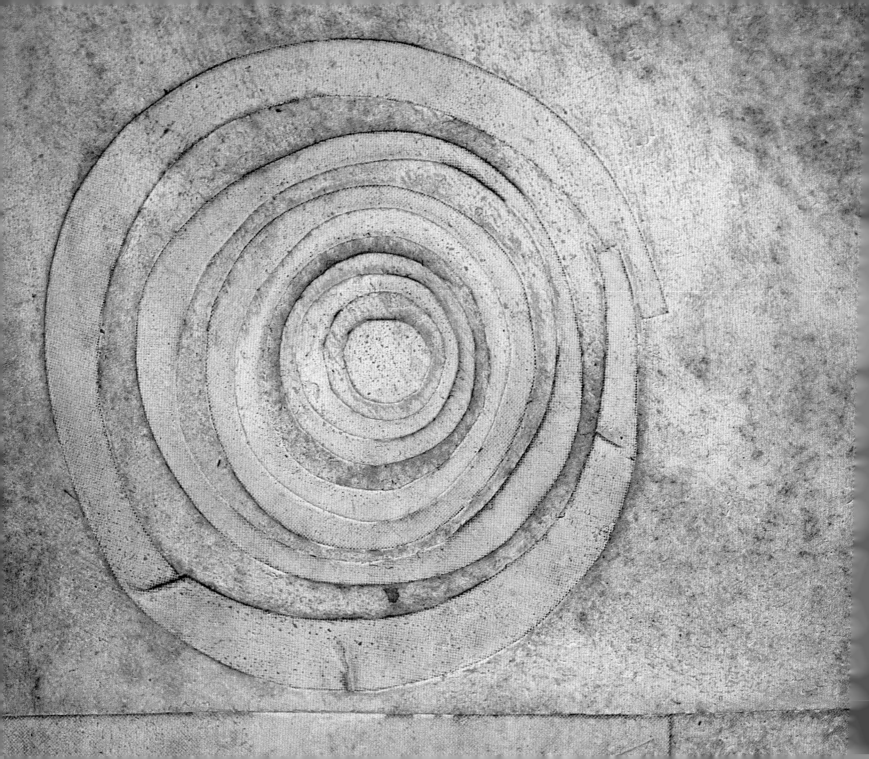

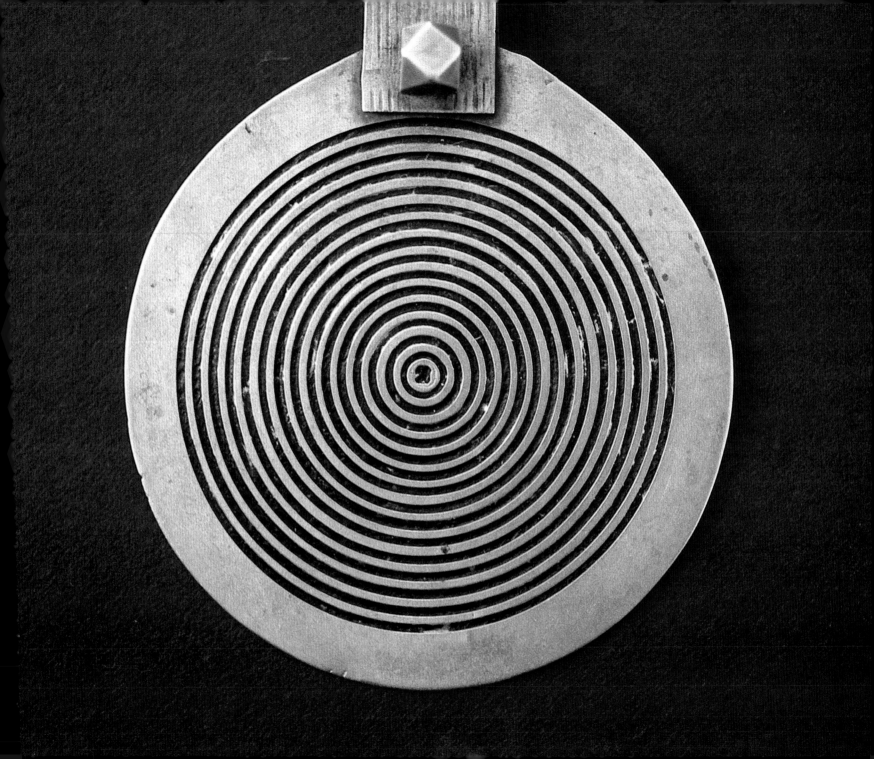

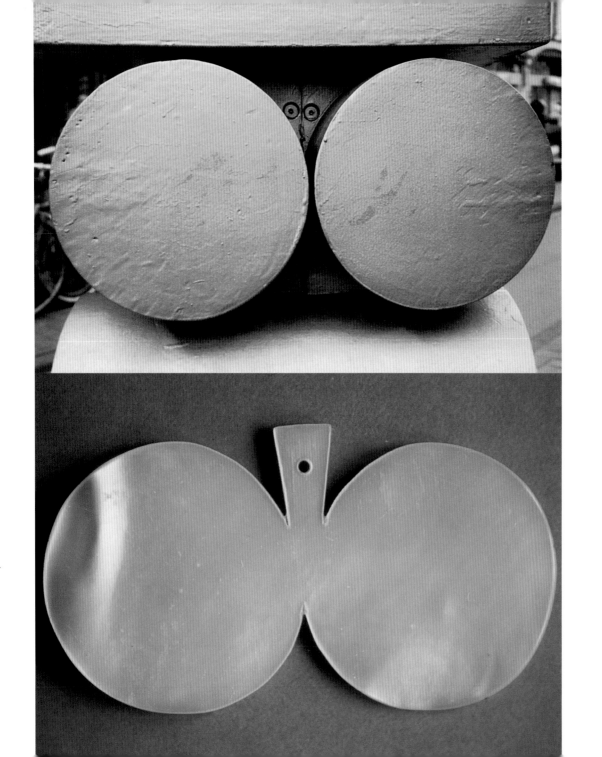

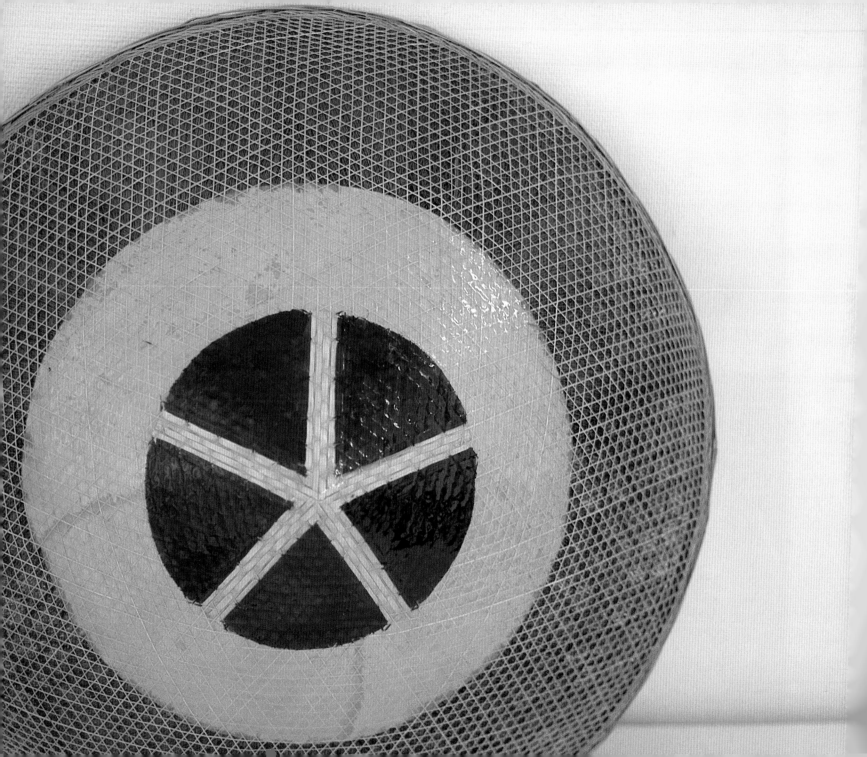

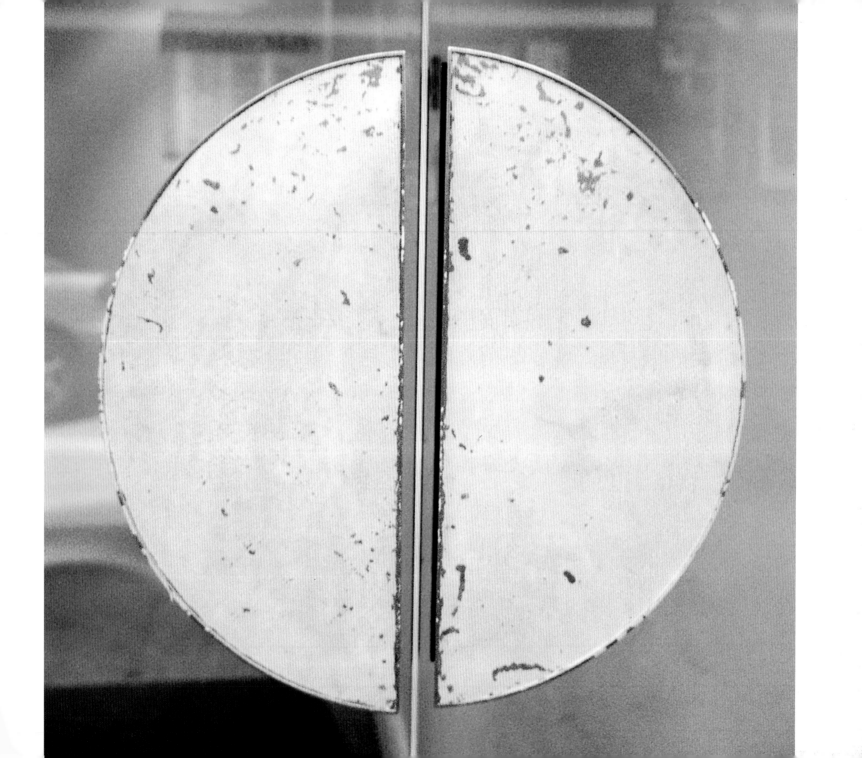

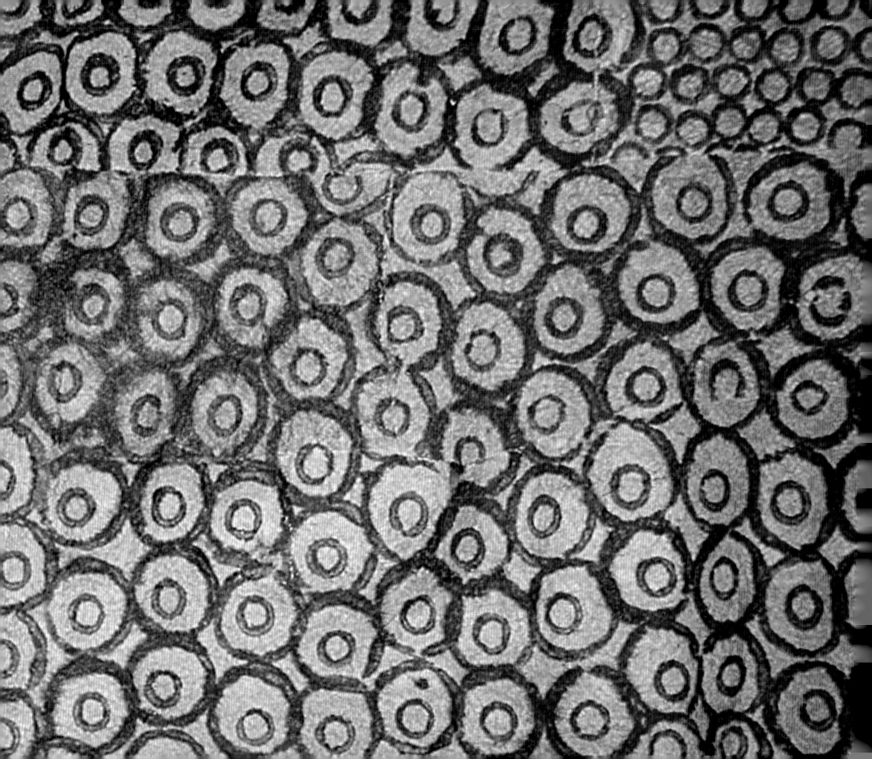

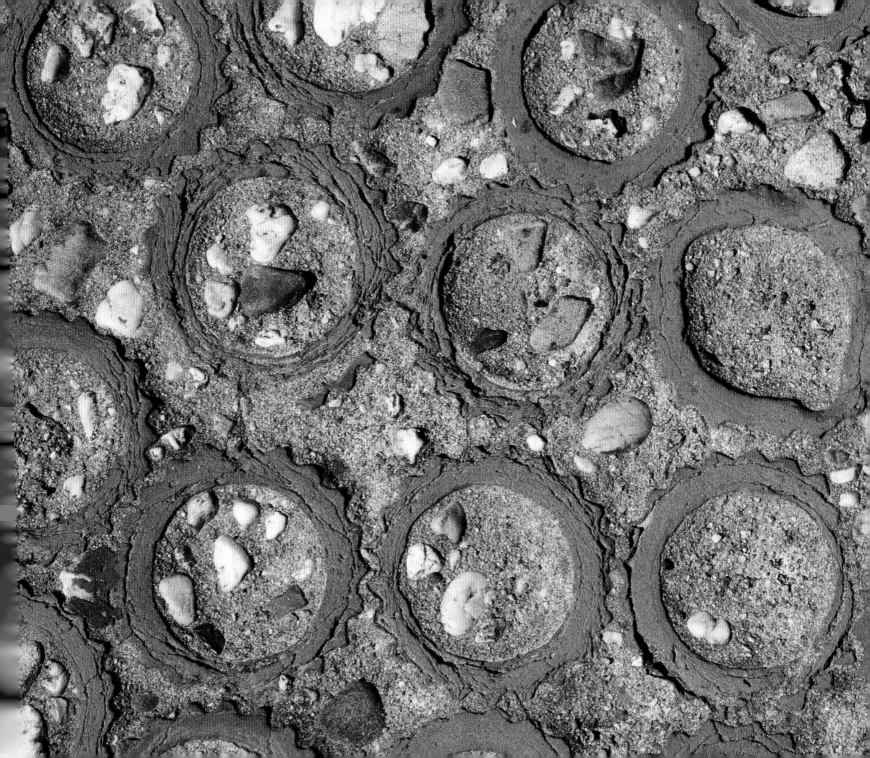

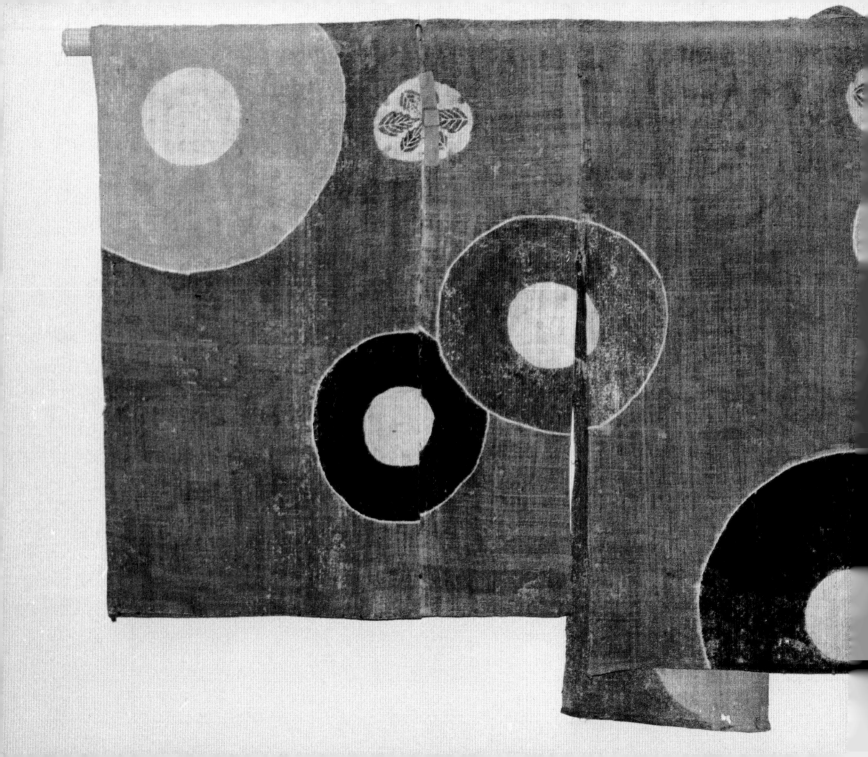

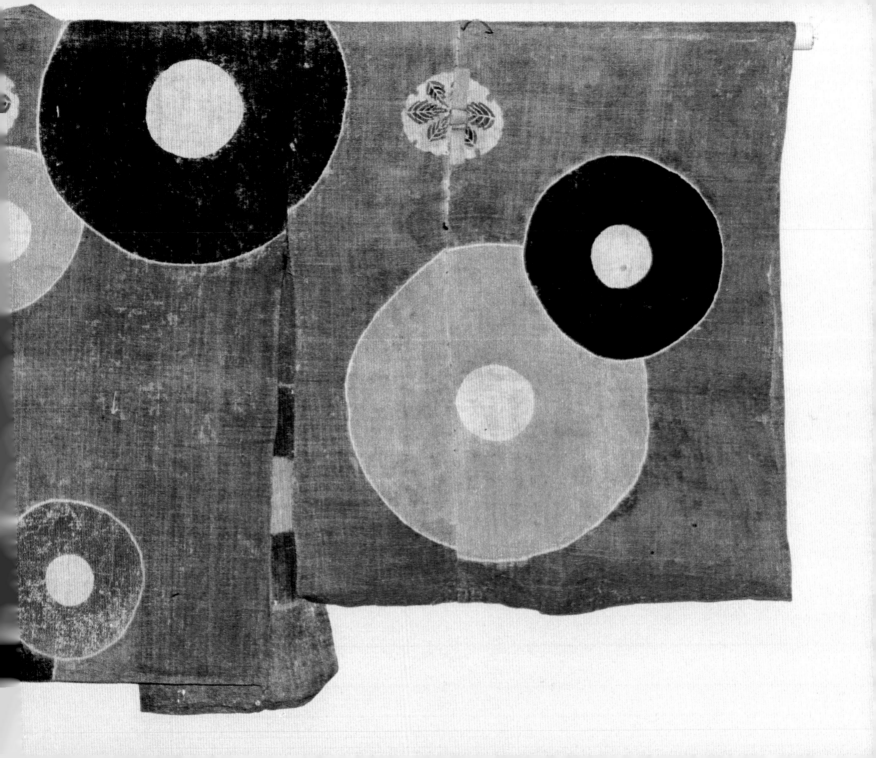

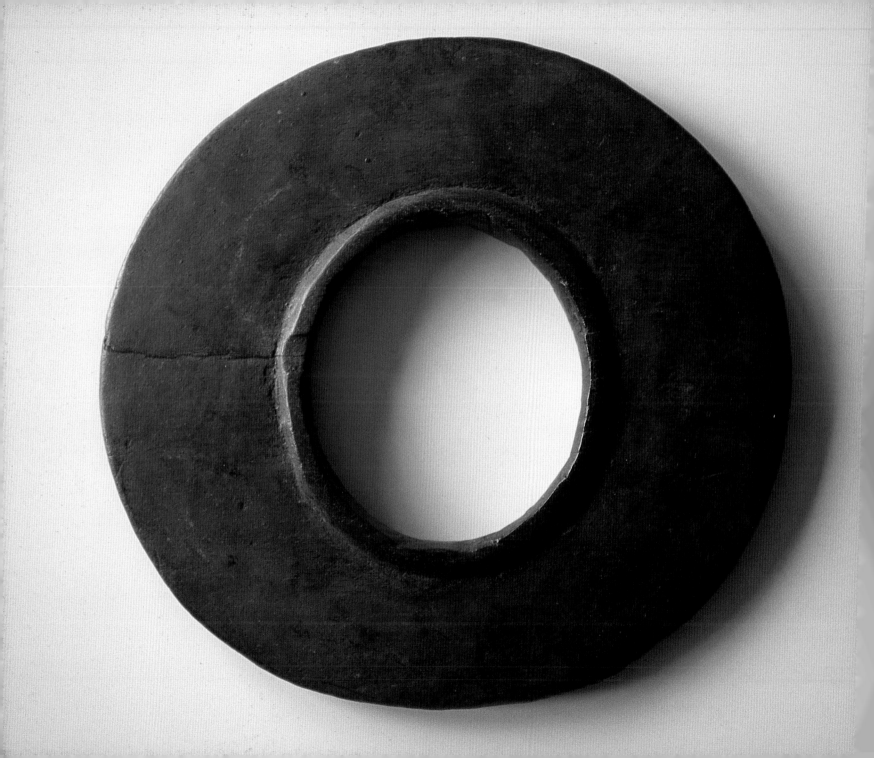

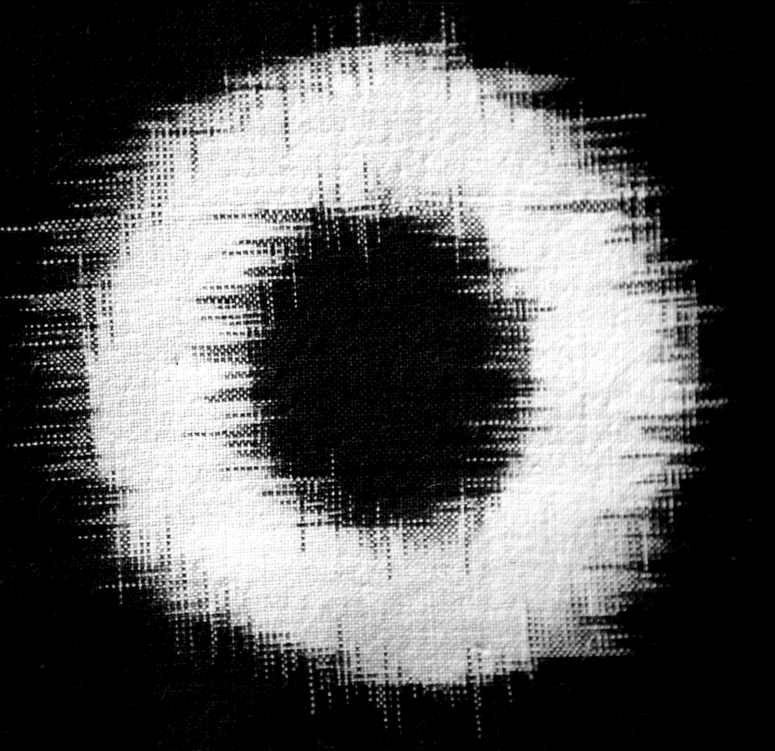

List of plates

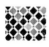

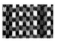

pp. 26-7
Wall with shadow pattern,
Marrakesh, Morocco

p. 27
Vegetal fibre, Boumalne,
Morocco

p. 28
Detail of concrete pillar, Cultural
and Sports Centre CESC Pompéia,
architect Lina Bo Bardi, 1977,
São Paulo, Brazil

p. 29
Sand beach, Paraty, Brazil

p. 30
River Schelde, Sint Amands,
Belgium

p. 31
Detail of fabric, *Wave*; melt-off,
warp of polyester micro-slit yarn
with aluminium; weft of polyester
filament; design Junichi Arai,
1994, Japan

pp. 32-3
Detail of diamond-shaped
fibre panel with nassa shells,
63cm high, New Guinea,
private collection

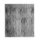
p. 33
Detail of cotton towel, Japan

pp. 34-5
Sand dunes, Merzouga,
Morocco

p. 35
Bamboo door, Koumi, Togo

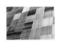
pp. 36-7
Detail of building front
with slats of sun blinds,
Rio de Janeiro, Brazil

p. 37
Detail of fabric, *Changing View*,
sewn pleats, sprayed and
painted with disperse dye,
Trevira CS, designed for garments
and buildings by Ella Koopman,
1998, The Netherlands

p. 38
Rocky landscape near Elmina,
Ghana

p. 39
Detail of tricot top, polyurethane
38%, rayon 30%, polyester 10%,
wool 14%, nylon 8%, France

p. 40
Detail of soil, Olmsted Point,
Yosemite National Park,
California, USA

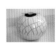
p. 41
Raku ceramic pot, design Rudie
Delanghe, 2000, Belgium

p. 42
Detail of cushion cover,
polyester

p. 43
Overgrown rocks, west coast
of Ireland

pp. 44-5
Detail of thatched roof, Africa
Museum, Berg en Dal,
The Netherlands

p. 45
Left: detail of dress made of rusty
nails and muslin, design Louise
Richardson, 1998, England

p. 45
Right: detail of model of preserved
hedgehog, Ecodrome, Zwolle,
The Netherlands

pp. 46-7
Spots of rust and paint on drain
cover, Antwerp, Belgium

p. 48
Left: detail of back of woollen
shawl with mirror embroidery,
India

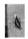
p. 48
Right: detail of metal door,
Moulay Idris, Morocco

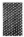
p. 49
Left: detail of cotton fabric
for Kabuki Theatre, Japan

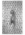
p. 49
Right: detail of cast iron door,
Coptic village, Egypt

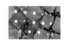
p. 50
Shadow of folding chair,
Antwerp, Belgium

p. 51
Detail of drain cover, Antwerp,
Belgium

pp. 52-3
Landscape between Ankara
and Amasya, Turkey

p. 54
Nails on wooden door,
Great Coxwell Barn, c. 1300,
The National Trust, Oxfordshire,
England

p. 55
Nails on wooden door,
Great Coxwell Barn, c. 1300,
The National Trust, Oxfordshire,
England

p. 56
Detail of buttock cover, *negbe*,
sycamore bark and fine grasses,
Mangbetu people, Congo

p. 57
Scrub stone, Erfoud, Morocco

pp. 58-9
Shell, *Conus eburneus* (Hwass 1792), Philippines

pp. 60-1
Detail of painted loincloth, beaten bark cloth, Pygmy people, Central Africa

p. 61
Girl with cotton wrapper embroidered with running stitch, Mopti, Mali

p. 62
Detail of woman's skirt, raffia pile embroidery, *ntshak*, Kuba people, Congo

p. 63
Shed door, Teli, Mali

p. 64
Detail of woollen card-woven belt, missing-hole technique, Turkey

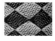
p. 65
Detail of plaited mat, *losa*, vegetal fibre, Mbole people, Congo

p. 66
Sunset in Farafra desert, Egypt

pp. 68-9
Chalk line on stone wall, Paris, France

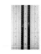
p. 69
Detail of Conference Centre, architect Tadao Ando, 1992-93 (Japan), Weil am Rhein, Germany

pp. 70-1
Mountain scene near Nigde, Turkey

p. 71
Detail of Coptic weave, 5th-6th century AD, cotton, Coptic Museum, Cairo, Egypt

p. 72
Detail of drain cover, Ghent, Belgium

p. 73
Detail of drain cover, Ghent, Belgium

p. 74
Detail of door, wood and paper Suwon, South Korea

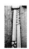
p. 75
Left: detail of garden architecture,
Toyama, Japan

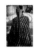
p. 75
Right: woman wearing indigo
tie-dyed cotton cloth, Djenné, Mali

pp. 76-7
Fences, Koumi, Togo

pp. 78-9
Tilt land near Meknes, Morocco

p. 79
Detail of iron structure with
reed, Zuiderpershuis, Antwerp,
Belgium

p. 80
Detail of batik *cap* (stamp),
red copper, Indonesia

p. 81
Reed structure, Rissani, Morocco

p. 82
Drain covers, Antwerp, Belgium

p. 83
Detail of blouse, *Willow Crêpe*,
dobby weave with double warps
and double wefts of overspun
silk 97%, cotton 1.5%, polyurethane
1.5%, design Reiko Sudo,
1993, for Nuno, Tokyo, Japan

pp. 84-5
Building in São Paulo, Brazil

p. 85
Right: brick nogging, 16th century,
Troyes, France

pp. 86-7
Detail of woollen blanket, Berber
people, Morocco

p. 88
Design drawing for carpet *Friwill*,
design A.W.G. bOb Van Reeth
ARCHITECTS, 1986, Belgium

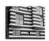
p. 89
Detail of House Van Roosmaelen,
A.W.G. bOb Van Reeth ARCHITECTS,
1985-88, Antwerp, Belgium

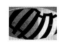
p. 90
Detail of Jantar Mantar
Astronomical Observatorium,
18th century, Jai Singh,
Jaipur, India

p. 91
Piece of laminated industrial
foam, *Moving stripes*, design
Maria Blaisse, 1997 (part of
Kuma Guna project), The
Netherlands

pp. 92-3
View of Copan office building,
architect Oscar Niemeyer,
1950, São Paulo, Brazil

p. 94
Outdoor mat of rubber and steel,
London, England

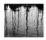
p. 95
Water reflection of yacht masts,
Cala d'Or, Majorca, Spain

pp. 96-7
Detail of iron bridge railing,
Rotterdam, The Netherlands

pp. 98-9
Detail of ceramic plate, Japan

p. 99
Paving stone with mosaic
decoration, Amsterdam,
The Netherlands

pp. 100-1
Detail of foot of Reclining
Buddha, Bangkok, Thailand

p. 101
Detail of painted wooden shield
with bamboo binding, New Britain,
Bismarck Archipelago,
private collection

p. 102
Preliminary study for
supplementary weft weave,
design Ria Vercammen,
1998, Belgium

pp. 102-3
Graffiti wall, Paris, France

p. 103
Detail of printed jeans fabric,
cotton twill weave

pp. 104-5
Stack of wooden crates at
the market, Zagora, Morocco

p. 107
Traffic signs, Calonge,
Majorca, Spain

pp. 108-9
Building material in depository
of the National Trust, Coleshill,
Oxfordshire, England

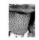
p. 109
Detail of plaited reed bag,
Zagora, Morocco

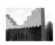
pp. 110-11
Detail of wall, Todra, Morocco

p. 112
Detail of printed cotton fabric,
India

pp. 112-13
Concrete supporting construction
of Museum of Modern Art, architect
Affonso Eduardo Reidy, 1953,
Rio de Janeiro, Brazil

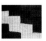

p. 114
Detail of pre-Colombian interlocking plain weave, camelid fibre, Proto Nasca, 3rd century BC, collection Gallery Daroun, Antwerp, Belgium

p. 115
Staircase at Fundació Pilar i Joan Miró a Mallorca complex, architect Rafael Moneo, 1998, Palma, Majorca, Spain

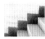

p. 116
Detail of warrior's shield, carved wood, Mappi-Digul area, New Guinea, c. 1950, collection Tropenmuseum inv. no. 5805-11, Amsterdam, The Netherlands

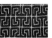

pp. 116-17
Detail of woman's blouse, *mola*, cotton appliqué, Cuna Indians, San Blas, Panama, collection Tropenmuseum inv. no. 3232-90, Amsterdam, The Netherlands

p. 118
Detail of Palestinian woman's dress, cross stitch and herringbone stitch embroidery, silk thread

p. 120
Detail of wall of Coptic church, Achmim, Egypt

p. 121
Detail of double ikat fabric, *kasuri*, hemp, Okinawa, Japan

p. 122
Detail of brick wall in Coptic graveyard near Cairo, Egypt

p. 123
Mooring posts, Antwerp, Belgium

pp. 124-5
Detail of painted umbrella, cotton, design John Tytgat, 1999, Belgium

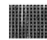

p. 126
Detail of wooden grid, Cultural and Sports Centre CESC Pompéia, architect Lina Bo Bardi, 1977, São Paulo, Brazil

p. 127
Detail of metal sculpture, *Galliart's weave*, design Tom De Hoog, 1998, USA

pp. 128-9
Wall with shadow pattern, Fès, Morocco

p. 129
Front of postal sorting centre, architect Van Hoecke-Cools, 1988-93, Antwerp, Belgium

pp. 130-1
Construction site, Berchem Station, Antwerp, Belgium

pp. 132–3
Tie-dyed cotton fabric, *laharia*,
Rajasthan, India

p. 133
Detail of tin plate door, Todra,
Morocco

p. 134
Wooden door, Asilah,
Morocco

p. 136
Brick wall of Maison de l'Outil
et de la Pensée ouvrière
(formerly Hôtel de Mauroy),
1550, Troyes, France

p. 137
Detail of woollen kilim, early 20th
century, Afyon, Central Turkey

p. 138
Stone wall, Thebes, Egypt

p. 139
Detail of wrapping cloth, *pojagi*,
patchwork, hemp, South Korea

pp. 140–1
Overgrown stepping stones,
Sint Amands, Belgium

p. 142
Detail of patchwork border of
woman's skirt, *ntshak*, cotton
and raffia, Kuba people, Congo

p. 143
Tiled floor in children's clothing
shop, Antwerp, Belgium

p. 144
Tiled floor of porch in temple,
Bangkok, Thailand

pp. 144–5
Indigo Square Series, warp
cotton, weft hemp, dip-dyed
in indigo, own technique,
Hiroyuki Shindo, 1985,
Gallery Gallery, Kyoto, Japan

p. 146
Detail of stone wall, Zagora,
Morocco

p. 147
Detail of kimono, double ikat,
kasuri, silk, Japan

p. 148
Tiles with interlocking motif
in front garden, Antwerp,
Belgium

pp. 148–9
Detail of batik, cotton, Java,
collection Tropenmuseum
inv. no. 2160–52, Amsterdam,
The Netherlands

pp. 150–1
Detail of drain cover, London,
England

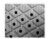

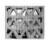

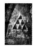
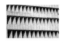

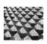
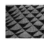
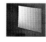

p. 168
Hand embroidery, silk, designed and made by Cecile De Kegel, 1964, Belgium

p. 171
Portico in cemetery of the Brion family, San Vito d'Altivole, architect Carlo Scarpa, 1969-78, Treviso, Italy

p. 172
Left: window in traditional Japanese architectural style, Toyama, Japan

p. 172
Right: drain cover, Ghent, Belgium

p. 173
Left: Ifugao basketry, Philippines

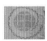
p. 173
Right: detail of embroidered Hausa mantle, Nigeria

pp. 174-5
Iron cart wheel, Antwerp, Belgium

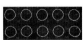
p. 176-7
Detail of man's body cloth, indigo-dyed cotton with circles made of cowrie shells and rectangles made of supplementary weft yarns of red-dyed dog's hair, Naga people, India

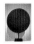
p. 178
Woman's hat, *isicholo*, human hair, red ochre, Zulu people, South Africa, private collection

p. 179
Cotton bag, appliqué, China

p. 180
Woman in tie-dyed cotton dress with child in baby carrier, Paris, France

p. 181
Left: woman in tie-dyed cotton dress, Mopti, Mali

p. 181
Right: woman in tie-dyed cotton dress, Djenne, Mali

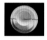
p. 183
Ceramic tableware *ON-LINE*, design A.W.G. bOb Van Reeth ARCHITECTS for Royal Boch, 1997, Belgium

p. 184
Detail of church square, St Mary Redcliffe, Bristol, England

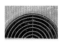
p. 185
Drain cover, Antwerp, Belgium

p. 186
Detail of work on paper, mixed technique, Anne Westerduin, 1964, Belgium

p. 187
Silver pendant, Berber people, Morocco

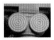
p. 188
Top: detail of pavilion in Middelheim Park, architect Charles Vandenhove, 1984–92, Antwerp, Belgium

p. 188
Bottom: toy made by African child, exhibited at *African children, art of dreams*, 1995, Brussels, Belgium

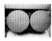
p. 189
Top: detail of lamp post, design Alexander Schabracq and Ton Postma, 1989–90, Amsterdam, The Netherlands

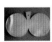
p. 189
Bottom: pendant of mother-of-pearl, Ifugao people, Philippines

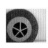
p. 190
Rain hat, bamboo and palm leaf, Yunnan, China

p. 191
Detail of door, London, England

p. 192
Detail of girl's skirt, bark cloth painted with black clay, Burundi

p. 193
Detail of exterior wall of African hut, Africa Museum, Berg en Dal, The Netherlands

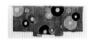
pp. 194–5
Kyogen costume (*suo*) with circle pattern representing the eye of a snake, indigo stencil-dyed (*katazome*) hemp, 19th century, Japan, private collection

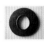
p. 196
Wooden bracelet, Dan people, Ivory Coast

p. 197
Detail of double ikat, cotton, India

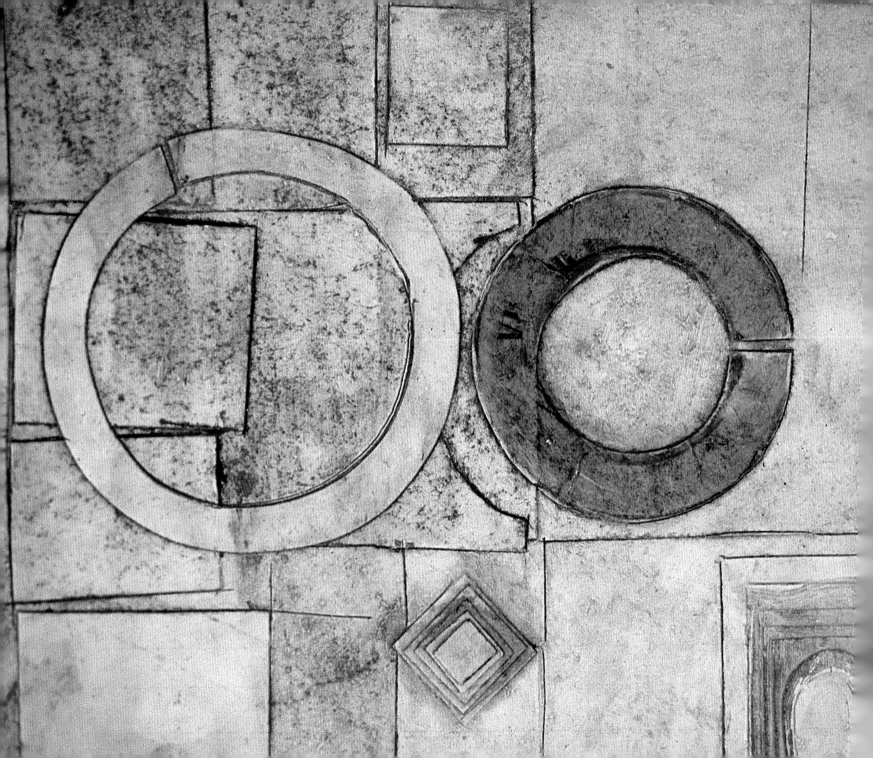

the elements of design